Leet Noobs

new
literacies
q

AND DIGITAL EPISTEMOLOGIES

Colin Lankshear and Michele Knobel
General Editors

Vol. 55

The New Literacies and Digital Epistemologies series
is part of the Peter Lang Education list.
Every volume is peer reviewed and meets
the highest quality standards for content and production.

PETER LANG
New York • Washington, D.C./Baltimore • Bern
Frankfurt • Berlin • Brussels • Vienna • Oxford

Mark Chen

Leet Noobs

THE LIFE AND DEATH OF
AN EXPERT PLAYER GROUP
IN *WORLD OF WARCRAFT*

PETER LANG
New York • Washington, D.C./Baltimore • Bern
Frankfurt • Berlin • Brussels • Vienna • Oxford

Library of Congress Cataloging-in-Publication Data

Chen, Mark.
Leet Noobs: the life and death of an expert player group
in World of Warcraft / Mark Chen.
p. cm. — (New literacies and digital epistemologies; v. 55)
Includes bibliographical references and index.
1. World of Warcraft. 2. Computer games—Social aspects.
3. Shared virtual environments. 4. Virtual reality—Social aspects. I. Title.
GV1469.25.W64.C54 794.8–dc23 2011043456
ISBN 978-1-4331-1611-7 (hardcover)
ISBN 978-1-4331-1610-0 (paperback)
ISBN 978-1-4539-0255-4 (e-book)
ISSN 1523-9543

Bibliographic information published by **Die Deutsche Nationalbibliothek**.
Die Deutsche Nationalbibliothek lists this publication in the "Deutsche
Nationalbibliografie"; detailed bibliographic data is available
on the Internet at http://dnb.d-nb.de/.

Cover image by Mark Chen

The paper in this book meets the guidelines for permanence and durability
of the Committee on Production Guidelines for Book Longevity
of the Council of Library Resources.

© 2012 Peter Lang Publishing, Inc., New York
29 Broadway, 18th floor, New York, NY 10006
www.peterlang.com

Printed in the United States of America

Dedicated to Robin and Ushki.

Table of Contents

Acknowledgments

Tons of people to thank, but foremost are Colin Lankshear and Michele Knobel for thinking this book had promise back when it was just a terrible mess. Thanks, also, to Peter Lang folks: Chris Myers, Sophie Appel, Catherine Tung, and Maria Abellana!

I'd also like to thank people who gave me feedback on various parts of the various drafts: Phil Bell, John Bransford, Beth Kolko, Jen Stone, Tom Boellstorff, John Carter McKnight, Lisa Galarneau, Aaron Hertzmann, Heiji Horde, Hillary Kolos, Sam Lowry, Bonnie Nardi, Amanda Ochsner, Vanessa Svihla, Jonas Heide Smith, Reed Stevens, Doug Thomas, Constance Steinkuehler, T. L. Taylor, Drew Davidson, Eric Ellis, Moses Wolfenstein, the Everyday Science and Technology Group at UW, and alumni of the 2011 Digital Media and Learning Summer Institute. There's no way *Leet Noobs* would have turned out as well as it did without your help.

To my guild and the MC raid group whom this book is about: Thank you for letting me write about our experiences. I miss you guys a lot!

Thanks also to Mom, Dad, Grandma, Dee, Frances, the rest of my family, and CACS. <3

Thanks and love to Robin for putting up with my gaming and helping me be less academic in my writing. ☺

In memory of Bill Winn whose enthusiasm and wonder were limitless.

A shout-out goes to Lyndsi Achucarro at Blizzard Entertainment for her massive help.

Everyone I've forgotten to include: Thank you, too!

Portions of this book were made possible through funding by the National Science Foundation through the Science of Learning Center program under grant SBE-0354453.

An earlier version of Chapter 1 appeared as Chen, M. (2009). Social dimensions of expertise in *World of Warcraft* players. *Transformative Works and Cultures*, 2. DOI: 10.3983/twc.v2i0.72.

An earlier version of Chapter 2 appeared in *Games and Culture*, 4(1), 2009 by SAGE Publications, Inc. All rights reserved.

Screenshots in this book were taken by me. Reprinted by permission of Blizzard Entertainment. All rights reserved.

In the Fiery Depths...

Imagine 40 people grouped together in a dark, hot, volcanic cavern deep beneath the earth. Some of them appear to have been human at one point, but the flesh rotting off their frames clearly points to some supernatural force. Others are muscular, green-skinned brutes or wiry, purple-skinned figures sporting mohawks and tusks. A few hefty, cow-like, bipedal forms stand much taller than the others. Some in this exotic group are dancing, some are jumping up and down, others are sitting and drinking water and various other liquids, but the majority of them are just standing around, waiting or watching the large, spiky snake-man creature in the middle of the chamber. The humanoids are wearing an assortment of leather or metal armor and/or cloth or silk robes, and they are equipped with glowing swords, maces, and staves. A few of them are discussing the upcoming confrontation. One of them in particular is talking about the specific positions and roles for the others during the fight. Many of the others are talking privately with each other at the same time, sharing pleasantries or chatting about more mundane events, as if oblivious to their locale and the upcoming battle.

The apparent leader of this raiding party, the one who was summarizing roles and strategy, yells, "Get in positions!" and everyone spreads out, running to various parts of the large cavern. A sizable group of them bunches up near a lava flow, directly across from the snake-man.

"Talk to Domo!" yells the raid leader, and one of the green orcs, decked out in full metal armor, rushes to the snake-man, Majordomo Executus.

Domo, seeing the orc approach, yells, "Impudent whelps! You've rushed headlong to your own deaths! See now, the master stirs!" He then summons his boss, the overlord of this intricate cavern system known as Molten Core.

The overlord's name is Ragnaros, and he emerges from the center of the chamber, adding to the sweltering heat, his fiery, semi-liquid form towering and massive like no other monster in this harsh land known as Azeroth.

"Behold Ragnaros - the Firelord! He who was ancient when this world was young! Bow before him, mortals! Bow before your ending!"

Surprisingly, Ragnaros bellows, "TOO SOON! YOU HAVE AWAKENED ME TOO SOON, EXECUTUS! WHAT IS THE MEANING OF THIS INTRUSION???"

"These mortal infidels, my lord! They have invaded your sanctum and seek to steal your secrets!"

"FOOL! YOU ALLOWED THESE INSECTS TO RUN RAMPANT THROUGH THE HALLOWED CORE? AND NOW YOU LEAD THEM TO MY VERY LAIR? YOU HAVE FAILED ME, EXECUTUS! JUSTICE SHALL BE MET, INDEED!"

With that, Ragnaros slays Majordomo Executus with a flaming ball of fire.

"NOW FOR YOU, INSECTS! BOLDLY, YOU SOUGHT THE POWER OF RAGNAROS. NOW YOU SHALL SEE IT FIRSTHAND!"

The raid leader, unfazed, yells, "ATTACK!" and a flurry of activity commences.

Within moments, the raiders are all dead.

This event was experienced repeatedly by a group of players in the massively multiplayer online game (MMOG) *World of Warcraft* (WoW) within the in-game cave system known as Molten Core (MC). This book follows the trials and tribulations of this group, examining its online gaming culture as its members formed friendships, learned how to work together and deal with failure and conflict, and ultimately broke apart due to a tense, fiery meltdown. Before melting down, however, the players developed a form of group expertise with the game and the gaming community, successfully leveraged various resources, and exacted revenge on Majordomo Executus and his tetchy boss, Ragnaros.

Introduction

Wait a Sec... Is Expertise in Games Valuable?

Well, yes, it is. And I don't mean that learning how to be an effective player in WoW prepares one to be effective in other areas (though, I fully believe it can and sometimes does). I subscribe to the notion that the purpose of education is to prepare people to be successful in all areas of life. This includes helping people become engaged in civic life and prepared to take actions towards their personally meaningful life goals. This means that the role of education is to help people develop critical attitudes in the settings they participate and care about. In other words, I value everyday learning and expertise, recognizing that people position themselves and get positioned (Holland & Leander, 2004) in deeply situated contexts that require experiential knowledge and specific literacies (Knobel, 1999) about not just how to be, but how to be successful. I look at gaming culture and online games as a setting for studying the development of everyday expertise, but I see this as part of a larger endeavor in education that looks at informal learning contexts and values any setting in which consequential decisions are made and meaningful actions taken.

The definition of expertise in these socially situated contexts moves away from a cognitivist conceptualization of expertise as individual knowledge and skill acquisition. Instead expertise is about successfully learning to participate in a *community of practice* (Lave & Wenger, 1991)—a group that is defined by its members' common actions and behaviors, coming from a shared understanding of legitimate participation within that community—and developing expertise can depend heavily on access to these communities of practice.

This definition aligns well with new definitions of literacy from a field called "new literacy studies," in which being literate is no longer just about reading and writing. It matters what kinds of texts are being read and written, which means it matters in which social contexts or domains of practice the activity is occurring, because different texts are valued in different contexts.

Being literate means being able to take on an identity as someone who is part of a larger discourse, affinity group, or particular domain of practice (Gee, 2003; Heath, 1983; Street, 1984). A full or legitimate participant is someone who can produce, consume, remix, and critique the cultural goods and actions of their particular group. In other words, new literacy studies always looks at the social setting in which meaningful interactions and discourse occur.

New literacy studies' concept of literacy dovetails with both Project New Media Literacies's (Jenkins et al., 2006) and the National Research Council's (2010) list of necessary 21st century skills for students to be successful, and I have combined the two lists together to form the one below. While the NRC report focused specifically on science education, its list fits in perfectly with the more general list that Project New Media Literacies came up with while thinking about what it means to be successful in our rapidly changing, digital world. To be successful, people should be able to

- *produce, consume, remix, and critique all sorts of media.* This is important for an engaged public.
- *communicate and coordinate on joint tasks.* This is important for mobilizing our collective resources in solving our world's problems.
- *play and problem solve.* Everyone should be able to act as a scientist and engineer. Everyone should be able to act as a gamer.
- *perform, identity shift, and metacognate (Bransford, Brown, & Cocking, 2000)*–the ability to reflect on where one is in relation to end-goals of a task or endeavor–in all the various settings they participate in. This ability to play different roles is necessary for thinking about what could be and assessing where we are in relation to that imagined future.
- *think in systems and form social networks.* An awareness of the world as globally connected and comprised of systems upon systems and then being able to take advantage of networks that leverage this understanding is important for radical change.

Many of these skills are developed naturally through game play. Good games inherently provide two main benefits as a backdrop for participation. First, all games, to be considered *games*, present players with a system of rules or constraints that must be recognized, understood, and navigated in order for players to reach predetermined goals (Salen & Zimmerman, 2004; Juul, 2005). This is why *Second Life* is not a game but more a platform for user-generated content and interaction. What this means is that, in good games, players have to see the game as a system and take a playful stance of trying, failing, revising,

and retrying various tactics and strategies in order to become expert players and achieve.

Second, many games tell a story or narrative that drives and motivates play, and, actually, in such games it is player decisions and interactions that create an emergent narrative. This requires what Gee calls a *projective identity* (2003, p. 55), where players must imagine who the hero / avatar that they are controlling and being is like and what outcomes should result from their play before making strategic decisions. The imagined future gives players agency, and good games reward them with satisfying stories that players understand through embodied experience.

Understanding these two aspects to games and gaming necessarily complicates our current push to use games for learning and to appropriate gameplay for schools. To play is to explore the rule / constraint systems in a game, motivated by an imagined reality. In many cases, to play expertly is to push at these rules / constraints, to exploit them and break them, to make the world the way it ought to be. This obviously turns the way learning happens in schools on its head. The very act of gaming is subversive and radical, the antithesis of top-down models of authoritative schooling. Yet seeing these benefits to gaming makes it clear that games represent sites of empowerment and agency.

At the time of this writing, there is a battle coming up within the games for learning arena. It may be happening as you read this. This battle is for the future of games for learning and its place within both formal and informal educational contexts. Evidence of this upcoming battle can be seen in the line-up of presentations on games for learning at the 2011 meetings of the American Educational Research Association (AERA), which seemed focused on the assessment of specific content areas (i.e., facts and figures), and the Games Learning Society (GLS), which focused on gaming ecologies and systems thinking.

On one side of the battlefield exists the old guard, the dominating power, which represents a traditional view of how technology and games should be used: as new content delivery platforms—tools for rote memorization. This way of looking at games' potential fits within a model of top-down assessment in schools. Teach to poorly designed standardized tests, focus on content knowledge, use games to deliver this content.

On the other side of the battlefield, mostly younger researchers who have grown up as gamers line up (or, more accurately, clump up in a haphazard, unfocused, amorphous mob) to argue for games as part of larger ecologies of practice and meaning-making. I identify with this group, and we understand

games as systems and gaming as participating in a larger culture around games, learning how to solve problems, collaborate, and push at the systems. Games make the perfect sites to study how people can develop 21st century skills and everyday expertise and how people can learn to be agentive in the face of difficult problems. More precisely, emergent play that is situated in gaming culture—historically and socially based practices, beliefs, and symbolic thought—and with specific games can give us insight into the development of expert practice in personally consequential settings.

Social and Cultural Capital

Ironically, sometimes the most resistance I receive when I express the importance of everyday learning (and posit that expertise exists in all settings in which people participate in meaningful ways) comes from gamers themselves. Having grown up accustomed to the idea that what is valued in schools, labeled as "education," only happens in schools and other formal environments, many people see elective activities, such as gaming or reading comic books, as holding no educational value. I suggest, however, that success in life does not necessarily depend on one's knowledge of decontextualized facts and trivia. Instead, it depends on knowing how to act and be within one's everyday activities and communities.

A useful idea here is found in Bourdieu's (1986) writings on social and cultural capital that are alternative to economic capital as ways of valuing status and participation. Specifically, social capital is what one accrues through personal relationships such that parties in the relationships have an understanding of reciprocal responsibilities. This is the idea of scratching one another's backs when someone in the social network has an itch. Making these social connections and maintaining one's network is important for online gaming (Jakobsson & Taylor, 2003).

As summarized by Thomas Malaby (2009), Bourdieu's cultural capital takes on three forms: having embodied knowledge—that is, knowledge originating in lived experience—about what is important or how to do things, owning particular artifacts or tools that are important to the culture, and being labeled as an expert by some sort of institution or authority that identifies one as having cultural credentials (pp. 36–45). What Malaby adds is the idea that relevant *contingent* acts—performative acts that have a chance of failure—can often be more valued than non-risky acts (p. 87). By their nature, games present players with spaces in which to routinely make these contingent acts. More to the point, any sort of community of practice or cultural domain has a

lexicon of contingent acts that people can perform to build up embodied cultural capital.

The idea that expertise development is dependent on access to expert practice means that one has to have the ability to accrue social capital and make connections with other people or friends. These friends are more valuable if they can be leveraged or can act as sponsors into an activity space or community of practice, providing social supports that help facilitate moving between spaces (Brandt, 1998). Knowing what the actual practice is and how to take part in that practice by going through the process of enculturation into the community becomes embodied cultural capital. And, of course, these two forms of capital build on each other. The old saying, "it takes money to make money," can be applied to other forms of capital. It takes capital to make capital.

For elective pursuits, including engaging in gaming culture, both social and cultural capital need to be developed in order for a person to fully participate. Therefore, everyday settings are definitely sites where meaningful and consequential events and linkages are happening among their participants. To counter the gamer who doesn't value gaming, the cultural production and social bonds that form in informal everyday settings can have great importance to many of the people who are participating in those communities, so socially produced value exists as part of these informal settings. It may be unrecognized by the gamer, but it is there, and the gamer is using it. The educator in me—the human in me—wants to help people in these settings. Furthermore, if certain people are successful in some settings but not in other settings, perhaps this means that the idea of "transfer" should get turned on its head. Instead of trying to help people transfer individual skills from one setting to another, we may want to think about how to help people transfer or convert their social and cultural capital from one setting to another.

Description of Chapters

The specific game that this book is about is *World of Warcraft* (WoW), which follows a tradition of role-playing games where players take on the identities of characters in a fantasy setting full of things like elves, dwarves, and orcs. More precisely, however, this book is an ethnographic (narrative) account of WoW gamers and their situated practice as they learn the game together, make new friends, and test new ways of being social. Players each log in to the game from their own computers, and they are represented as avatars in the virtual world.

This ethnographic account is along the same tradition as Bonnie Nardi's (2010) description of WoW culture and play in My Life as a Night Elf Priest. Most of my book, however, will focus specifically on a group of about 60 players as they engaged in a joint-task called "raiding" for about 10 months. The raid group I participated with was made up of an alliance of several permanent player associations called guilds. Players from one main guild organized the raid group. This included Maxwell, the leader of the raid group, an undead mage. I'm calling his guild The 7/10 Split in this book. I was affiliated with and actually served as an officer of a different guild called the Booty Bay Anglers.

During a raid, the players gathered at a location within the game world known as Molten Core (MC) and fought a series of formidable monsters as a team. These sessions normally lasted several hours at a time and occurred two to three times per week. Every Tuesday the game servers would reset, repopulating MC with monsters, and each week the team would attempt to clear as much of the zone as possible. It took the group about 7 months before it was able to accomplish the final goal of defeating every monster within MC, including its last boss monster, Ragnaros the Firelord.

I collected in-game text and voice chat, recorded videos of in-game practice, and archived out-of-game communications on web forums. This research is similar to the work of other games scholars who write about their gaming groups, such as Constance Steinkuehler (2007) with the MMOG Lineage, T.L. Taylor (2006a) and the MMOG EverQuest (EQ), and Bonnie Nardi (2010), who gives a terrific overview of WoW culture and player discourse analysis. Like them, I bring what Reed Stevens and Rogers Hall (1998) call a disciplined perception—a way of seeing things that only an expert to that particular domain could—to orient to the kinds of activities and meaning-making taking place in and around the game. After writing this and seeing what I've got, I notice that the accounts I present tend to lean on the personal, painting a general overview of WoW life from my point of view. Partly this is done out of necessity because of the kinds of data I am allowed to share ethically, but partly this is done because I, of course, only had a small sliver of a window into the world of WoW. Whenever I make a huge generalization, please take it with a grain of salt. This is especially true since I really do believe that the server I was on and the groups I hung out with were different than most others in how they chose to organize and in their expressed values and goals. In any case, this research documents the practices of a raid group as it learned to raid through a distributed cognition (Hutchins, 1995a, 1995b) and actor-network theory (Latour, 2005) lens, mapping the learning pathways of

the group as systemic wholes, which includes the members' use of technological / material resources.

Chapter 1 represents an exploration of everyday expertise and how its development can be attributed to successfully accruing social and cultural capital. It also describes in more detail the benefits of ethnographic methods while painting a general overview of (a) leveling up with a guild and (b) raiding in WoW. This sets the stage for a series of points that I hope to make clear: expertise is defined through emergent *sociomaterial practice* (Orlikowski, 2007)— that is, actions and behaviors that are situated within a specific setting made up of "the constitutive entanglement of the social and the material in everyday organizational life" (p. 1438); it depends on the accrual of social and cultural capital; what counts as capital is also socially governed; and what counted most for the 10-month raid group I studied was "hanging out and having fun."

Chapter 2 documents the communication and coordination practices of The 7/10 Split-led group while raiding within the game. Little has been written to describe actual player practice in MMOGs, especially with regard to "endgame" or "high-end" raiding—high-stakes raiding that typically happens after players have played the game for a few months. Additionally, some academic literature (cf. Zagal, Rick, & Hsi, 2006) suggests that games and educational software could be designed to promote cooperative behavior, placing emphasis on game design's effects on player choices. In response to this research, I present a thick description of raiding practice, demonstrating the nuanced nature of play motivations and how decisions players make in the game are not necessarily tied solely to game mechanics. I also make the claim that trust is necessary for group success and that my particular group of players built trust through careful alignment of shared values and motives and emphasis on camaraderie rather than through game-designed incentives.

Chapter 3 describes the mechanics of combat in WoW and then analyzes the adoption of a new user-created modification to the game's interface by the MC raid group through the lens of actor-network theory (ANT), distributed cognition, and other *object-oriented* ways of looking at systems of activity. I take a cue from science and technology studies (STS) and consider the activity system a complex arena full of contentious parts engaged in acts of resistance and accommodation, otherwise known as a "mangle" (Pickering, 1993; Steinkuehler, 2006), "actor-network" (Latour, 2005; Giddings, 2007), or "assemblage" (Deleuze & Guattari; 1987, T.L. Taylor, 2009). These are useful as analytical tools because I document the emergent practice and relationships among the various people and objects and their relations and associations in the activity.

Chapter 4 details how the MC raid group under study eventually broke apart due to a change in what players wanted out of their raiding experience. Player goals that were once aligned toward hanging out and having fun eventually became fragmented and more differentiated, in part due to the WoW community's continual movement towards normalizing the valuing of magic equipment and gear (known as "loot") and efficient progression in in-game raid zones. Added to this fragmentation, the leaders of the raid group mishandled the conflict and shut down possible avenues of recourse. Thus, this book really is about the life and death of a raid group and its distribution work over time from the perspective of a participant with the raid group from its inception in late 2005 to its demise mid-2006.

Between these main chapters are interlude sections featuring short vignettes of WoW playing to help ground our understanding of the larger context of raiding practice. Each of these interludes includes an introductory paragraph or so describing the section and what it illustrates.

While each chapter could probably be read independently, when put together they tell a story with a consistent through-line about how playing *World of Warcraft* and participating in raids was situated in a complex network—driven by a mangle of numerous parties, ideas, and values—resulting in socially and historically emergent practice. The conclusion will summarize this through-line and the process in which expert players became novices or "noobs" again to relearn expert or "leet" gameplay within the context of raiding. They were not true novices because they already had a good understanding of the complexity of gaming practice. Rather, they were "leet noobs" who had to realign and adapt their individual gaming arrangements to new sociomaterial structures, a process that was negotiated through joint venture.

The story also details how the practice emerged out of conflict and trust: conflict between player goals and in-game constraints, as well as conflict among individual players; and trust between players, having resolved their conflicts and negotiated roles and responsibilities through a shared understanding of common culture. Furthermore, the actors in the story are not limited to human players. There was also conflict between players and their nonhuman resources when those nonhumans failed to act or perform their agreed-upon roles. Similarly, there was trust between human and nonhuman actors in the system when things were working. And, like many good stories, this one has an ending that is both compelling and depressing as the group of players I document came to face insurmountable differences that could not be renegotiated.

A *World of Warcraft* Primer

As mentioned before, *World of Warcraft* follows a tradition of role-playing games loosely based on *Dungeons & Dragons* (Gygax & Arneson, 1974; Wizards of the Coast, 2008) set in a Tolkien-inspired fantasy world (Tolkien, 1954/1955) full of exotic locales, aggressive monsters, and glory to be had (Blizzard Entertainment, 2004). Each player chooses a type of character class to play (e.g., a brawny warrior, a backstabbing rogue) and the race of his or her character (e.g., orc, human) that, in turn, determines which of the two opposing factions his or her character is aligned with (Alliance or Horde). Character class and race also determine one's initial attribute values (Strength, Agility, etc.) and the available abilities or actions one can perform (such as the rogue ability Sinister Strike; see Figure 1). The abilities from one class complement those from a different class, encouraging players to team up and cooperate. As a player journeys through the land with his or her character, completing quests and defeating monsters, the character accrues experience points (XP). After a certain amount of XP, the character advances an experience level and becomes more powerful through a rise in his or her attribute values and access to new abilities. Additionally, the corpses of defeated monsters can be searched for loot that they "dropped" that help characters outfit themselves and be better prepared for future encounters. Some loot, for example, is enchanted and gives additional bonuses to a character's attributes.

During the time of data collection for this project, WoW had a level cap of 60, which means that characters started out at level one and could only advance to level 60, at which point no more XP could be gained. (The level cap at the time of this writing is now 85.) Eventually, most players discover that to continue to advance efficiently, they need to team up with other players who are working on completing the same quests and defeating the same monsters.

To team up, the player-character joins a "party," a group of up to five characters. Once reaching the level cap, one of the only ways to continue getting stronger was to join a raid group—composed of several parties, making a larger group of up to 40 players—that could go to high-end dungeons to kill the monsters within for the loot they dropped. For some of the encounters a group faced, it was important to compose the party or raid with favorable proportions of the different character classes. For example, it was often useful to have a warrior in the party to take the brunt of the blows from the monsters because warriors have high Stamina and are allowed by the game to wear plate armor, and it was also important to have someone who could heal the other

party members when they took damage. Some encounters were much easier with certain group compositions.

The roles players assumed in the game were as much determined by their character classes and personal skills as by their social relationships. Often a character was invited or allowed to join a raid group only if he or she met the raid's requirements in terms of his or her character class in relation to the existing composition of the raid. This worked under the assumption that the player was skilled and familiar with the game mechanics to play effectively (i.e., had relevant cultural capital). It was not the only factor, however. Preference was also often given to players via their standing social capital (e.g., based on their relationships with others in the group). Generally, players who had formed friendships or at least knew each other or were connected via their social networks joined up together. Two brothers joined the group together, for example, the older one getting the younger an invite when the older was invited to the raid group based on his reputation as a skillful player. Players also gained access through affiliation to reputable guilds—in-game organizations that let players more easily communicate with others while playing—or through sponsorship from guildmates who were already part of the raid group. A common misconception is that raiding groups are synonymous with guild groups. Although this may be true in most cases, it was definitely not true with my raid group or on my server, in general, back in the day. In fact, of the raid groups I personally knew about, only a handful were guild-exclusive.

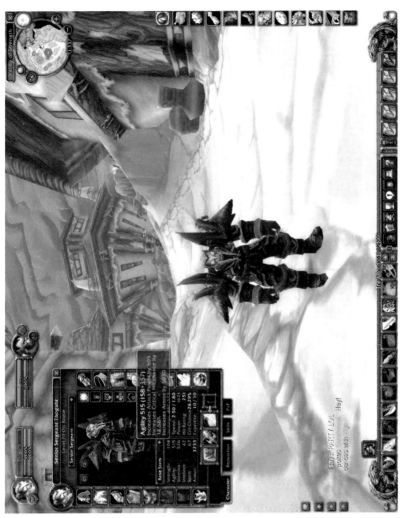

Figure 1. User interface showing the character panel with a mouse-over tooltip detailing the Agility attribute. The row of buttons at the bottom left include different abilities that I could activate. Image from *World of Warcraft*® provided courtesy of Blizzard Entertainment, Inc.

Setting, Group, and Data Collection

World of Warcraft subscribers were divided up by region (North America, Asia, etc.) and time zone. Each of these zones had separate computer servers, running different instances of the game, so that each server had about three thousand players. Blizzard Entertainment decided to create different types of servers for players to log into, catering to different play styles, thus, some research findings may not be universal to all who engage in WoW play. The server that some existing friends of mine and I joined was a North American role-play (RP) server, where players agreed to use character names that stayed within the fantasy lore of Warcraft. We chose an RP server because players also agreed to restrict the content of their communication to in-game topics and limit their use of "leet speak"—a way of communicating using substituted characters and shorthand commonly associated with gaming culture, sometimes similar to the shorthand found in texting or instant messaging. In reality, there did seem a tendency for more in-character talk and less leet speak, but out-of-game references and abbreviated forms of communication still occurred, especially in private back channels and during moments where efficient, combat-specific talk (such as "rez pls") needed to happen (see "Role-Playing" interlude). Our assumption was that less leet speak made for a more mature player base that valued effective communication skills.

In the spirit of joining an RP server, I created Thoguht, an orc rogue, and thought of a back-story featuring him as a "stabby stabby," cutthroat character who had reluctantly joined the Horde in its battle against the oppressive Alliance. His description, as written in 2006 for an RP "add-on" (user-created modification to the game) called FlagRSP:

> Thoguht appears short and stocky for an orc, but his movements are graceful and efficient. When he has his hood off, it is clear that the braids of his beard are well groomed. With his hood on, you can still see the scowl on his face betrayed by the frown around his eyes. His is a life of violence having been born into demonic slavery. The demons taught him well, however, and when he joined Thrall for freedom, he was able to ply his knowledge of the shadowed path against his former oppressors. Unfortunately, since gaining his freedom and attempting to stake out a farmstead, he has found new oppression from the Alliance who understandably want revenge for years of war and pain suffered at the hands of the enslaved orcs. And so, he takes up arms again but, rather than fighting against the Alliance, he seeks common enemies in the hopes that fighting them will unite the two ever disparate factions.

My friends and I quickly formed one of the server's first guilds, the Booty Bay Anglers. In the game, we (that is, the guild) had our own chat channel and interface panel to help us see who else was online, so we could form groups or share newly discovered information. Out of the game, we created our own

website, with forums where we planned play times and events, discussed strategies, argued about character strengths and weaknesses, made "your mom" jokes (something I didn't particularly care for), and posted links to *World of Warcraft* machinima and Internet memes.

The first few months of my playing time were spent leveling up, completing quests, and learning the rules of the game. Over the course of playing, our guild gained members and reputation and formed alliances with other guilds. About a year after I first started playing the game, I was able to join a raid group for endgame content through one of these alliances. It was a newly forming 40-person raid group that met up each week to delve into the dungeon known as Molten Core for a period of about 10 months (October 2005 through July 2006). For the 8 months after I had leveled up but had not joined a raid, I participated in smaller five-person group activities in a sort of transition or training period meant to get powerful enough equipment for the larger high-end activities.

Molten Core is a volcanic cave deep below Blackrock Spire, located in a fiery, barren landscape (see Figure 2). The sounds of lava flows and rushing hot air provided steady background noise as we delved and fought the monsters inside. These monsters included a bevy of generic monsters like rocky Molten Giants and two headed Core Hounds and several big "bosses"— unique monsters with carefully scripted combat sequences, providing players greater technical challenge, with names like Majordomo Executus and Ragnaros. The other players and I became so familiar with these unique monsters that we referred to them with the diminutives "Domo" and "Rags." Like all WoW monsters, each monster in MC had a set of abilities they used when fighting. For example, Molten Giants had a Stomp ability that damaged everyone around them. Part of successfully raiding meant learning effective approaches to each encounter (i.e., effective counters to each monster ability).

Over the months, the membership of this raid group fluctuated (see Appendix). We had a core of about 20 players from several guilds who had shown up every week since the formation of the group, another pool of 30 or 40 who were regulars for two or three months, and another 20 or so who showed up either just once or sporadically. On any given night, we would start forming up about an hour before actually going into the dungeon. If we were short a few players that night, we needed to invite others who were not regulars by having raid members ask their respective guilds if anyone was available to join us. I did not analyze any chat data from non-regulars to the group, but I did look at online message postings from all players, as it was a public forum.

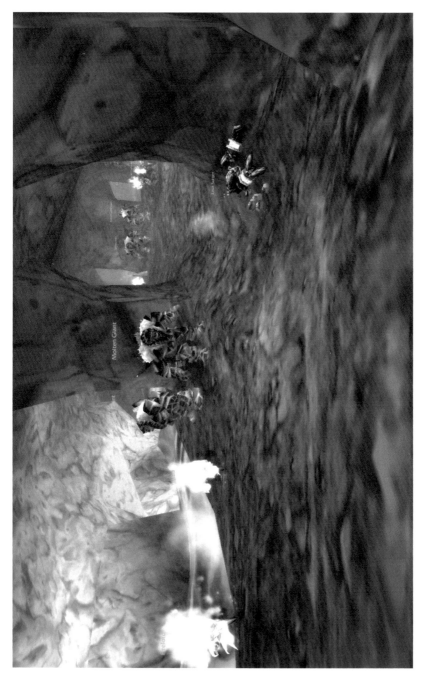

Figure 2. Molten Core, a fiery cave system full of monsters such as Lava Elementals, Core Hounds, Lava Surgers, and Molten Giants. Image from *World of Warcraft*® provided courtesy of Blizzard Entertainment, Inc.

The raid group met twice a week to go into MC for roughly 7 months and then just once a week for 3 months as it became more efficient in killing monsters. During this time, however, the group added additional dungeons and caves to explore to its docket so that we were meeting three times a week about halfway into the 10-month lifespan. Only one of those three times was spent in MC. Each session lasted about 5 hours, and each week the group would attempt to kill as many of the boss monsters as possible before all the dungeons reset every Tuesday. That is to say, every week the group would start anew because MC and other raid zones would be set back to their initial states and all of the bosses and other monsters would reappear. This mechanic was deliberately designed into the game to allow groups to achieve progress through iterative attempts to clear the zone. It also limited how frequently players could clear the same zone for the loot the monsters dropped. Some of the regular non-boss monsters also reappeared (known as "repopping" or "respawning") after a few hours making backtracking during a session difficult. Only after 7 or 8 months of attempts was the group able to clear the dungeon completely before it reset the following week.

The last 3 months of this 7–8 month period were spent achieving the ultimate goal of raiding MC: defeating the last boss monster, Ragnaros, and collecting the epic loot he dropped (see Figure 3). In sum, then, it took the group 5 months of regular practice in MC to learn how to kill efficiently the monsters leading up to Ragnaros. Then it took another 3 months to learn how to execute successfully the Ragnaros fight. Half this time, however, wasn't actively spent on Ragnaros. It took time to get to him within MC and we weren't yet fast enough to make reaching him a given. Spring break occurred during this period for many of the raiders, which slowed our progress, as well.

Like most WoW boss monsters, when he died, Ragnaros only dropped three or four items. This meant that raid groups typically continued to visit the dungeon to defeat Ragnaros multiple times even after they had solved the complex problem of his defeat so that every raid member, in theory, at least, could receive a loot reward. Different groups used different reward systems to ensure loot was distributed evenly and fairly. One common method was to award points for participation that could then be spent during in-group loot auctions. The most famous of this system is called "dragon kill points" (DKP; Malone, 2009). Another method, a "laid back" one used by my group, was by randomly awarding raid members with loot, giving veteran raiders weighted chances of winning, and emphasizing the group's values of friendship over loot (see Chapter 2).

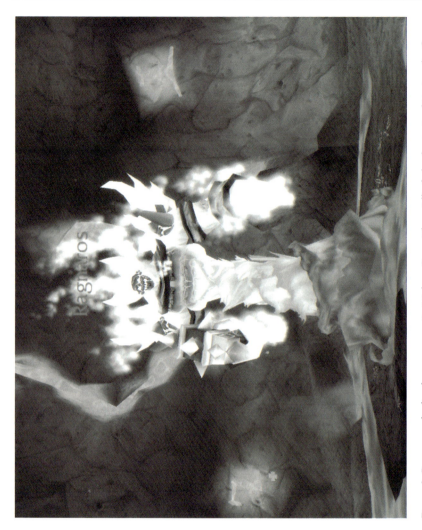

Figure 3. Ragnaros, the last boss monster in Molten Core. The raid's skeletal remains littering the floor around him are good indicators of his size. Image from *World of Warcraft*® provided courtesy of Blizzard Entertainment, Inc.

I collected raid data in the form of text chat logs during the whole 10-month period (about 600 hours of chat). During this time, I was also able to collect about 80 hours of video data that includes our voice chat for certain key battles. Much of my insights come from my overall experience with the game community across several years of play, and some of the quotes I use come from publicly available web message board posts or in-game chat in public, non-raid channels. A selection of these play sessions were then written up as narrative events, using Rogoff et al.'s (2002) *functional pattern analysis*, that include enough detail to give rise to patterns of practice across the set of narratives. When I started collecting video data, I asked for permission and asked the raid members to tell me if they were below 18 years of age so I could exclude their chat from my analysis. Only one told me he was below 18, which supports my suspicion that back then most players of WoW on RP servers who get into high-end raid groups were adults. This was partially because of the time commitment required of high-end raiding and leveling a character up to 60 (Ducheneaut, Yee, Nickell, & Moore, 2006b). There were certainly many minors playing the game, in general, but I did not normally have much interaction with them once I was involved with the endgame content. (And, yes, that's interesting in itself! How does it change what we should be thinking about to realize that for many multiplayer games, kids are hanging out with mostly adults? Does that affect our thinking about games as a childish, trivial, or valueless pursuit?)

World of Warcraft had several default in-game text chat channels. These channels were color-coded in-game and included the following:

- say—which only displayed talk from other players if they are near enough
- yell—displayed talk that is broadcast to a large region
- emote—displayed text for in-game character animations
- whisper—displayed personal chat between two players
- [Party]—for up to five players who had teamed up to complete quests or tasks
- [Guild]—to send messages to guild members no matter where they were in-game
- [Officer]—for the officers of a guild
- [Raid]—for up to 40 players, consisting of eight parties of five players each

There were also optional channels that most players in the raid group, including me, unsubscribed from because it was too daunting a task to keep

track of that many channels and because the talk found on those channels was irrelevant to the raid. Any player could, however, also define custom chat channels to share with other players. My MC raid group used six custom channels, broken down by character class / role in the group. These were as follows:

- [healsting]—for the healer classes to talk about who to heal
- [madtankin]—for the warriors to talk about who would play certain roles
- [splittranq]—for the hunters during a specific fight in MC
- [madsheep]—for the mages to coordinate who would cast polymorph spells in certain encounters, turning enemies to sheep
- [soulburn]—for the warlocks to talk about who to support and which monsters to banish
- [madrogues]—for the rogues to talk about general rogue strategy like when to use poisons on our weapons

While these special channels were created to facilitate coordination, we all ended up also using them for informal banter between friends. Normally, each player only subscribed to one of these channels depending on his or her character class. For much of the spring of 2006, I subscribed to all these channels so I could see the simultaneous coordination going on during our raid excursions.

The text chat from all my subscribed-to channels was recorded to external text files using a player-created add-on to the game. The raid group also used third-party voice chat software (Ventrilo), and I was able to record movies of my computer video and audio, including our voice chat during certain boss fights. I then coded portions of the chat that I thought were evidence of various forms of learning or were particularly representative or meaningful to the group, such as chat from new boss fights or from other moments that included large amounts of strategy talk.

Even though I never knew most of my participants' offscreen names, all character and guild names have been changed to further protect participants' identities. I took this opportunity, however, to code meaning into the character aliases by using ones that start with the same letter as the characters' classes (e.g., "Roger" is a rogue, "Maxwell" is a mage, etc.). The only exception is for warlocks. To disambiguate from warriors, I used the player shorthand for warlocks ("locks") and gave all the locks in my group aliases that started with "L."

In the chat and message board data that I will be presenting, I did not correct for grammar or misspellings, as I sometimes found them indications of whether a player was being mindful of what he or she was typing. The communities I participated in valued proper English sentence formation, grammar, and spelling, even if they also used common game-specific terms. Careful readers may notice that the timestamp format changes once in a while. This is because during the course of playing for a year or so and then participating with the MC raid group for 10 months, I had to switch between different logging add-ons as they broke whenever Blizzard updated or patched the game and as new ones became available when add-on creators adapted / recoded for the game changes. It was not until after I had collected the majority of the data I would use when Blizzard included tools for chat logging as part of the standard game.

Pugging the Chicken Quest

The following interlude section describes a play session while leveling up: conversing and meeting up with a friend, followed by forming a group with a stranger to cooperate on a quest. This is meant to illustrate typical, non-raiding gameplay and the different norms that existed how to "talk" in game on the public and private chat channels on a role-play server.

❋

In the first few months of my WoW life, while leveling up, I'd often log onto *World of Warcraft* as soon as I woke up. WoW had become a part of my life like no other game before it. Certainly, there were games such as X-COM: *UFO Defense* that would sustain my engagement for weeks, when the first thing I did every day was turn on the computer to play, waking up an extra hour or two before work, and the last thing I did every evening was play into the night. Taco Bell's "4th meal" was created for me. But WoW was nearly all consuming.

When I logged into WoW every morning, another guild officer for the Booty Bay Anglers, Meep, was often already online since he lived in the Eastern Time zone (I was in Seattle). The officers normally partied together whenever we could, so Meep sent me a party invite as soon as I logged on without asking if I wanted to join first. We quickly decided to do the chicken escort quest in Tanaris and agreed to meet at the quest start location, but my character, Thoguht, had to train some new rogue abilities first (after having leveled up the night before) and then check something in the Auction House—an in-game market driven by players, similar to the online auction site eBay.

While I was checking the Auction House, I asked Meep if he could wait 15 minutes, but I ended up making him wait for about an hour due to travel time and going "afk" (AKA "away from keyboard"). Most cities had game-controlled non-player characters called Flight Masters who offered player-characters a sort of airline service on the backs of wyverns that flew from city to city. This was much faster and less laborious than manual navigation by the

player on foot or using mounted transport. It took a good 10–12 minutes to fly from Orgrimmar to Gadgetzan. But then I went afk for 30 minutes to take care of some offscreen, "in real life" (AKA "IRL"), errands. (Unlike the depiction in *South Park*, some of us used the restroom and showered.) After finally getting to the deserts of Tanaris and marveling at how oppressive the visuals and art design for the arid heat could be (even before they added weather effects) during my run, I met up with Meep. When I got there, I saw Meep standing by a small robot chicken hidden behind a sand dune. I accepted the quest with Meep, but, while preparing for our task, we came across another Horde player, a priest named Powder:

[Thoguht] says: Hi.

[Powder] says: hey you guys going to save the Chicken

Powder greets everyone with a hearty hello!

[Thoguht] says: Yes. want to join us?

[Powder] says: sure

[Party] [Meep]: ready *[Meep used the party chat channel, a private channel that only members of the same party can see.]*

[Thoguht] says: Meep is the party leader and he is currently daydreaming for one sec... *[At this point, Powder can't see that Meep is ready since he is not yet in our party.]*

[Powder] says: lol

Powder joins the party.

[Party] [Powder]: hey

[Thoguht] says: Ready?

[Party] [Meep]: Hve you done this before Powder?

[Meep] says: Animus Arcanus! *[Meep liked to use button macros that would have his character automatically say things as he cast certain spells. In this case, he was casting Arcane Intellect on my character.]*

[Meep] says: Animus Arcanus! *[And again on Powder.]*

[Party] [Powder]: nope i tried once by myself

[Party] [Meep]: Well, the key is to hang way back

[Party] [Powder]: but that was just no good *[The <Enter> key is sort of like a comma in text chat, often used to break a sentence up into separate ideas or clauses. This is especially true in*

informal chat, whereas more formal speak on an RP server tended to be full sentences. This utterance was a continuation of Powder's previous one.]

[Party] [Meep]: And dont attack ANYTHING unless the chicken attacks it first

[Party] [Powder]: right

[Thoguht] says: Ah right. etiquette. Let the chicken attack first. Do not attack anything unless the chicken attacks. *[I had not yet switched to the party channel for some reason.]*

[Party] [Powder]: did the one in Feralas too *[There was another chicken quest in a different zone named Feralas.]*

[Party] [Meep]: Righto.

[Party] [Meep]: I'm ready

[Party] [Powder]: stupid Chikens

[Party] [Powder]: rdy

[Thoguht] says: yes.

Grouping with people who were strangers was known as participating in a "pick-up group" (AKA "PUG"). Once WoW play matured and players moved onto endgame content, "pugging" was generally reviled since it was more likely to end up with a player who did not fit in established social norms of one's normal group of players. As was common in the early days of WoW playing on a role-play (RP) server, Meep and I would keep our "says" in character or "IC" (as opposed to out of character or "OOC"). That is, we would type out full sentences and pretend we were really in Azeroth. This is why when Meep—or, more precisely, the player who controlled Meep—was afk, I explained that he was daydreaming. It also explains why Meep's player felt compelled to include a chant in the [say] channel while casting certain spells (e.g., "Animus Arcanus!"). Since we had never met Powder before, we spent some time up front to greet each other and make sure we were working on the same quest before joining forces. Contrast this with Meep's instant invite to me as soon as I logged on. Once we were all in the same party, we used the [Party] chat channel to talk about strategy more informally, without having to adhere to RP standards.

The three of us activated the quest, and, with a start, the mechanical chicken woke up and announced, "Homing Robot OOX-17/TN says: Emergency power activated! Initializing ambulatory motor! CLUCK!" It then took off running Northeast. For the next few minutes, the three Hordies ran after the robot chicken, letting it attract the attention of local predators before

jumping in to rescue it from harm. Unfortunately, we became overrun with monsters, losing the chicken to a large-dog-sized Basilisk. We had failed the escort quest and had to try again, but while running back to the start location of the quest, Meep took the time to reflect on what went wrong and how to improve our strategy with, "I shoulda AoEd em."

"AoE" stands for "area of effect," and to AoE someone was to activate abilities or cast spells that did damage to an area rather than to an individual target. Meep realized that when we got mobbed by many enemies, he could have hurt them all at once instead of one at a time. As will be evident in the next chapter, this time to reflect on performance was important for raiding. This case with Meep shows that reflecting and learning from failures was part of standard WoW practice, not just raiding practice.

On our second attempt, Meep used the private [Officer] channel for our guild to talk to me, but our side conversation was interrupted by the chicken as it attracted the attention of some specially spawned, quest-specific enemies:

> [Officer] [Meep]: can't priests do any offence? :)

> [Officer] [Thoguht]: depends on the spec [Players could customize (AKA "spec" for specialization or specification) their characters in specific ways.]

> Homing Robot OOX-17/TN says: CLUCK! Sensors detect spatial anomaly ~ danger imminent! CLUCK!

> Wastewander Scofflaw says: No one challenges the Wastewander nomads ~ not even robotic chickens! ATTACK!

By using the private [Officer] channel that Powder was not privy to, Meep and I could agree on how we thought of Powder. Was he a good player? Did he know what he was doing? These were implied questions Meep was asking when he asked me, "can't priests do any offence? :)" The months spent leveling up our characters during the early days of WoW was when we met new players and formed bonds of allegiance. Navigating different social networks, finding others who aligned to our particular play style was important in several ways. First, we may not have known at the time, but we would eventually need to leverage our networks to form raid groups for endgame play. More importantly, though, without a stable network, there was no way the game would sustain our interest after we had gotten our fill of its designed content. Our guild discussed behavior of non-guildies to assess whether they were friend material.

After the three of us defeated the Wastewander Scofflaw and his nomad friends, we successfully escorted the chicken back to base. Powder seemed to

be aware of how little help he had been and said, "thanks guys sry about the no help," to which Meep replied, "No prob :)"

While the mechanical chicken despawned ("Homing Robot OOX-17/TN says: Cloaking systems online! CLUCK! Engaging cloak for transport to Booty Bay!"), Thoguht, Meep, and Powder said goodbye and thanks to each other:

[Thoguht] says: K thanks.

[Party] [Powder]: later thanks a lot

[Thoguht] says: Bye.

Powder leaves the party.

Powder waves goodbye to everyone. Farewell!

Meep bows before Powder.

Powder bows before you.

Powder bows before Meep.

[Party] [Meep]: What now?

We used a combination of chat and in-game animations called "emotes," even though typing the emote commands took time. Our desire to be cordial to each other was well within the norms of playing on an RP server. The norms that were being set were not explicit, however, as it is clear that Meep and I adhered to syntactically correct English more so than Powder. Meep and I were mostly careful about capitalizing first letters in sentences and ending our sentences with periods when we were talking with strangers. Powder brought with him his own notions of communicative norms and chose not to adhere to the same rules that Meep and I were using.

Norms and etiquette were emergent and dynamic through player interaction and not completely standardized between groups of players. When new players encountered each other, they had to attempt to align and "translate" their differing norms until a common understanding was achieved. When this was done well and players liked the emerged common "language" or way of being / acting, they often "friended" each other. The following chapter describes some of the emerging norms and the sociomaterial nature of expertise development in *World of Warcraft*.

Individual vs. Group Expertise

Before graduate school, I was part of a small informal online gaming group that met once or twice a week to play some sort of cooperative game. We mostly concentrated on tactical shooters, such as *Hidden & Dangerous*, where each of us could play a specialized role that complemented the other teammates' roles. I enjoyed playing as a scout or sniper, for example, though, honestly, I'm not very good at it. Someone else would be the heavy-machine gunner, someone the explosives expert, etc. We also played *Warcraft 3* for a while, again focusing on cooperative play, each of us choosing a different tactic that complemented the others'. I tended to focus on building up my hero units since, again, I kind of sucked. It was difficult for me to manage a lot of units at once. I'm much better at thinking about overall strategy.

After this confession of "kind of sucking," you may be surprised to hear that I consider myself a total gamer, maybe even an expert gamer, probably a hardcore gamer. Being an expert in this case might not necessarily be tied to proficiency. I have played and know about a lot of games, especially digital games, especially PC games. I'm what Drew Davidson might call "well played" (ETC Press, 2011), in the same sense that someone can be "well read," though, his term is also about taking a critical approach to gameplay. But that doesn't necessarily mean I can beat other expert players in a one-on-one match. This is partly why I like cooperative games, especially ones where players take on roles that are so distinct that to compare performance in those roles to each other is meaningless.

I don't play games to compete with others or for skill mastery; I primarily play games for the stories. I like strong narratives, both planned, designed narratives and emergent, player-discovery narratives that are impossible to predict or pre-engineer. When I'm by myself I like the feeling of agency I have within a particular game world, and I like moving the story along with my actions. When I'm with others, I like how we enact a strong narrative about a small band of elite troopers, trying to survive against relentless hordes of zombies or Nazi oppressors (of course).

When I went off to graduate school, I kept in touch with my gaming circle by continuing to play with them in cooperative online games. After a year or so, *World of Warcraft* came out, and it changed everything. Naturally, we decided to check it out together. We hopped on the open beta and started exploring the world of Azeroth, taking delight in discovering the hills and valleys of the world, helping various in-game denizens with their problems (most of which involved killing things or collecting gizzards), and spending quite a bit of time fishing. Yes, fishing.

Fishing was the perfect time waster while waiting for others to log on or travel to quest locations. Not only that; the rewards from fishing were pretty good. Once in a while, a rare or valuable item would be reeled in, but even the regular fish were relatively valuable in large quantities. We were so enamored with in-game fishing, in fact, that when it came time for us to create a guild, we almost chose a guild name based on fishing: The Fishing Goons or some such. Our guild name at that point didn't matter much, however, since at the end of the beta period, when WoW became officially released to retail stores and people started playing in earnest, our characters and guild would be deleted.

When WoW was released, my friends and I had a leg up on having enough people (10) to form a guild, having met five other players during the beta period whom we liked enough to invite to our group. Within a week, we created a guild. In tribute to our fishing predilections, I've chosen to use the Booty Bay Anglers as our guild's alias for this book. I don't care if I'm the only person who smiles at this.

In reality, it took us a couple of days to come up with a good guild name. We had at least a dozen contenders including tongue in cheek, confusing names like The Horde Alliance (poking fun at the two factions within the game). Eventually, we'd pick a name that was inspired by George R.R. Martin's gritty fantasy series, *A Song of Ice and Fire*.

We also spent quite a bit of time designing our guild tabard, which would determine the colors we wore and our logo. Ultimately, it was up to me what the tabard would look like since I was the guild leader. This was done by taking screenshots of the in-game interface for tabard design at the guild hall in Orgrimmar and emailing or IMing them to other players to get their feedback. Tedious.

Oh, and, yes, I was guild leader. The fact that we spent more time on our name and look than figuring out how our guild would be structured and who would lead is evidence of our implicit alignment in ideology at that point. Either that or we were very, very naïve. Actually, to be truthful: a little from Column A, a little from Column B. We wanted a relatively flat structure, led by five officers. The only reasons I was the guild leader were that the game

forced us to have one and that I was the first one to accrue enough gold to buy a guild charter. Back then having 10 gold pieces was nothing to sneeze at!

Later, we would realize that designed game structures had their own rhetoric and ideology. In other words, we came to realize that the game essentially *forced* us to *declare* a guild leader. Our growing guild membership defaulted to seeing the leader as someone above the other officers in terms of power and, alas, as the most suitable person with whom to air grievances.

This did my graduate school studies no favors. And I was glad to pass the mantle over to a different officer after half a year or so.

It also made it difficult for me to get as much time devoted to leveling up and engaging in game activities as the forerunners of our guild. While they were completing quests, sometimes when I logged on, I would just sit in Orgrimmar for an hour or two, mediating disputes between guildies. This placed me into the second wave of leveled characters, along with Meep who couldn't devote as much time as the rest of us logged into the game due to IRL commitments.

It sucked. It felt like crap having my friends pull ahead. We weren't experiencing the game for the first time together. The bond we shared while playing *Hidden & Dangerous* and *Warcraft 3* was starting to unravel. We weren't playing with our original friends. Sure, we had made new friends, but they weren't the same friends. This phenomenon is so prevalent in MMOGs that there's a *Penny Arcade* (2004) comic about it, and MMOG designers later attempted to address it by introducing sidekick mechanics or faster XP gains for friends in the same party. Unfortunately, these solutions were not in WoW in 2004/2005.

As new members joined the Booty Bay Anglers, as the guild matured, this problem of different-leveled characters would consistently be a major source of tension. During a particularly stressful moment for the Booty Bay Anglers, Lott, one of the officers, posted (April 1, 2005):

Lott <Booty Bay Anglers> (5:49 PM)

I know people sometimes feel left out of the level 60's antics. Like maybe they are having all the fun, and ignoring lower levels... there is something I've come to realize about our higher level parties.

There arn't enough of us.

....

I'm not a subtle or gentle person, so I can think of no better way to say it than

> to use bold and put it in all caps, to thus imply I am yelling it at everyone:
>
> YOU ARE NOT BEING SINGLED OUT. YOU ARE NOT A FAILURE. WE DO NOT HATE YOU. WE DO NOT EXCLUDE BASED ON CLASS/RACE/SPEC THEORY. WE ARE SIMPLY LIMITED BY A SMALL POOL TO PICK FROM.
>
>
>
> There is only one real solution. And that is time. Alter your viewpoint. It isn't a matter of getting what you want NOW NOW NOW. It's a matter of setting up a system to make sure everyone can get what they want in the long run.
>
>
>
> Everyone, be they level 20 or level 60 or anything between, needs to realize accept that whenever the guild isn't focused on acheiving your private goal, it is because we are working for the long-term betterment of all, or own our enjoyment to keep from burning out and quitting.
>
>
>
> It doesn't mean we're ignoring everyone else. It means we're only human, despite what our avatars look like. Which also means, the more people scream about being the 'victim' and 'ostracized' and whatever, the more likely it is to happen, just because we don't want the frustration. And it's a bad idea to reward negative behavior just to make it stop, because what starts up again the next time someone wants something...?

Lott understood that people have different amounts of time available to play, that making sure everyone in an ever-increasing group is satisfied with their experience is difficult, and that not everyone's needs or desires could be attended to, especially when they were all of varying level. Some player's needs are not met not because the guild doesn't care but because it is composed of "only" humans. Reminds me of the difficulty some teachers have with differentiated instruction for kids of varying needs and learning pathways.

Interestingly, for individual members of the Booty Bay Anglers, after a few weeks it appeared that this problem went away. Eventually, an individual player would hit the level cap and would be able to group up with the others, going into dungeons together, etc. Yet this was a façade, a mistaken use of character level as an indicator of equivalent character power. WoW's real game started to emerge, and its real barrier revealed itself.

Though it may seem so initially, WoW was not about leveling up a character. WoW was also not about engaging in a deep storied experience. It

was about the endgame. WoW was about getting to the level cap to play the *real* game: going to dungeons and raids to get "tiered" items (AKA epic loot), and with this new stage to the game came new barriers to entry.

Expertise Understood Through Ethnography

A recent increasing interest in the use of digital games for education has included a look at designed games or virtual environments for specific content learning (cf. Holland, Jenkins, & Squire, 2003) as well as a look at what players can learn from non-education-specific games (Prensky, 2000; Gee, 2003). Researchers in the latter field argue that there are certain algorithmic processes or methods (such as using trial and error found in inquiry-based activity) to be learned through playing in a rule-based system, and the value of learning these processes may outweigh subject area knowledge acquisition. Yet other researchers look at game players and their literacy practices (cf. Hawisher & Selfe, 2007). This increasing interest among educational researchers in digital games touches on a larger scholarly movement that includes humanistic debates on whether games are essentially narratives, allowing for literary analyses, or essentially systems with goals and constraints, begging for process-oriented analyses. See, for example, the archives of the Digital Games Researchers Association (DiGRA) conferences (http://www.digra.org/), the online journal *Game Studies* (http://gamestudies.org/), and the print journal *Games and Culture* (http://gac.sagepub.com/).

This movement also includes sociological / anthropological examinations of the culture and players around games (cf. Games Learning Society, 2010). I take a cue from this latter aspect of the movement to reframe educational inquiry into the learning that happens with digital games by considering the sociomaterial settings in which learning occurs. When one thinks about learning, it cannot be disassociated from specific contexts, and in fact, learning is only meaningful if it helps people participate in their activities of choice. One way to examine learning trajectories for participation is to approach it as expertise development.

Expertise development is not limited to professional or classroom settings and may occur in all the domains of activity in which people participate. In other words, one can be an expert outside traditionally considered domains, and looking at expertise development in these various settings is important for understanding consequential learning across settings. This way of looking at the development of expertise considers it a sociocultural process rather than an individual experience. In other words, individuals participate within a

larger social context, and acquiring expertise is, as Collins and Evans (2007) note, "a matter of socialization into the practices of an expert group" (p. 3). As Bricker and Bell (2008) further note

> Learning is therefore deeply bound up in an account of expertise development because one must learn what expertise means within the confines of the groups to which he/she belongs, learn what practices and other, possibly tacit, understandings are associated with that expertise, and learn which networks of people and resources are best able to socialize one into these practices and understandings. (p. 207)

Other educational researchers have looked at "possibly tacit" forms of expertise using ethnographic methods (Lave, 1988; Hutchins, 1995a; Goodwin, 1994). The social and material aspects of expert practices need to be directly observed to get an accurate picture of the interaction that goes into making expertise. This is similar to cultural or social anthropology, which considers culture as social relations of meaning-making and not just embodied knowledge in individuals. Boellstorff (2006) states

> If culture, in Goodenough's (1964) terms, "consists of whatever it is one has to know or believe in order to operate in a manner acceptable to its members," then it is hard to explain why men and women, who both can operate acceptably, are nonetheless unequal. Rich and poor people can both speak language, but framing culture on the model of a language elides issues of inequality that can be found in most cultures worldwide. In game studies to date, the relative absence of feminist, political economic, queer, and other theories of culture is striking, particularly given the importance of profit, consumerism, and capitalism more generally in gaming. (p. 31)

The idea that learning and expertise development occur within particular sociocultural settings complicates educational research, since it is therefore important to understand how people within these various settings display and develop expertise, using their own contextualized notions of what constitutes legitimate practice. On top of this, it is important to pay particular attention to inequities and issues of power in the various local settings under study. To do this, it is helpful to participate in local expert practices to better understand their meaning and value from real experience.

I see my work with *World of Warcraft* as part of effort to understanding local contexts and situated expertise. Since I was a fellow player before I had any intention of studying the game or its players, my eventual research participants saw me as a comrade-in-arms rather than as an observer. After a particularly impressive feat, which led to a massive raid success, I was even given the title "Rogue King, Savior of Raids." After playing WoW for a while, I came to realize this was a site where people attach deep meanings to their activities and experiences with the game and other players. It became clear that social relationships and connections have a profound effect on an individual

player's experience with the game, and the emerged social and cultural world of the game make playing it feel very different than playing a single-player game.

For example, as hinted at earlier, access to in-game content was often limited by a player's ability to align him or herself with a larger group of expert players, since at higher levels, monsters and quests were not easy enough to overcome alone. This, in turn, depended on successful networking and possessing a high enough reputation, similar to what Jakobsson and Taylor (2003) saw with successful players of EQ, an MMOG that preceded WoW. Access also depended on the possession of social and cultural capital.

These gateways to expert groups are not clearly revealed in existing literature based on survey data such as the research of Ducheneaut et al. (2006a). Through longitudinal census data, they found that players tended to form more groups once they had reached level 55 (at the time, level 60 was the highest a character could be in the game). They write

> Therefore WoW seems like a game where the endgame is social, not the game as a whole. One player summarized this situation nicely by saying that WoW's subscribers tend to be "alone together:" they play surrounded by others instead of playing with them. (p. 410)

The responses they saw with large-scale surveys have helped set the groundwork for more detailed accounts of practice, such as looking at the ways players actually group together. By doing this grouping, I witnessed the barriers to entry that prevent some players from finding stable raid groups when they reach the higher levels.

In fact, I only became privy to the endgame stage of *World of Warcraft* after playing for over a year and attempting to join a large raid group for over half a year. This was largely due to constraints imposed by the game, such as requiring 40 players to band together and play at the same time, sometimes for up to 15 hours a week. Many players, myself included, could not find groups that matched their schedules. This frustration from high-end raiding requirements meant that many players decided to stop playing once they got to level 60. These players are not captured in surveys that draw on current players as their pool of participants.

Ducheneaut et al. also don't capture the ways in which players may communicate with others through methods such as in-game chat channels or out-of-game voice chat with third-party software or telephones. In other words, players often find themselves mired in a myriad of different communication and co-presence practices, which include the assemblage of various social and material resources, even when their characters are neither physically in the

same game spaces nor in the same in-game group. These were details that were made clear to me through lived experience.

Expertise development in World of Warcraft was not limited to an individual player's ability to grasp the underlying mechanics of the game. The social aspects—social and cultural capital, social networking—played a tremendous role in whether a particular player was successful and could engage in the various seemingly equally accessible game activities. It was these social aspects that determined whether players were included as participants who helped determine the ever-changing sociomaterial practices that defined expertise.

Okay, so becoming an expert player in WoW meant playing with the right people, but this was further complicated as friends preferred to play with friends. There were many sub-groups and guilds in WoW, each developing unique instantiations of the overall gaming culture. And when things were starting to stabilize once everyone hit the level cap, new complications arose, serving to fragment existing relationships again by making access to the same raiding groups difficult to come by. These raids, however, also gave players the chance to make new friends and strengthen bonds through intense game play.

Thus, playing World of Warcraft occurred in roughly two stages: (a) progression through more forgiving early game content and (b) engaging in technically difficult endgame content. Both stages included disciplined assemblage of social and technical resources to success. These stages were separated by this mechanical difference (light-weight vs. hardcore content; solo or small-group play vs. large-group, highly coordinated play) and social difference (casual play with friends vs. more regimented play with a team).

It should be noted that looking at expertise development in these two stages is relatively artificial because most players were involved in many activities and group memberships throughout their game-playing lifetimes. Furthermore, many players had multiple characters of varying levels and power. Many players, however, likened WoW to two different games, divided by the level cap. In early March 2005, one Angler confided in me

> It is amazing how much meat there is in the end game... I feel like the game only just got interesting now that we are 60.
> I feel like there are so many more interesting choices now in terms of builds and armor sets and such.

Thus, treating these two parts of the game as two different stages with different player practices that emphasized different skills is useful for separating game rules or mechanics-based expertise from socially and culturally relevant forms of expertise. Many players considered rules-based or content-based knowledge as what defined expertise in WoW, especially in the first

stage, but, in actuality, partaking of expert practice that included distributing the work of playing across multiple resources defined expertise. Ultimately, if the gamers I played with wanted to succeed in their endgame or stage two endeavors, their social networks and social capital were as important as their game-content knowledge because it gave them access to a community of sociomaterial practice.

Stage One: Leveling Up

Expertise depended highly on social interaction, yet many players held onto traditional notions of expertise and saw expertise while leveling up as defined by a player's ability to kill monsters efficiently. This necessitated knowledge of the multitude of actions available to a particular character class and the underlying math behind those actions. In other words, to these players, an expert had to be able to recognize and understand the game mechanics under the narrative. This essentially is what defines expert status in any single-player game: games are inherently systems of rules that need to be understood to win. *World of Warcraft*, however, is a multiplayer game with a whole social world layered on top of the mechanical in-game world system, and therefore it provides a social setting where success was dynamically defined through consensus on expert practice. This was new for many of us who had spent most of our gaming lives playing single-player games. In fact, the game presented different players with hugely varying experiences, much of it depending on their ability to navigate the social world and gain access to expert groups, a process initiated in this first stage of play.

With WoW, as with most digital games, a player could go about learning the rules in different ways. The focus for new players tended to be on solving quests and leveling up their characters. To do this, it was possible to simply interact directly with the game and use whatever the game provided for solving quests and killing monsters. It was much easier, however, to reference third-party material like online quest guides to learn how the game worked. Once WoW was out for a few years, for example, most players referenced websites such as Wowhead (http://wowhead.com/) and Thottbot (http://thottbot.com/) to read about quests and to plan an efficient process for completing them. Wowhead and Thottbot are both community driven in that the hints and tips for each quest or item listing are written as comments by users of those sites. The use of these sites was eventually considered expert practice. *World of Warcraft*'s lead designer confirmed this when he said, "The people that don't go to Thottbot are the casual players" (Edge Staff, 2006).

That is, supplementing the in-game resources with third-party tools was the norm for expert or hardcore players, and non-experts, or casual players, tended just to use what was available in the game. This is an early example of expertise being socially dependent, as usage of these sites is propagated through word of mouth. Casual players or players who did not communicate much with others could have been oblivious to these outside resources.

When my guild first began to play, however, these sites did not yet exist. In fact, our experiences in those early days were very different and filled with a sense of new exploration and discovery. By the time we hit level 40 or so, Thottbot came into existence, and its use became our standard whenever we were unclear about new quests, but only after we attempted to discover for ourselves how to conquer them. Like I said earlier, in the early days, the other guild founders and I also tended to group together to work on shared quests as a party. Sometimes we would join a party together even though we were in different game regions and working on our own separate quests or killing different sets of monsters. We did this so we could use the [Party] chat channel, making communication easy across great distances, akin to a radio channel or an Internet relay chat (IRC) channel. The ability to work on different quests simultaneously allowed players who were at different levels and working on different content still to be co-present, making the "alone together" image take on a new spin.

Being able to quest "alone" or in a small party also simplified monster encounters because it was usually best done by "spamming" certain abilities. While in a small party, each player focused on whatever role their character class was meant to play. A warrior, for example, was meant to take the brunt of the monster blows (called "tanking"), while a priest was supposed to heal the other party members, and a rogue was meant to focus on dealing as much damage per second (DPS) as possible. An able player knew which abilities were efficient at tanking, healing, or DPSing during most situations.

Learning about these abilities when leveling up for the first time was usually a process of trial and error. Characters could learn new abilities at every even-numbered level, which could then be tested in future encounters to get a sense of their usefulness. Players could then build mental models of the combat mechanics underlying the game and then share these models with other players, making scientific arguments about the most efficient way to play. I remember going to an in-game area, the cage found in Gadgetzan, for example, with a warrior friend to test out different abilities, weapons, and shields while dueling each other to help us determine which combination of items and abilities was most effective and to help us understand the underlying math of the game (see "Theorycrafting" interlude). We later would learn that

this practice of testing out different variables under different conditions was called "theorycrafting" (Paul, 2011). Our mental models did not need to be perfect, though, as there was a lot of lenience in the monster fights during this first stage of WoW. Successfully killing monsters and leveling up, in other words, depended on only a general knowledge of game mechanics.

When my guild and I were leveling up our second or other "alternate" characters (AKA "alts"), common practice was to use third-party add-ons or extensions to the in-game interface—found on clearinghouse websites such as Curse.com—that had not yet existed while we were playing our first characters. Most add-ons revealed some of the underlying mechanics of the game. Blizzard Entertainment has always allowed the use of these add-ons—though they wouldn't allow me to show you screenshots of WoW that feature add-ons—by including a way to edit the user interface through a simple scripting language. For example, many players used an add-on that displayed information about the math behind a particular ability when one hovered the mouse over that ability. This helped players evaluate and determine the effectiveness of their various abilities and plan accordingly.

Experienced players often used additional add-ons to make fights more transparent. Many of these player-created add-ons helped lessen the cognitive load (Sweller, 1988)—the total amount of working memory used in a specific situation or task—a player needed to maintain his or her mental model of the fight by visually displaying relevant information that the player could reference quickly, thus allowing the player to concentrate on decision making. In other words, becoming a better player meant continually reassembling or rearranging the player's personal network of responsible objects—continually enrolling new resources into the network. A typical fight from this leveling-up stage of *World of Warcraft* might have featured many of these resources.

Using me as an example, before I started raiding, I used an add-on that showed me statistics about my abilities, one that announced in-game events that occurred during fights with specific monsters, one that showed me how long I would have to wait before using an ability that I had just used (since each ability has a "cooldown" time), one that customized how my map looked, one that rearranged the buttons of the UI, one that showed me current health and stats of the monster I was fighting, etc. The list goes on. At my heyday, I was using dozens of add-ons, each one enrolled to perform a very specific function. I loved it. Not only could I obsess over the level of customization possible, but I could also be a very, very good player. Most of my "suckiness" in previous games was my inability to manage my cognitive load—to keep track of everything that was happening—and my inability to click or move the mouse fast enough. These add-ons remembered things for me, lessening my cognitive

load, so I could focus on the performative, physical actions and devote most of my mental capacity to strategy.

Since each player needed to understand the system, even if just in a gross sense rather than the exact numbers behind the different actions he or she could perform, this first stage of *World of Warcraft* could be viewed as one of individual arrangements. Through the process of leveling up, players acquired a sense of the effectiveness of all the different abilities for the particular characters they were playing, so by the time they hit level 60, they could loosely be deemed competent players. This did not necessarily make them expert players, however, as it was actually relatively easy to level up. In other words, it was difficult to determine expertise by simply looking at the level of a player's character, a form of cultural capital that was determined by institutional credentials. Instead, using third-party add-ons and outside websites was a good gauge of expertise as it was an indication of being able to draw on skills and resources beyond the ones provided by the game, something that was defined by the player community as being expert practice. In other words, it was this lived experience or embodied experience with the game that produced acknowledged cultural capital. In yet more words, it was this legitimate sociomaterial practice that players valued, not one's character level.

Leveling up to 60 took a rough average of two or three months for people who played about 40 hours a week and were leveling their first character and taking their time to explore and discover. Meanwhile, players gained reputation and social capital and built their social networks during this leveling-up process through interacting with other players whom they came across while traveling the lands (see "Pugging" interlude). By the time successful players hit level 60, they had built up a pool of friends they could call on for help or company, as well as a list of players to avoid. Players could designate other players as "friends," which then put their names on a list within the game interface that could be used to quickly see if any of them were online. Working together in a party (AKA "grouping") was the most effective way to determine whether another player was competent and worthy of being placed in the friends list. In this way, players could display expertise through their performance, rather than just relying on their character level (see "Pugging" interlude).

Grouping was also useful to determine how sociable other players were. In other words, no matter how knowledgeable a player was, it was possible he or she could be ostracized by certain gaming circles for lacking social skills or, even worse, being outright antisocial. Surprisingly, many players seemed to be antisocial, as it was generally agreed that participating in a PUG was often an unsatisfactory experience since there was no guarantee that the players in the

werd = socially not conscious? challenges concept? So socially conscious = more successful?

Leet Noobs 41

party would all be sociable or competent. Often, the sociable people were also the competent ones. It was assumed that players who took the time to be conscious of their talk and actions also paid attention to and learned from how others behaved.

Expert practice in this first stage of playing was the sum of using external websites and add-ons as well as learning the mechanics of the game well enough to play in a team. These were all skills propagated through effective communication and networking. The development of expertise came out of participating and building social capital through normalized communication and material practices. Learning about the various external resources available to players and about the pros and cons of certain character abilities was facilitated through participation in player communities, both in the game and out of the game. *What r external add-ons + websites for LoL?*

Stage Two: Raiding

While expertise in the first stage of *World of Warcraft* depended on individual arrangements of sociomaterial resources, the second stage required players to transition to a collective model of expertise where roles and responsibilities became specialized and distributed among multiple players and their material resources. The social nature of WoW was important in both stages of the game, but endgame activities made it take on a new light and more clearly revealed how social interactions and social and cultural capital contributed to success. Indeed, players began to experience a new form of frustration that eclipsed the previous frustration of falling behind the higher-leveled characters in one's guild or gaming circle. This new frustration came from the continual negotiation and renegotiation that needed to occur, sometimes weekly or even daily, for a steady raid group to exist.

Pages and pages of forum threads on guild websites were devoted to this negotiation and the meta-problem of having to do the negotiation. This negotiation existed for individual players as they tried to join existing raid groups, but it also existed for groups of players as they tried to form new raid groups. In a way, players had to come to a common understanding of the situation and how best to approach it. They had to align their goals and values, even if implicitly, for the group to be stable. Guilds like the Booty Bay Anglers began to define themselves in terms of their raiding philosophy. On September 18, 2009, after the Anglers had been around for almost 5 years, Rage summed up the Anglers's raiding history and included the following:

> **Rage <Booty Bay Anglers> (11:21 AM)**
>
> The Anglers was always about famliy style play and team work. We did not want to leave anyone out due to skill or any other reason. The problem was, without a set roster, it became stressful and time consuming to create a fair raid team. Plus, without the consistency of a set roster it just didn't work. There was no progress, and in fact we reverted to re-learning bosses everytime a new person joined us.
>
> This caused a large chunk of the guild to break of and form their own guild.
>
> Raiding doesn't have to be serious business, but the nature of loot distribution, learning encounters and time committment do mean that there must be some level of discipline. So rather than create a more hard core team we decided to stop raiding altogether and re-organize the guild.
>
> We'd been around long enough and had a good reputation so were able to find raiding groups for those that wanted to commit to something more structured that worked with our schedules.
>
> This is why we don't raid as a guild. However, that was a long time ago and it's not the same guild. The original founders did not want this to be a raid guild. At this point, those of us left mostly all raid. That is why it's funny to say we're not a raiding guild. And if the timing were ever right I could see it happening. Though it would not be along the lines of what we ran years ago. We'd have a set roster and some form of DKP.
>
> And that, is the history of the Booty Bay Anglers and raiding. Many things were learned, many guildies were lost.

STOP WORK + RE — ORG

IDENTITY

A few days later, Walt, another long-time member, replied with: "Set roster and DKP would have made it so much easier (and so much less inclusive). That was the trade-off. I thought we made a good show of it, but I wouldn't want to do it like that again." The Booty Bay Anglers's continual struggle to stay "family" oriented and inclusive meant that more time was spent on management than if the guild had chosen other ways of forming raid groups. At least one guild member, however, thought that the Anglers had been relatively successful, though, he doubted whether the work was worth it, after all was said and done.

The second stage of WoW, the reason why guilds attempted to organize raid groups, mostly consisted of dungeon-specific settings that required up to 40 players to team up if they were to defeat the monsters inside. It was useful, then, to have an established pool of players to draw from for this new activity. Many guilds, like the Anglers, did not have enough players to fill a 40-person raid (leaving it to focus on 25-or-fewer-person dungeons). Members of these

smaller guilds could, with varying amounts of difficulty, join inter-guild raid groups, which is why I eventually joined one led by The 7/10 Split.

For some of the encounters The 7/10 Split-led MC raid faced, it was crucially important to have specific character classes in the group composition. For example, it was usually necessary to have a warrior or two in the group, usually orcs named Warren and Wendy, to take the brunt of the blows from the monsters, and it was equally important to have people who could heal the other party members when they took damage. Some encounters were much easier with certain group compositions. This was very important for new bosses, when everything that could be tilted in the raid's favor mattered.

Often, however, whom we invited was fully grounded in the various social networks and friends lists of existing raid members. In fact, we sometimes prided ourselves in trying to defeat certain endgame encounters without the optimal group composition. When we were first forming, our raid leader, Maxwell, wrote, "As for class balance, I'm not going to tell people who to bring. We're here to have fun, not be forced to do something, after all."

Instead, we were more open than some other raiding groups to making sure our friends were being included in our activities. This social obligation we felt was evidence of the importance of social capital and reciprocal friendships, but valuing social networks was not necessarily a given for all players. We needed to negotiate this as a norm for our group by priming players for socialization. In response to troubles my guild was having with a particular player who was not fitting in, I wrote on my guild's discussion board (March 8, 2005):

Thoguht <Booty Bay Anglers> (2:28 PM)

So, realize that *World of Warcraft* is NOT a single-player game. The things that make someone a good player in a single-player game do not hold the same value here. In a single-player game, for example, you could concentrate on working the system and maximizing your efficiency in winning the game. In WoW, things work a little differently. The first thought most players have is that to be a good player and work well with a party is to know your class. I would argue that it is only a part of what makes you a good player. This is because a MMOG is a social game. You have to deal with other people who may or may not be as adept as you. They have different personalities, goals, motivations. Sometimes they are having a really great day, sometimes a really bad day. All the players form a social network and community in which certain behaviors are considered normal and others deviant. So, my point is that just because you are good at your class, doesn't mean you are a good player. We value you as a player, not as a class.

As stated earlier, however, the friendships we formed were, in part, due to successful displays of competence with the game. On top of this, we also had a wealth of common experiences to reference, and we had developed a shared culture over the months of play. We collectively groaned whenever anyone mentioned "Barrens Chat" (WoWWiki, 2011), for example, and we knew the ebb and flow of player vs. player (PvP) combat near Tarren Mill as if we'd lived in that amorphous rhythm our whole lives. We also knew the basics of game mechanics and the usage of add-ons from the first stage of *World of Warcraft*, but raiding focused on highly technical encounters that were uniquely scripted with various events or phases in which monsters activated powerful abilities, and the group could only be successful if players learned to adapt and relearn the ways they played the game.

Additionally, spamming the same abilities used in a basic fight during a raid fight often resulted in catastrophic failure. It was generally understood for rogues, for example, that they had to play a careful balancing game using good, steady damage rather than bursts or sharp spikes of damage, as was normally the case for pre-raid monsters. This was because spikes during a raid fight could pose enough of a threat to a monster that it would decide to focus its attention on the character that had spiked. Each character class has to adapt to new parameters like these for raid encounters. Failure to do so resulted in death, making the rest of the fight more difficult. If a critical number of characters died, the fight soon ended in a "wipe," where all the characters died because they could not sustain enough damage before the monster(s) killed everyone. When this happened to my group, we would have to respawn or resurrect ourselves and try again, costing us precious time.

Similar to the distributed cognition that Hutchins (1995a) writes about on a naval vessel among its crew and their material resources, the raid as a whole succeeded when simultaneous specialized actions were performed by players who may have only been knowledgeable about their individual roles. For Hutchins, the ship can be seen as an entity whose behavior is completed through collective action and distributed responsibilities. This distribution of specialized roles was built into *World of Warcraft* raiding through its use of specialized character classes. Thus, to succeed, raid members had to trust each other and be confident in each other's knowledge and ability to stay coordinated throughout a fight. This trust let the raid members safely identify with the group, treating the raid as a single entity.

Successful simultaneous role-playing included using specialized chat channels that only players of specific roles could see. For example, in my game play, general raid talk was done using the [Raid] channel while all the rogues

used a user-created channel called [madrogues] for talk about rogue-specific strategies.

The talk in all of these channels included questions and answers, conjectures on different strategies, off-task joking around, and pleasantries. Most of this talk was done during planning before an encounter, followed by assessment and reflection time after the encounter. For example, when the raid group was first learning how to defeat Ragnaros, the last boss in Molten Core, preplanning took as much as an hour. This time was mostly spent listening to our raid leader and other players (who had read about or done the fight before) summarize the different phases of the encounter, where each type of character class needed to be standing at each phase, Ragnaros's various abilities and actions, and our instructions during those moments. During the summary, some players would ask clarifying questions or make suggestions for other strategies to use given our particular raid composition. In addition to this in-game preplanning time, we were expected to have read online strategy guides such as The Pacifists Guild's guide to Ragnaros, which is a good 14 pages long. (Sadly, the webpage no longer exists, but the Internet Archive version can be found at http://web.archive.org/web/20071213075344/ http://pacifistguild.org/ragnaros/.)

Whether it was before, during, or after an encounter, the talk was full of task-specific lingo. Utterances such as "Remember, ss target will change at Domo, but until then, your rezzer is to be ssed at all times" made complete sense to our group of players. Like any group of people who spend a lot of time together on a shared activity, World of Warcraft players developed their own communication shortcuts full of activity-specific references. This was necessary both as a way of communicating efficiently and as a way of affirming and strengthening our cultural production.

All this communication may have served to make the task of dungeon delving seem less like work (cf. Nardi, 2010, p. 100, for more on how raiding was like work). Unlike in stage one fights while leveling, players assumed new responsibilities to other players in stage two fights. Consequently, these encounters had to be planned carefully and were serious business. Group fights while leveling needed planning too, but not to the degree found in endgame raids. Physical position mattered. Often, for example, rogues needed to be standing behind a monster's back, while mages and other spell casters needed to be spread out around the fight's locus. Many endgame bosses had abilities that affected all characters in front of them or all characters in a tight bunch. This was unlike most non-dungeon monsters, where a fight was often between just one character and the monster, and players could not get behind the monster as it would always be facing that one character.

Given how varied the fights are in *World of Warcraft*, all successful players exhibited *adaptive expertise* (Hatano & Inagaki, 1986)—the ability to generate new procedures to solve novel problems—to some degree in that they were able to adjust to specific monster abilities and choose which personal abilities were most suitable to execute. For raiding, the adaptation included changes to how players thought about fights, including a change in player expectations and stance. Some players were able to adapt faster than others.

Indeed, the step up in difficulty of boss encounters could sometimes be a shock for new players to raiding, and part of socializing new players included aligning them to new attitudes. One player, Walt, an officer for the Booty Bay Anglers, wrote about frustrations over failing at some early raid encounters:

Walt <Booty Bay Anglers>

Now I hope no one's getting frustrated. This is how raids go. It's normal: You fight and fight and fight until your gear is broken, repair and do it again. Once you finally get it down you can farm them [repeatedly kill the same monster] for loots. It can take a while to master these encounters but we're doing good work!

Each time a character died, his or her equipment took some wear and tear. When enough deaths happened, the equipment broke and could no longer be used. Repairing equipment required a trip to a blacksmith in town who could fix items for gold. Walt was reinforcing the idea that dying over and over again, to the point of having equipment break, was normal and no cause to become frustrated. He was giving those unfamiliar with raiding context in which to compare their experience, thereby managing their expectations through explicitly naming what was happening as a normal thing (reification), which could then be understood through lived experience (participation) in a reification–participation duality (Wenger, 1998) taken on by the newer raiders. Raiding took time and many attempts but eventually rewarded us with loot.

To help do the "good work," my raid group used a common set of third-party add-ons. One add-on, which I detail in the Chapter 3, for example, kept track of the "threat" each character posed to whichever monster was being fought so that we could be sure not to generate more threat than the main tank. Another add-on kept track of the various abilities boss monsters had available and notified raid members when those abilities were being activated so that we could take appropriate countermeasures. The use of add-ons was part of our common expert practice and exemplified how we used material resources to help with our memory and decision-making processes. In other

words, our responsibilities and memory were distributed among the raid members and collective and individual material resources. Installation of these add-ons was required for any new players if they wanted to participate in the raid.

In summary, access to expert groups in WoW was done mostly by leveraging existing social bonds. Players' subsequent experience with tasks that depended on position and synergy of distributed specialized roles was the core of the endgame expertise development. Part of this development was an induction into a normalized way of communicating—veterans did "framing" work (Goffman, 1986) to help align teams to new expectations with in-game encounters. Players who did not have or could not gain access to these groups were dependent on PUGs and, I surmise, were less likely to keep a sustained interest in the game. It was through these expert groups that players shared knowledge about new add-ons and new strategies to use on raid encounters.

Reflections on Studying Expert Practice

The social nature of *World of Warcraft* is a given, but a player's experience depended more on his or her social and cultural capital development than his or her personal game-content knowledge. Thus, mastering WoW was more than simply mastering a particular character class; it also meant being able to move in various social circles and communicate effectively. It meant being able to use third-party tools and other resources that had been taken up by expert players as common practice.

The practices players participated in were constantly changing, affected by new information about the game, new developments or patches to the game (tweaking the rules slightly or addressing balance and fairness issues), and new players constantly joining the player base. The network or assemblage of play was constantly changing. In addition to using certain add-ons, a new practice when I joined was the use of outside websites to discuss in extreme detail the strategies, abilities, and effectiveness of particular ways of playing specific character classes and how to improve one's performance and value for a raid group. The theorycrafting for rogues on Elitist Jerks's (2011) website, for example, was aimed at helping rogues maximize a steady damage stream specifically for raiding. The high-level talk found on this web forum, with all of its shortcuts and jargon, was more readily understandable to people with an intimate knowledge of the rogue class. The best way to gain this knowledge was by playing the game as a rogue.

When I decided to study *World of Warcraft*, it was with a relatively new culture. WoW had only been around for a year, and the player community around the game was in its infancy. The early months felt like a new frontier to me and to the gamers I played with. Social norms and etiquette had not yet stabilized, and players were still figuring out the underlying mechanics of the game. In the early days, for example, encountering another character in a remote locale in the game was sometimes awkward (see next interlude). We had not yet established the proper way to greet each other or even if we were *supposed* to greet each other. This was exacerbated by being on a role-play server where it seemed as if, in keeping with the fantasy of the game, one would definitely at least say hello to someone found in the middle of nowhere. Sometimes it seemed obvious that the other character was working on common quest objectives, but it was unclear whether we should group up to do them together. I tended to befriend those who were receptive to greetings and talk, which might have slowed down their leveling but showed that they were willing to be social.

Understanding the social nature of *World of Warcraft* through observing and participating as a player is crucial for mapping out an accurate picture of expertise development within the game. Learning with digital games in this case meant learning *with people* in a game where the game itself served as a setting or backdrop for group work. This learning was deeply experiential, and the players valued these common experiences. Part of the reason why many players hated "gold farmers" (players who tended to stay in one area of the game, repeatedly gathering resources or killing monster to convert their drops to in-game gold which would then be sold for out-of-game U.S. dollars), was that it let other players bypass the full experience of leveling up and dealing with in-game constraints imposed by the rarity of resources. My player community generally frowned upon buying gold. Some of us even organized cross-faction raids to systematically kill the farmers at Tyr's Hand, a high-level zone with monsters that dropped relatively valuable loot:

[08/03/05][19:05][Walt] says: Tyr's Hand won't know what it it!

[08/03/05][19:11][Raid] [Lilandra]: I believe they know we're coming tonight.

[08/03/05][19:11][Raid] [Walt]: Don't worry. They have no healer!

[08/03/05][19:11][Raid] [Walt]: They care not for other! They're greedy farmers!

[08/03/05][19:15][Raid] [Lilandra]: Steal their raw farming goods.

Gaining access to expert player groups and learning from them, accruing social and cultural capital, and building one's social network affected a player's

learning trajectory far more than simply grasping the game's mechanics. Expertise development within WoW, then, was tied inextricably to a player's ability to socialize and negotiate into expert communities.

Chat Norms

This interlude describes a moment of tension between my expectations for normal behavior on the RP server I was playing on and the lack of communication coming from a stranger I met in a remote, secluded in-game zone. I knew that many players did not role-play—that is, they did not engage in in-character talk—but most players on my server did at least say, "hello," and were cordial to strangers, so when this event occurred, I needed to reflect on why it happened. The descriptive paragraph below is written as if for another WoW player to highlight game-specific terms that developed through play. It is followed by a set of notes that explains it in case you don't have experience playing WoW.

✤

Once while I was soloing[1] Felwood,[2] I came across another player who was also soloing. At the time I was working on killing Treants for a specific drop[3] but I was making my way to a thorium vein.[4] When I saw the other player, I unstealthed[5] and greeted him. I then asked if he was a miner[6] before mining the thorium as a courtesy to him since I didn't want to prevent him from getting the skill-up.[7] I talked to this other player in character[8] because we were on an RP server,[9] but his reply was a terse "no." I then told him what I was hunting for and asked if he was doing the same in the hopes that we could party together.[10] His reply was an equally terse "blood amber." I then asked who dropped those and he said that he wasn't sure and asking a few people atm.[11] After a while thinking about it, I then said that I think they were to the east in a cave south of the road a bit. He didn't reply, so I left and continued killing Treants. After 3 minutes or so, I sent him a whisper[12] asking if I was right, but he never replied.

At the time I felt slightly jilted. Here was someone, to whom I was being courteous, even considerate, but I felt he clearly did not want to talk to me; so much so, in fact, that he did not even want to acknowledge my help. The more

I think about this, though, the more I am willing to believe he just did not have time to talk to me or he just did not understand the situation's social norms. It was possible he was having an off day. It was even possible he didn't see my whisper. I have known players who play while at the workplace (sometimes illicitly, bosskey at the ready), so they divide their time between the game and their actual work. How they could possibly do their work efficiently, without missing things, is beyond me, since it is obvious they miss things in-game. Often their characters are just standing around while the rest of the players are asking them questions or wondering why they aren't moving.

A few days later, I went to an in-game party. There were so many players at the same in-game place that the contents of the chat window were scrolling by faster than anyone could read. It was only days later, when I took the time to go over my chat logs, when I realized that I missed at least a couple of whispers to me! In face-to-face speech *and* in instant messaging or texting, it is pretty easy to repair missing messages since one is limited to a few participants and it is clear when one of the participants has missed something. In this game, and I suppose in online chat rooms, directed chat that was missed sometimes never got addressed / repaired or even recognized as missed. Managing and filtering chat and all the other streams of information available in the game was even more important for raiding. As described in the next chapter, this was one reason why players installed add-ons or found other ways of configuring the game to be successful.

Notes

1. adventuring by myself rather than with a group of players

2. The continents in *World of Warcraft* were divided into regions that were set to be a certain difficulty level so that players could go to their level-appropriate area without worrying about dying too often. Felwood was one of the higher-level regions.

3. When monsters were killed, their bodies were lootable. Different monsters dropped different items. I was searching for a specific item that only the Treants dropped. There were many slang uses for words (e.g., "drop") and even new words (e.g., "lootable") in the context of gaming.

4. One of the resources to gather in WoW was ore of different types. Each character chose early-on which kind of resource he or she would focus on collecting in the game world by choosing the appropriate profession.

5. I played a rogue, and one of the rogue's abilities was to stealth or become invisible to other players.

6. Miners were those who could collect ore. The other choices for gathering professions were Herbalists and Skinners.

7. Each profession a character had was rated from 1 to 300 to represent how proficient they were in that skill. Each time that skill was used there was a chance to move up one point in that skill. When one mined an ore deposit until it was depleted, the deposit disappeared preventing other miners from gathering from the same location. Most deposits could stand at least two mining actions before being depleted, but a character could only get one skill-up from a single deposit. I was going to mine the mineral once to get the skill-up and then offer it to this other player if he was a miner so he could also get a skill-up.

8. I talked in character as opposed to out of character. *World of Warcraft* was a role-playing game. Out-of-character speech was typified both by the way sentences were written as well as the content of the sentences. For example, leet speak was considered out of character as was talking about the Iraq War.

9. RP servers were ones specifically for players who wanted to role-play. In this case, leet speak was not only out of character, it was expressly forbidden and frowned upon by the server's regulations and populace. In fact, proper grammatically correct sentences were the norm rather than the exception.

10. To "party together" meant to "form a party together". The item I was looking for was a rare drop. If he was searching for the same item and therefore also killing Treants, we would have made it more difficult than it already was for each other because players could only loot from bodies that they or their party members had killed, and there were a limited number of Treants to kill.

11. at the moment

12. a personal message sent directly to a player who could be anywhere in the game world

Communication, Coordination, and Camaraderie

This chapter will describe the communication and coordination practices of my group of players in *World of Warcraft* by contrasting two nights of game playing—one successful, one unsuccessful. This first night was chosen as it depicts representative practice for the group; the second lets us examine a poor performing night and the repair work the raid group engaged in to recover from the resulting drop in morale. This chapter also contrasts the practices of this group against the generally conceived notion of how a group like this operates. My MC raid group went through a process of trial and error with many failures—a norm in gaming practice (Squire, 2005)—before we finally succeeded in defeating all the monsters in MC. Success depended on the ability of our group members to coordinate our efforts and maximize group efficiency by having each member take on a specialized role as determined by game mechanics, specific contextual details of the battles, and group norms. To achieve the desired level of group coordination, as mentioned earlier, my group used a variety of communication channels, including specialized text chat channels for specific teams within the group. The general notion was that most players who participated with others to go into MC needed to have characters that were specced in a certain way to maximize the efficiency of the group. It was also assumed that most players did this because they wanted valuable in-game equipment, which they could loot off of the monsters after defeating them. The 7/10 Split-led group, however, was able to adapt and refine strategies and adjust to relatively nonstandard group compositions and nonstandard character specifications. The success of this group was because of its members' trust in each other and their shared goal of having fun rather than a collection of individual goals emphasizing loot. This approach of giving preference to friendships might be a way to think about how people can be encouraged to cooperate and participate in other types of groups.

(Computer) Game Theory

One prominent line of research about player behavior includes those focused on games from a perspective emphasizing incentives and decision making (Smith, 2005; Zagal, Rick, & Hsi, 2006)—a line of research from economics known as game theory—where an examination of game rules leads to ideas about how people will behave and, therefore, how designing games in certain ways can construct certain types of communities.

My interest in game theory literature stemmed from an experience I had while playing through *Star Wars: Knights of the Old Republic* (KotOR) twice a few years ago (in a galaxy far, far away). (In fact, it was after playing KotOR and reading James Gee's *What Video Games Have to Teach Us about Learning and Literacy* that I decided I needed to wade into gaming culture and player learning research, moving away from instructional game design.) KotOR is a computer role-playing game that lets players make moral choices as a Jedi Knight. I wanted to play once making all the Light Side choices and once making all the Dark Side choices, so I could see the whole set of outcomes for the progression of the story that the developers designed into the game. While I was playing a Dark Jedi, I noticed that sometimes the choices I made were the same ones I made as a Light Jedi. For example, in the game, I was presented with the classic game theory model, the prisoner's dilemma (PD), which I had learned about in Psych 100 over a decade ago in undergrad—only in KotOR it had Star Wars trappings. I had to choose whether to betray a friend (a Wookiee warrior) for selfish reasons, and he had to make the same decision of whether to betray me. In both cases, I chose to stand by my hirsute friend. I would never betray a friend as a Light Jedi, of course, because I was being selfless. As a Dark Jedi, I reasoned that if I betrayed my friend for immediate benefit, we would not be able to use each other for mutual personal gain in the future, so I actually ended up standing by him in my second play-through, too.

Making a selfless choice and making a selfish choice actually lead to the same decision! Game theory simulates considering future interactions between participants by modeling iterated versions of the PD. In this model, it has been demonstrated that mutual cooperation can be both stable and attractive, even for selfish players. Yet KotOR did not present this scenario as a recurring one. It could be argued that I brought my knowledge about the game's world and imaginings of future interactions with my evil henchman to the decision-making point in the game. In other words, my choices were motivated by how I saw myself playing a particular character situated in a specific setting rather

than by "rational" thought as presented in the game developers' traditional game-theory model.

The PD is part of a larger set of situations that economists and game theorists call social dilemmas (SDs; Axelrod, 1985; Hardin, 1968), wherein many people, rather than just two, are making choices of whether to cooperate or defect. Basically, a situation is considered an SD when an individual's immediate self-serving choice is not the same as the choice he or she would make to benefit the community as a whole. A common feature of many models of SDs is that the whole community benefits when a certain *critical* number of people cooperate. The most humorous explanation I could find that defines SDs is embedded in *The Onion*'s (2000) headline, "Report: 98 Percent of U.S. Commuters Favor Public Transportation for Others."

The Onion pokes fun at our human tendency to be selfish and sticks right at the heart of the issue: Individuals can defect—make the self-serving choice by free riding—so long as enough other people are cooperating, but if too many people free ride, the whole community loses any benefits. It is relatively easy to show how two people can rationalize cooperating with each other (by not betraying each other and maximizing their benefit over time). It is much harder to convince someone who belongs to a larger community that cooperating makes sense.

The body of literature from people looking at SDs in games has mostly focused on how different games support cooperation through various game mechanics and rules. If a team of players is trying to figure out how to most efficiently beat another team of players or a set scenario in the game, they will choose to do such and such because of certain game rules and how the game works. I found, however, that my experiences with games, in general, and with KotOR and WoW, in particular, showed that the choices being made in certain situations were not so tied to game rules. Instead, they were more complex and tied to how I saw myself playing a particular person in a socially situated world.

This mirrors Gee's (2003, p. 55) notion of *projective identities* where players role-play what they want their characters *to be*. His look comes from a multiliteracies perspective where a player's multiple identities is grounded in the social discourses he or she participates in. The greatest power for role-playing games in education is the way in which players can think or take on a certain perspective by being someone with that perspective. This perspective shifting allows understanding through situational experience.

In WoW, many norms and rules have emerged from the player community. Taylor documents this very well with her experiences in EQ (2006a) and WoW (2006b), recognizing that game culture that emerges in and

around a game is co-constructed between all the various authors, including both developers of the game and its players. Players start with the base game but need to develop myriad social norms, etiquette, and practices that ultimately help define what it means to be a player of a particular game. The same thing has happened with WoW, and some of these norms or rules could be looked on as socially constructed SDs. These emergent situations are ignored when looked at through a game mechanics lens. Additionally, even in situations that could clearly map onto SD models, the choices I saw being made by both me and other players were not so cut-and-dried and rational. They were contextually contingent.

One could argue about game mechanics all one wanted, but in doing so, a sense of actual game playing behavior in a real game context rather than some sort of construct will never be realized. Smith (2005, p. 7) made this same comment, and I would take that argument further by saying real social situations—like the ones I experienced in WoW—are messy and complex and problematize the very notion of constructs as convenient ways of modeling player behavior. Instead of starting with game mechanics, Taylor has been taking a different approach to looking at game behavior by looking closely at player practice. When one looks closely at practice, common assumptions are dispelled. All ethnography is about exceptions, about teasing out differences, about attending to the local pragmatics of situations. Taylor paints a rich world and is joined by other scholars doing ethnographic research in MMOGs—relating it, for example, to literacy and learning discourse (Steinkuehler, 2004), social learning theory and emergent social networks (Galarneau, 2005), and general portrayals of player experience and meaning-making (Nardi, 2010). One thing to note from Taylor is that some players of EQ have the distinction between work and play blurred. I also see this happening in WoW, but, as Nardi (2010, pp. 95-96) supports, there are definite differences in how some players take on responsibility in-game and out-of-game. These responsibilities—to the group, to friends, to the self—are intricately tied to game mechanics, the emergent game culture, and personal beliefs taken up by the players about what it means to play and have fun. I follow in this ethnographic tradition and discover that social norms and responsibilities defined by social contexts can play a large role in providing incentives and consequences for player behavior in a way that mechanics-based motivations fail to do.

A Typical Night in Molten Core

Gathering and Chatting

At about 5:15 p.m. server time on Friday, April 14, 2006, my raid group started forming up, as it had been doing every Wednesday and Friday for the past 6 months. Our raid leader, Maxwell, from The 7/10 Split guild, was inviting the rest of us into the group, and I was invited early this night. Meanwhile, the rest of us were all over the game world—working on other quests or PvPing or whatever—or just logging into the game after getting home from work or school. Once invited, we knew we were supposed to make our way to the entrance of the dungeon, but getting everyone there so we could start took a while, *as usual*. Our official forming-up time was 5:30 p.m., and our official start time was 6:00 p.m., but we usually ended up starting at around 6:15 p.m. because some people tended to show up late. That night we started fighting monsters at around 6:10 p.m. In other words, I was in this raid group for almost an hour before the group actually started fighting monsters in MC. The original task of forming a new raid group started by finding enough people who wanted to go at a certain time, and, for my group, it was done through a combination of in-game chat and announcements and out-of-game web forum postings on guild-specific sites. Once that was done (which took several weeks because friends wanted to be invited with each other and it was difficult to find a time that fit the schedules of 40 different people), the raid leader still had to deal with the task of getting everyone in the group together at the agreed time every week, twice a week. That the composition of the raid group was made up of members from different guilds could not have helped the situation any.

Some of us resented the fact that we sat around for upward of an hour before actually fighting, and this is evidence of the tension some players had between their expectations of what it meant to play a game—that video and computer games are thought of as immediate gratifications—and the reality of playing—where participating in a shared activity required administrative overhead (i.e., work). Others of us, however, did not mind the initial wait time and used it to greet each other and catch up with old friends.

We discussed new things about the game, new discoveries about the game, and new strategies to try out, or otherwise engaged in small talk, and most of this talk was laid-back with a lot of joking around. For example, below is a snippet of what the rogues were talking about that night while we were gathering. (We were using the [Party] channel since we were all temporarily in

the same 5-person party while Maxwell was organizing the 40-person raid and finalizing invites and the 8 in-raid party compositions.)

18:00:46.484: [Party] Rita: You guys have become familiar faces—I'm glad I'm with you all:).

18:01:04.734: [Party] Thoguht: Thanks! you too!

18:01:05.921: [Party] Rebecca: Hi Rita!

18:01:34.468: [Party] Thoguht: We've been having some crazy rogues nights recently.

18:01:37.578: [Party] Rebecca: What's everyone's best unbuffed FR?

18:01:43.234: [Party] Rita: 137.

18:01:52.468: [Party] Thoguht: I feel lame.

18:02:03.734: [Party] Roger: 92.

18:02:13.375: [Party] Thoguht: I feel cool!

18:02:18.937: [Party] Rita: I feel sexy!

Here one rogue, Rita, was just invited to the group that night. Then, as a way of greeting the other rogues who were in her party, at about 6:00 p.m., she made an explicit comment about how much joy has come out of being part of our group. Rebecca and I responded and greeted back. I echoed that the last few sessions in the group have been really good to us rogues. What I meant was both that rogue loot had dropped and that we had had good success as a subgroup in the raid in terms of performing our roles well by dealing out good damage during fights and minimizing our deaths. Implied in my utterance was that the rogues, and the raid in general, had a healthy attitude, and morale was high. Then, changing topics, Rebecca asked what each rogue's fire resistance was.

When characters took or dealt damage, the damage was of a certain type, one of which was fire damage. Along with building up resistances to the other types of damage, characters could acquire items that protected them from fire damage. These resistances were quantified in-game, like almost every in-game attribute, on a number scale with no theoretical maximum. In practice, because resistances are gained through equipment worn and temporary spells, for rogues the maximum tended to be around 250 to 300.

By talking to other players in other raid groups and reading strategies online, we knew that most people suggest that rogues have at least 180 fire resistance during the fight with the last boss in MC, Ragnaros. When Rita said

137, I wrote that I felt lame because my fire resistance was low by comparison, but then Roger replied with a 92. I felt not so lame anymore (I had a fire resistance of 120). Playing off of my phrases, Rita said she felt sexy. This is a good example of the light atmosphere in our chat even when on-task strategies and assessments were talked about. It is also easy to see that we felt beholden to our fellow adventurers in a way that falls outside of normal game theory incentives and consequences.

Pulling, Coordinated Fighting, and Division of Labor

After we all sufficiently gathered, we buffed up and started pulling. "Buffing" is the term used to describe the act of casting beneficial spells on other characters. "Debuffing"—placing curses on enemies—is the opposite of buffing. "Pulling" is used to describe grabbing the initial attention of monsters that are found standing around at preset locations in the world. Once their attention was caught, they charged toward whoever did the pulling. The first encounter in MC is with two Molten Giants who guard a bridge into the rest of the dungeon. Like most encounters in WoW, we initially had to learn how to approach the fight and what roles each different character class should play. For example, the warrior class was designed to play the role of holding the monster's attention (AKA "aggro") effectively. They can activate abilities that are specifically for angering enemies and keeping aggro (e.g., Taunt and Intimidating Shout)—abilities that other character classes lack. We usually had about five warriors in our raid group. Because most encounters in MC involve just one or two monsters, we learned to designate two of our warriors, Warren and Wendy, to be main tanks (MTs), so that all the warriors were not competing for aggro. The healers could then concentrate even more on these two warriors instead of all the warriors equally. Because we had multiple healers, too, we usually divided healing duty among them so that only a set of them were healing the MTs while the rest were either spot-healing the rest of the raid group when necessary or were assigned to heal specific parties in the raid. Furthermore, monsters in WoW also have special abilities that they can activate against the players, and part of what we had to learn was the kinds of abilities to expect from each type of monster.

To aid us in this coordination, each role in the raid had a specialized chat channel. For example, the healers had a channel in which they managed the assignment of healing and buff duties:

18:21:48.843: [3. healsting] Paula: how about Pod 1, 2, . . . Paula 3, 4, 5 . . . and Peter 6, 7, 8? For DS buff

Here, the priests and other healers used the [healsting] channel. Paula was suggesting that each priest be assigned certain parties in the raid (there were eight parties in the raid group, remember) on which to cast the Divine Spirit (DS) buff, which increases the party members' Spirit attribute, which in turn determines how fast spell casters regain spell points (AKA Mana) that were needed to cast spells. This assignment of roles was common among all channels. Here is an example from the warlock channel:

> 18:11:20.421: [4. soulburn] Lori: Remember, ss target will change at Domo, but until then, your rezzer is to be ssed at all times.

Lori was reminding the other warlocks that one of their unique warlock abilities—to create a soulstone (SS) and apply it on other characters—should be active at all times. A SS allows whoever it is applied on to resurrect himself or herself after dying. This was important to keep active on characters who could resurrect others ("rezzers"). In this way, if the whole raid group died (wiped), our rezzers could come back to life and revive everyone else in the raid.

Note that in the above examples, Paula and Lori were in charge of their respective classes or channels. These leadership roles were consistent from week to week and were sometimes established on demonstrated leadership ability in previous raiding activities. (I'm told that in many raid groups, class / role leads were supposed to read up on the fights and brief everyone they were in charge of. This was not the norm for my group until we'd "banged our heads" on the fight a few times first.) What mattered more often, however, were previous relationships before the raid began, including rank in the main guild organizing the raid and out-of-game friendships. As stated in the previous chapter, these existing social obligations (i.e., our built-up social capital) were important to the group because we had established a norm of valuing players for their social skills rather than just game-content knowledge.

Roles were also assigned by character class. These roles were generally determined by what each class was designed to do (e.g., priests tended to heal others). Most "serious" raid groups take these game-defined roles at face value and require that players design their characters to most efficiently take advantage of their class' roles. In other words, these roles were based on specialized functions within the group, akin to distributing responsibilities according to specialized expertise. This raid group, however, valued diversity and accepted variation in how people defined their character's abilities. In WoW, players can differentiate their characters by choosing special talents every time their characters gain an experience level. Priests could specialize (spec) even further into healing, for example, but they could also choose talents that let them be very capable damage dealers as "shadow priests." In

general, though, even shadow priests could heal, and instead of mandating that a priest's abilities were maximized for healing, this raid group accepted any sort of priest, so long as there was *enough* total healing ability across the whole raid.

At other times, a player was assigned a role because he or she had participated in an encounter that no one else in the raid had taken part in before. If no clear candidates were suited for encounter-specific roles, these roles were taken up by players who had established themselves as capable of managing their cognitive load either through some competency or, more likely, through the use of add-ons. Cognitive load theory (Cooper, 1998; Sweller, 1988) posits that people have a finite capacity of working memory. In terms of instructional design, and all information design in general, elements of design and interface take up some of this working memory, thereby increasing cognitive load. Confusing elements put on more load than otherwise necessary, taking away people's ability to work with the content to be learned or the actual information being conveyed. Many players supplement WoW's built-in interface with user-created add-ons, which replace or augment certain design elements to help them keep track of all the information in the world. A player having an add-on that notified him or her of specific events during an in-game encounter (e.g., the add-on called CEnemyCastBar) was sometimes the deciding factor when roles were being assigned or taken up.

All these different roles that people assumed—leadership, class, and fight-specific—were divided through a combination of game mechanics and emerged social practice. In other words, as Moses Wolfenstein (2010) describes in his research that compares leadership in WoW to leadership in schools, often leadership tasks were completed by various individuals who were not necessarily assigned "leaders." This division of labor process mirrors that found in work and school settings by Strauss (1985) and Stevens (2000), where the different tasks associated with a particular project are assumed by different people depending on social factors and emerged practice, which included the enrollment of various technomaterial resources that were distributed among the activity system. In WoW raiding, at the very least, those factors included game mechanics, players' understanding of the mechanics, players' ability and skill, and relationships of trust.

While chat was happening in these specialized channels, concurrent chat might have been happening in the [Raid] channel, the [Party] channel, the [Guild] channel, and any other channel that a particular player was subscribed to. Managing all the information coming from these various sources was challenging, especially when one had to concentrate on and navigate through the physicality of the virtual world at the same time. In fact, reading through

some of my transcripts shows pretty clearly that I missed some utterances that were directed at me (see "Chat" interlude). Also, sometimes, the chat in one channel referenced chat in another channel.

In this way, chat could be—and often was—interwoven and layered. Furthermore, on top of the text chat, there was voice chat that was also sometimes running parallel to and sometimes interwoven with the text chat. Those who were not using voice chat were often exposed to non sequiturs in text chat. On the flip side, some people responded to the threads in a specialized text channel through voice, which was confusing to those not participating in the particular specialized channel.

So, to start off our night in MC, we pulled a couple of Molten Giants (after sitting and talking and gathering together for an hour). Our fight with the Giants was routine and only lasted a little more than a minute. The text chat was relatively sparse because we all were familiar with the encounter and knew what to do. Even so, it was steeped in meaning. Here's the chat from it:

18:11:34.671: [Raid] Willy: INCOMING Molten Giant!

18:11:34.687: Willy yells: INCOMING Molten Giant!

18:11:36.187: Larry thanks Mary.

18:11:40.640: [Raid] Lester: Pat is Soul Stoned.

18:11:45.203: Marcie hugs Lev.

18:11:45.562: [Raid] Roger: rebroadcast ct please?

18:11:49.343: Willy yells: ATTACK!

18:11:49.453: [Raid] Willy: ATTACK!

18:12:57.359: [Raid] Sherrie: This whole only shaman group is amazing!

First, Willy, who was the second in command for this evening (spontaneously asked to lead by Maxwell while Maxwell was still organizing and getting ready for the rest of the session), alerted the raid that we were pulling the Molten Giants. To help him alert the rest of us, he employed a button macro that let him announce things in multiple chat channels in rapid succession. That way, all he had to do was target a monster and hit a key to tell us when something was "incoming!" In some cases, if he had spent some time upfront to set it up, an add-on that we all used called CT_RaidAssist (AKA CT Raid or CTRA), would also make these announcements appear as pop-up text overlays, smack dab in the middle of our screens, while a loud alert sound further let us know that something eventful was happening. In other words,

although the chat log shows that Willy used two channels to tell the rest of us that the Giants were incoming, it was in fact mostly automated text accompanied by an automated sound. In this way, Willy offloaded responsibility to a material resource that then carried out its ascribed duty.

"Incoming!" is actually the cue for one of our hunters in the group to take a potshot at one of the Molten Giants, which initiated the fight. After the potshot, the Giants charged our group and Warren and Wendy grabbed their attention. The two warriors then ran in opposite directions and positioned the Giants so that the Giants' AoE damage from their Stomp ability was not overlapping. This way we could kill one Giant without taking damage from the other Giant. While this was happening, Larry thanked Mary for something. What we cannot see in the text chat is that Mary, who was a mage, gave some water to Larry. Spell casters, like Larry (a warlock), used up a certain amount of Mana with each spell cast. Casters had a finite reserve of Mana (depending on their class, level, and equipment), so after casting enough spells, they ran out and were no longer effective participants in a fight until their Mana pool replenished at a slow and steady rate. In between fights, however, they could consume water or other liquids to regain their Mana at a quicker rate. These drinks could be purchased in towns or cities from certain vendors. Mages, like Mary, however, could conjure up water and share it with other characters, thus, saving them from having to buy water. (Even in game, some people didn't like paying for water.)

Next we see that Pat had a SS applied to her by Lester, so we had a safe rezzer in case something went horribly wrong. Then Marcie hugged Lev. In addition to SSes, warlocks like Lev could create healthstones and pass them out to other characters. Consuming a healthstone would heal some damage, giving players a way to regain Health in an emergency during a fight if, for example, the healers had run out of Mana or if they were occupied healing the MTs. Lev had just given Marcie one of these healthstones, and she returned the favor with a hug.

Roger, an undead rogue, then asked if "ct" could be rebroadcast. This was in reference to the aforementioned CT Raid, which among other things, also allowed raid leaders to designate MTs. Once designated, little windows showing who the MTs were and what the MTs had targeted appeared on every CT Raid user's screen. The CT Raid add-on worked by using its own specialized, hidden chat channel usually given a comical name by the raid leader. Anyone who used CT Raid would automatically be subscribed to that channel so long as the raid leaders synched everyone up by broadcasting in [Raid] chat a certain key phrase that CT Raid recognized. Players who joined the raid group late or who somehow temporarily lost connection to the game

often had to be resynchronized by having the raid leaders rebroadcast. CT Raid was the most popular add-on for raiding groups in 2005/2006, and using it was often required or highly suggested by raid groups. Thus, game experience and practice within the game was not defined just by the developers of the game. The practice around raiding and the coordinated work required for raiding allowed a common tool to be developed and propagated such that it was hard to imagine playing the end game without the CT Raid add-on.

About 4 seconds after Roger asked for the CT Raid channel to be rebroadcast, and about 15 seconds after pulling and separating the Molten Giants and then letting the MTs build up aggro, Willy called the rest of the raid group to attack. It took us about a minute after that to kill the Giants, at which point Sherrie announced that she liked being in a shaman-only party. Shaman could place ("drop") totems on the ground, which gave some sort of benefit to party members standing near them, but each shaman could only drop two unique totems, so they often had to weigh the pros and cons of which totems to drop. By having five shamans in one party, they were able to drop a very effective combination of totems because the party was no longer limited to only two totems.

Making Encounters Routine by Finding Balance

After this fight, we prepared for the next pull by making sure our casters had regained Mana and that people were healed. The next fight was with another kind of monster, which had different abilities, but it was just as easy with little danger of failure or of having lots of people die. In fact, our MC experience had become a series of routine fights where we got ready, pulled, and killed in a systematic way until we reached a boss. These monsters were made so routine that the gaming community had come to know them as "trash mobs." They were "trash" in that they did not pose a threat, and the loot they dropped was often worthless in terms of making our characters more powerful but could sometimes be sold for in-game currency (gold). This loot was also known as "vendor trash." The term "mob" stands for monster object, which is how developers of MMOGs refer to game-controlled monsters or enemies.

Making these trash fights a routine activity took us several weeks. For me, a rogue, it took time finding the right balance between doing a lot of DPS and not taking aggro away from the tanks. The problem was that if I did too much DPS, the Molten Giant or Lava Annihilator or whichever mob we were fighting would consider me its greatest threat and start attacking me instead of paying attention to the warrior who was tanking it. As soon as this happened, in most cases, I died. Early on, this happened to me often. Embarrassingly

often. But at least I wasn't the only one who struggled with aggro. After 6 months, one or two of us still had a difficult time of finding that balance, and drawing aggro happened to just about everyone in the raid at least a few times.

Once we matured as a raid group, grabbing aggro from the main tanks and dying in such routine pulls was met with laughter and people who did it were only jokingly chastised. Some even felt a bit of pride when it happened because it meant they were "out-DPSing" others in the raid.

Even non-DPS classes had to find the right balance of abilities versus aggro. Healers, for example, drew aggro by healing the warriors. The monster would suddenly consider a healer more of a threat than the warrior in front of it. If enough of us attracted the attention of the mob we were fighting during a single encounter, the monster would "bounce" from person to person, moving to and killing whoever was the next highest threat. When this happened, usually we wiped—enough of us died that there was no hope of defeating the mob before it killed the whole raid group.

Learning each encounter could involve many wipes, and when it happened, it took time for our healers to resurrect themselves and then resurrect everyone else. If we did not have any safe rezzers, we all had to release our "ghosts" in the game at the nearest graveyard and then run back to the entrance of the dungeon to reclaim our bodies and reappear in the world. Although it could be frustrating to wipe over and over again, many of us in the raid, including the raid leader, took this opportunity (the time it took to either rez everyone or run back to the entrance from the nearest graveyard) to reflect about what had happened and suggested things to change about our approach or suggested completely new strategies to try. This mirrors the practice of another successful raid group that Sarah Walter (2009) wrote about in a different MMOG, suggesting that it is perhaps a necessary practice for successful raiding, no matter the game. Indeed, reflective thought is needed for metacognition (Brown, Bransford, & Cocking, 2000)—the ability to step back a bit from one's activity and assess where one is and where one needs to go—in any setting.

This practice of failing multiple times on new encounters might be unique to raid groups whose members are all relatively new to the raid encounters. Many players, after they hit 60, attempt to find memberships in mature raid groups, often joining guilds that concentrate on endgame raiding. It is possible for these players to never experience multiple wipes. Unfortunately, I cannot speak to this experience much. It should be clear by now that raiding takes an enormous time commitment, so even if I had access to a mature raid group, I would not have been able to join both groups. My choice of participating with a new raid group, however, allowed me to see group learning and talk around

shared understanding of encounters and the game world. As Walter demonstrated in her research about newcomers to established groups (2009), learning happened in a mature raid, but it was of a more individual nature where a newcomer learned the predefined role the raid group had established for him or her. In contrast, the raid group I participated with did not start out as a mature one, so the local instantiation of broader raiding practice was still being defined and shaped heavily by the collective endeavors of the group members.

A raid that had progressed enough to treat trash mobs as routine was one venue in which an SD was present. Individual players may have been tempted to free ride off the efforts of the other raid members. In a mature raid, to defeat a monster, a critical mass of raid members must have known what they were doing; it was often not necessary for all players to play their best. In fact, when I spoke to a member of a raiding guild that had put Molten Core on farm status (meaning that the task had become so routine that it had become repetitive and easy), he confided in me that he and other raid members tended to play *Tetris* or *Breakout* or other casual mini-games during the raid sessions. (Too bad *Farmville* didn't yet exist.) To combat this free riding, some raid leaders used certain add-ons that kept track of the individual performances of raid members and then reviewed the logs after each gaming session. The raid group I was in only used this common damage and healing meter to help troubleshoot times when we were failing and trusted that raid members were paying attention. Instead of relying on a technological actor to conduct surveillance on each other (cf. Taylor, 2006b, p. 329), at this point of our raiding life, we had established a social norm of trust in each other that served as a powerful disincentive to free riding. Our reliance on material actors was slowly manifesting, however, and, as will be discussed later, this shift from trust through humans' internal sense of right and wrong to trust that is enforced by technology would fragment the group, leading to its eventual downfall.

Welcoming Failure in Golemagg and Other Boss Fights

Because this night was several months into our raid instead of when we first started, we did not wipe on trash mobs. Also, we were not wiping on the early bosses. Our goal this night was to make an attempt on the last boss in the instance, Ragnaros. The way the dungeon is set up, our raid group had to kill all the other bosses before Ragnaros's lieutenant, Majordomo Executus (Domo), would appear. Then after we defeated Domo's guards, he would teleport away to Ragnaros's chamber and summon his lord. This was a Friday

night, so we had already been in the instance once this week and had already cleared out some of the dungeon, including many of the early bosses, but we still had to defeat a unique Giant named Golemagg and his two Core Hound guards before reaching Domo. Boss monsters were special ones with more Health and more abilities. To fight one was to engage in an extended fight requiring more careful strategy. Boss monsters often had minions or guards near them, and challenging a boss in these cases was a matter of tanking each guard along with the boss then figuring out which ones to kill first.

We reached Golemagg a little after 7:00 p.m., about an hour after our first pull and about 1 hour and 45 minutes after we first started forming up for the evening. That is, we spent a good chunk of time just getting to a significant fight.

Our strategy for Golemagg was to kill him before his Hounds because, once he was down, his Hounds would automatically die, as well. To defeat Golemagg meant we had three warriors assigned to tank him and his two Hounds. While some healers were keeping the tanks alive, everyone else focused their attention on Golemagg. Golemagg had an ability that gave players debuffs that did steady damage spread out over a set amount of time ("damage over time" debuffs or "dots"), and he could apply this effect over and over again on anyone within melee range. A rogue's role was to run in, hit Golemagg a few times, run out of melee range when he or she had received enough dots, wait for the dots to wear off (because applying bandages could only be done when not receiving damage), bandage or otherwise heal (e.g., with a healthstone) himself or herself, then run back in to do more damage, backing off as needed. Again, learning the encounter was a balancing issue for rogues, maximizing DPS without getting too many dots. If I stayed within melee range to raise my DPS a little, I might have received more dots than I could wait out after retreating. The dots would kill me before wearing out, preventing me from applying bandages.

Learning how to engage in the encounter for the raid meant we had to know the overall strategy of concentrating on Golemagg. We knew this because some of us had been in a fight with him before with different raid groups, and some of us had read strategies online for the bosses in MC. The majority of us, however, were disinterested in reading about boss strategies before encountering them for the first time. A handful of us even considered it outright spoilerish, bordering on cheating. Contrast this with raiding in WoW several years later when the norm is to blast through content as quickly as possible, which comes with an implicit assumption that everyone is intimately familiar with all the boss fights and studies strategy guides or watches YouTube videos of successful fights beforehand.

Golemagg had a plentiful amount of Health, and this night, killing him took us almost 8 minutes (in contrast, the two normal Molten Giants earlier took us a little more than 1 minute). In long "endurance" fights such as this, it was common for healers and other casters to run out of Mana. If enough of our healers ran out, the warriors were no longer getting healed. They would die, causing the rest of the raid to wipe thereafter because all the other classes could not take more than one or two hits from Golemagg. The first few times we did this fight, like the first few times we did any of our boss fights, we wiped. This was not seen as a bad event but rather as a necessary component of learning the strategy and finding the balance or "groove" needed to succeed. A raid member, Rebecca, an undead rogue from The 7/10 Split, had this to say:

Rebecca <The 7/10 Split>
Ultimately each of us can only control our own character; so the most important job we each have to do is make sure we are doing our part both effectively and efficiently. . . . [S]moothly executing a kill on a boss that used to kick our tail is very gratifying, I think.;)

For Rebecca, the sense of accomplishment from finally defeating a difficult boss was very satisfying, and most members of the raid shared her sentiment. It was not just loot we were after. We enjoyed the challenge and success that came with the hard work of failing multiple times. To succeed, each of us had to learn to play our role effectively. We also had to trust each other to take on this responsibility. It is very clear that, just as Taylor saw in EQ (2006), some players took on responsibilities very seriously and that fun and pleasure were not so easily defined. Generally, each player decided when to play and when to quit based on personal goals and ways of seeing fun. For most players, this fun came from a (sometimes obsessive) desire to improve their characters through what WoW players have come to call "itemization"—the act of acquiring better and better equipment. Time and again, however, the various members of the raid I participated in reiterated their desire to do raids as a way of doing an activity *together* to sustain and strengthen relationships. In the words of Penny, an Angler, on June 27, 2006:

Penny <Booty Bay Anglers> (5:09 PM)
You guys, how are we "falling behind"? We're not a raiding guild. There's no competition to keep up with other guilds here. I want to go to Gruul's Lair again, too (and this time be successful), but pushing people too fast, and

> wearing ourselves out to get there isn't the way to go about. It takes time and patience.
>
>
>
> And you know what? We, as a guild, are raiding successfully. Part of being in this guild is working with everyone else, and the majotiry of the people in this guild have insurmountable patience and want to take their time plowing through everything. So that meant I needed to stop rushing ahead, wait up, and enjoy the fact that our guild is filled with enough talented individuals who are willing to work with each other each week to make it happen. No one is getting left behind and everyone is getting a chance, if they take the opportunity.

For players like Penny, deep bonds were forming around shared experiences, and they recognized engaging in these participatory acts as a way to deepen trust and friendships. Sure, they wanted to be successful, but progression was not worth leaving each other behind.

Socially Constructed Social Dilemmas AKA the Problem of Rare Loot

This night, we killed Golemagg relatively easily, and therefore, we could loot his body for valuable equipment. This was standard action according to in-game mechanics, which rewarded player participation through valuable loot when a group of players defeated high-end monsters. Each monster that a group killed only dropped a handful of items, though, so only some of the group's members were to receive this in-game reward. Setting up high-end rewards as scarce commodities caused player groups to come up with rules on how to fairly distribute the loot.

This practice was so prevalent that almost all groups clearly define loot rules before they set foot in a high-end dungeon, and many players had come to see endgame practice as only participating in these high-end encounters and winning loot. The most common way of dividing loot was through the DKP system where participating in certain monster kills netted a player a certain number of points (Malone, 2009; Wikipedia, 2011a). When loot was distributed, a player then bid his or her points in an auction against other players to win a particular item that would benefit his or her character. Winning an auction subtracted however many points were bid, thereby limiting how many points the player could bid on a future item, thus, giving someone else in the group a chance to win it. This can be likened to an SD, in that many players' bidding practices were motivated by selfish, individual benefits. Yet a particular player could win an item that would actually benefit

the whole group more if *someone else* won the item. This is because not everyone had the same equipment, and someone else's character might have been more effective in combat than the winning player's character with the same loot item. From a more general perspective, no matter what kind of loot rules a group used (see Wikipedia, 2011a, for many examples of other loot systems), the social dilemma of "who gets the loot?" existed. The addition of using a DKP system on top of the basic game structure reinforced the dilemma by more explicitly making the situation competitive.

Actions within this socially constructed SD are not so easy to explain through SD modeling, however. Other factors came into play, such as a player's relationship with others in the group. For example, two of the group members, Hizouse and Hatfield were brothers in offscreen life, and they tended to play games together, joining and leaving player groups together. Tight bonds like these were sometimes the cause for one player deferring to another when it came down to loot distribution. Additional factors also played a role: the attachment and commitment a player had with his or her character, how long the player planned on continuing to play the character, the fiction and role or identity he or she saw the character taking on, and personal values about what was an important goal and what constituted fun. This last point is important because if the group, as a whole, valued other things besides loot, the whole looting system itself had to be reanalyzed. The group that I played with, for example, took a completely different approach to loot rules—one which reinforced their approach to high-end content as opportunity for shared experience. The loot was an added bonus to the more valued experience itself.

The system this raid group used included a random element, and it was not always clear who would receive a particular item. The group used a weighted loot-roll system in which players initially "rolled" a random number from 1–100. For each session that a character was present but did not win anything, he or she subtracted 10 from his or her roll range (e.g., after two sessions without winning anything, a character would roll from 1–80). The lowest number won the item and the winning character's range would reset to 1–100. Probabilistically speaking, those who had a history with the raid group and hadn't gotten any loot in the last few weeks had a better chance at winning something they wanted, but there was always the chance that someone who was relatively new could win an item. The raid's leaders, informed by a long, open discussion in the group's online message board (three different threads spanning dozens of pages), decided that they wanted this informal, slightly chaotic, loot system to reinforce the raid's de-emphasis on loot (i.e., the raid's desire to forge friendships and hang out with each other).

This night was a good night. After dividing loot, our raid succeeded in killing some trash mobs and then successfully defeated Domo and his eight guards. Frustratingly, we then moved onto three failed attempts at killing Ragnaros. He proved frustrating because his encounter became "buggy," where he was activating abilities at odd times. We eventually gave up, and by the time we were done for the evening, it was almost 10:00 p.m. Our gaming session was almost 5 hours and, other than Ragnaros, was relatively successful.

An Atypical Night in Molten Core

In contrast to our good night that Friday, the following week on April 19, 2006, we had an atypical night in MC. It was atypical in that a series of events unfolded that caused us many wipes and generally gave us poor morale, which almost culminated in a "meltdown," where enough raid members fervently opposed each other on an issue that irreparable damage occurred to their friendships, effectively disbanding the raid. I believe it started with having enough people in the raid feeling stressed about other things happening in their offscreen lives. For example, about 30 minutes before the raid session started, a member of my guild made it known that she was depressed and contemplating committing suicide! As an officer and friend, of course, I was compelled to attend to her as best I could without knowing who she was offscreen. This meant I was engaged in a private conversation with her in-game, forcing me to miss some of the other chat that was happening. (I was also privately messaging other members of my guild and consulting an out-of-game friend about what to do. Thankfully, as I'd learn several weeks later, my guildie turned out okay.)

We also decided that night to try using two different warriors as our MTs for the first time, so that in the future we'd have backup MTs available, and it was clear that the warriors who were not used to tanking were not sure where to position their monsters. Furthermore, the warriors who were normally our MTs did not know which abilities they should be using and which weapons they should be using while playing DPS roles. To add to this, we had an abnormal group composition that night, with more shaman and hunters and fewer warlocks and rogues than we were used to. Though our raid did not strictly proscribe the exact composition of our group, this night still presented us with a combination of character classes that we were not familiar with. Additionally, some of the players expressed concern about people bringing characters who were not their primary characters. Instead, a few players were trying their alts in this night's raid session that they might not have been as

proficient in playing. This uncertainty manifested itself in our chat. At various times in certain specialized channels, raid members were bickering with each other:

18:46:17.640 : [2. healsting] Pod: Poll: Best Knockback

18:48:13.906 : [2. healsting] Pod: a) The Beast

18:48:23.453 : [2. healsting] Pod: b) The Fish Boss in ZG

18:48:31.296 : [2. healsting] Sven: Hmmm?

18:48:45.625 : [2. healsting] Pod: c) Garr's Lt.'s

18:49:01.062 : [2. healsting] Pod: d) other

18:49:06.296 : [2. healsting] Sven: Shaun's breath.

18:49:40.093 : [2. healsting] Shaun: you know, if you want to be the next shaun, it might serve you well not to always insult me

18:49:51.593 : [2. healsting] Shaun: i mean, why would you want to be just like somebody with bad breath?

18:49:54.515 : [2. healsting] Sven: I don't want to be "the next Shaun!"

18:50:08.218 : [2. healsting] Sven: You are simply going down. I shall overcome your shortcomings.

When Pod, an undead priest, was playfully polling the healers which WoW encounter featured the "best" knockback—when a monster pushed or threw player-characters away from them—Sven suggested that Shaun's breath was the most memorable knockback in the game. Shaun was generally seen as the de facto leader of the shaman class (and, generally, all the other healers, too), and it is possible that Sven resented him for it, as evidenced by their talk of "the next shaun" and "going down." This tension between Shaun and Sven continued later into a disagreement about where Sven was standing during the fight with the first boss monster, a snake-man named Lucifron:

19:00:02.468 : [2. healsting] Sven: I'm ranged for Will healing

19:00:10.515 : [2. healsting] Shaun:

19:00:17.578 : [2. healsting] Shaun: Sven, you are fired.

19:00:21.484 : [2. healsting] Sven: Hey, most people avoid you, Shaunny!

19:00:24.312 : [2. healsting] Sven: It's the breath

19:00:32.218 : [2. healsting] Sven: I'm giving an alternative!

19:00:46.406 : [2. healsting] Shaun: an option that is closer to the caves.

19:00:49.015 : [2. healsting] Shaun: you...

19:00:55.625 : [2. healsting] Shaun: you are trying to kill us all....

19:01:00.625 : [2. healsting] Sven: Well?

19:01:05.109 : [2. healsting] Sven: It hasn't happened, now has it??

19:01:17.703 : [2. healsting] Sven: Stop being so paranoid!

Sven was positioning himself away from the main group of players, dangerously close to an adjoining cave with monsters the raid was not yet ready to battle. Shaun thought that Sven should have moved to the rest of the group, just in case those other monsters noticed Sven and attacked the whole group. This interchange gave more evidence that there was a distinct lack of trust this night, which did not help motivate raid members to concentrate.

We ended up wiping three times on trash mobs because too many of us were either distracted or consciously free riding. After our third wipe, no one said anything in text chat for 8 minutes. That is, no chat was happening in the [Raid] channel, none in the [Party] channel, none in the [say] channel, and none happening in the various specialized channels for 8 whole minutes. The longest idle time from our typical good night was 2 minutes. Those who were not already feeling less than 100% became frustrated from our three wipes and the bickering that they were seeing in their specialized channels. At one point, the raid leader asked the raid if we should continue:

19:10:10.046 : [Raid] Maxwell: as fun as it is to goof around, we can't wipe to trivial stuff at the same time

19:10:43.937 : [Raid] Heather: What? We can't?

19:10:55.093 : [Raid] Pod: Yeah. I kind of need to make a profit tonight. Just spent most of my cash.

19:10:57.375 : [Raid] Roger: well, maybe hunters can.

19:11:12.937 : [Raid] Maxwell: time to be mean. If you are not all willing to focus and have a polished run I -know- we are capable of, let me know now and I'll find something better to do with my time.

19:11:25.578 : [Raid] Maxwell: do you want to raid MC tonight?

We decided to continue, which in hindsight was probably a mistake because a few minutes later we had an argument break out over loot rules. One of the regular druids, Dierdre, had to take an emergency phone call during a boss fight and could not participate. When we killed the monster and looted it, an argument broke out whether she should be allowed to roll for a druid item that dropped. This argument proved a shock to many of our raid members. What's more, Dierdre was not even one of the vocal participants in the argument. She did not care either way, but other raid members (who were also druids and potential winners of the loot item) argued that she should not be eligible to win the item. This caused other raid members to jump to her defense, citing the core values of the group. Some heated exchanges took place over voice chat, followed by some heated text chat exchanges. It ended with some people, including our raid leader, retiring for the night. A partial excerpt (prior to this, Shaun, the target of Sven's insults and Dierdre's offscreen partner, had already logged off in disgust):

21:06:29.656 : [Raid] Maxwell: all right, Dierdre is passing and I am giving the hammer to Sam, but I have something to say about all this

21:07:37.953 : [Raid] Maxwell: this is a somewhat unconventional raid in many ways

21:08:04.500 : [Raid] Maxwell: I don't do dkp, I don't dock people for only showing up for part of the evening

21:08:11.156 : [Raid] Maxwell: loot has never been the main focus of this

21:08:49.562 : [Raid] Maxwell: I find it disturbing that this much drama was raised over something like this *["Drama" occurred when players had to deal with stress and arguments with other players.]*

21:09:31.343 : [Raid] Wei: wasnt like it wasnt fueled

21:09:43.156 : [Raid] Maxwell: I am sorry that some of you feel this strongly about loot, but Dierdre has contributed as much to tonight as any of it *[meaning Dierdre had helped all along the way up until that point, and that effort should have been considered reward worthy]*

21:10:22.734 : [Raid] Maxwell: I am not having the best evening, I'm recovering from food poisoning and I feel like shit, so I am sorry if I seem a little out of sorts

21:10:46.265 : [Raid] Maxwell: but I am quite disappointed and will be taking a break from leading raids for awhile

21:11:23.343 : [Raid] Maxwell: this has been too much pressure on me, and I'm having a hard time with this right now

21:13:03.328 : [Raid] Maxwell: I just ask that you think about why you are all on these raids. I do this for all of you, not for any pieces of loot and I hope you all realize it's the people that make this worth it

21:13:06.156 : [Raid] Maxwell: good night

21:17:20.468 : [Raid] Sven: On this depressing note, I'm tired and depressed. I'm going to call it a night.

21:17:33.250 : [Raid] Iskaral: Ok guys I think I'm off for the night

21:17:45.953 : [Raid] Dierdre: i have to log guys...i am really upset right now, and am not thinking clearly. i am sorry i caused an issue while not even at my own keyboard. i shall see you all again tomorrow perhaps when the day is new

Maxwell was already feeling "a little out of sorts" when the dispute over Dierdre's eligibility came up. In the moment, he attempted to remind the raid members of the values that went into the formation of the raid, but he had to retire for the evening and possibly take a break from future raid events, too. This precipitated a chain of players quitting for the evening. The group decided to continue but eventually ended the session for good when the remaining players realized they couldn't defeat the next boss with so few raiders.

For many of the raid members, the drama came as a shock because they did not see the entirety of the chat that was happening in the various channels. It also came as a shock to me because I was not paying as much attention as I should have to the chat while it was happening. I was dealing with some particularly stressful situations in my own guild (including suicide threats). This was similar to Barron's observation that groups working on specific projects are often more successful if the group's members are able to maintain their attention on their discourse of problem-solving strategies (Barron, 2003, p. 332). The following day, many of us discussed what happened on the raid's web discussion board.

The raid members' values of friendship and ability to reflect and realign were clearly evident on the forums because the events that happened the previous night were seen as a fluke. One raid member said, "I personal find what happened tonight to be just plane old rotten luck. We had a bad run tonight and people where getting tired and a situation accrued." In light of this view, players were emphasizing the family nature of our raid group and how it is natural for people to sometimes disagree with each other. A tauren druid from The 7/10 Split, Drusella, said

Drusella <The 7/10 Split>

I love our raid. I know we are all going to get burned out at times and frustrated and upset and disagree with one another. It is part of being human. We are like brothers and sisters really. Stuff like this is going to happen. However I think we have all been playing long enough to know that we have a pretty great group of people going here and truly we care about and try to do what is best for one another.

Drusella framed the events as normal disputes a family would have and then emphasized the uniqueness of the group's collegial nature. We also talked about how we should treat each other in the future. One raid member said, "Stress, it happens. We have a wonderful group of people here and we should always keep in mind that every last one of these people has feelings." What mattered most was that we learned from this experience that conflict is normal, and people should be careful not to hurt each other while trying to resolve the conflict. In other words, the raid group was treating this as cause for reflection by trying to identify the problem (or at least symptoms of it) and solve it. I then suggested that we needed to consciously make the effort to lighten the mood:

Thoguht <Booty Bay Anglers>

I noticed that not many people were actually joking around with each other like we normally do. I think a lot of us were sick or tired or having a crappy day, and when we got together, we had enough people who weren't feeling 100% that it showed itself in chat, in our performance, and in our stress levels. It might seem artificial but if I notice that happening again in the future . . . I'm going to start making jokes.

Another raid member echoed my sentiments:

Hala <The 7/10 Split>

I also noticed the lack of joking around in raid chat, and vent was totally silent for the time [I] was on it. I agree hun . . . I will be right there with you making a nerd of myself to try and lighten the mood ☺.

To sum up, our lack of camaraderie was an indication that many people in the raid were feeling stressed more than usual and that some of them did not trust themselves or others to play their roles in the raid effectively. Somehow

the underlying goals of the raid as a whole became diluted or lost during our bad night. The fact that the ultimate dispute was over loot suggests that the goals of building relationships became eclipsed by individual motivations for progressing and winning loot—incentives that are built into the underlying mechanics of the game. In this instance, the effectiveness of the group was compromised when the motivations for cooperating with each other came from selfish sources. In other words, whereas one argument about how to address SDs is to appeal to people's selfish, "rational" nature, the experiences of this night for my raid introduces doubt into this approach's power. Perhaps more important than how individuals in a group are motivated to do their work is that everyone in the group is in alignment about where their motivation comes from.

One alternative way to address this issue was through explicitly reiterating the group members' goals and how they emphasized our experience together much like the reification / participation work that had been done before. Reiteration of assumed goals and expectations could only have served to strengthen bonds. Free riding that may have been occurring because players saw their efforts as work or obligation might have been lessened if players had seen their efforts as play or participation in hanging out. Additionally, players were not at their most attentive during this night, and it is possible that a look at how labor could have been divided differently would have helped. Finally, even though camaraderie in the MC raid group was just an indicator for effectiveness rather than the cause of effectiveness, one way to fix poor performance and wavering trust may have been for members of the raid to attempt to lighten the mood and be supportive of each other when trying new things.

Communication and Trust

Learning for this group of players occurred through iterative attempts to perform in-game tasks together. Failure was seen as progress so long as the raid group was given time to reflect on strategies and form new strategies. Failure inherently pushed at our initial concepts about how a particular fight worked. This poses two problems. First, failure is not often thought about in games where more attention has been paid to how games allow imaginary actions to become realized and/or how games allow players to reach a state of *flow* (Csikszentmihalyi, 1991), where players never fail in such an absolute sense. When failure is considered, it is usually associated with skill-based failure at a specific task rather than instances of non-coordination, which may stem from

a lack of trust. As I'll cover in more detail in the next chapter, this could be examined using a distributed cognition or actor-network theory view of failure as moments when the system of distributed roles and responsibilities fails to be in alignment. I make the claim, like Iacono and Weisband (1997) when they wrote about developing *swift trust* in virtual teams, that trust is closely tied to communication practices, and specifically, the frequency of communication turns along with the kinds of communication happening might be a good indicator of the level of trust in a group.

Second, time to reflect on failure and, more generally, time to talk, think, coordinate, and prepare for the actual in-game activity can represent much of players' actual experience. This also is not often the picture one conjures up while thinking about games as immediate gratification. As Walter (2009) demonstrates in her research on a different raiding group, the time to reflect was needed for any meaningful learning to occur, and time to talk through this reflection was necessary for group learning.

Frustrations for my group emerged not from actual failure but through the emerged social understanding of a particular night's gaming. We had failed many times before, over and over again, but in those cases we were "in it together." On our poor performing night, the raid collectively momentarily lost track of its goals, but it was able to reaffirm them on the web forums the day after in a bottom-up approach to management. These goals were of maintaining friendships and having fun (i.e., socially constructed goals) over the more traditional purpose of receiving loot to improve or progress (i.e., game mechanics goals). The raid's realignment with these shared-experience goals after a bad night was done through reflection and the ability to see that it had strayed and the ability to make suggestions for finding the path again. In a sense, the raid was metacognitive. The raid was made up of 40 different players on any given night, however, and it was those people who thought and acted. It is difficult to say whether everyone in the raid valued the same goals, and it is clear that they did not always agree; otherwise, there would have been no strife. Yet the majority of members felt very strongly about the familial nature of our group. In contrast to this, I have heard and read about other raiding groups in WoW permanently breaking up after a meltdown. It is possible that those groups did not establish alignment in the same kinds of goals, and the individuals in those groups valued raiding as a means to an end rather than the end itself.

Looking at game mechanics and systems to guess how players will behave can lead one to suppose that changing the rules of a game can encourage cooperation within situations that resemble SDs. Actual player behaviors, however, are complex. The concept of SDs cannot model all the different

social aspects that go into the choices players make in their situated experiences. If one were to look at these decision-making points not as a series of rational choices but rather as points where players act out of emotion and role-playing—identity-taking and action in a social discourse—it becomes clear that the issue of trust is more complicated than merely thinking that one's peers will also think rationally. The raid group I was in was able to foster a different kind of trust in its members by ensuring that they were in it for the sake of the group and having fun rather than for individual, self-serving loot collection, and this trust was enforced through our social norm of camaraderie and coordinated communication. Our social norms and communication practices allowed us to exist without other game-induced incentives such as guild affiliation or technical surveillance tools. This could be a new way of looking at the problem of trust in SDs. My raid group ensured this trust first by only recruiting players with whom other members had already established a friendly relationship (i.e., we had built up enough social capital among us to trust each other). Second, the raid group explicitly stated its goals in in-game chat and in the web forums and then reflected on its behavior in relation to these goals. Finally, the raid loot rules—socially established criteria for regulating group actions around collective goals relative to individual interests—were collaboratively agreed upon through its web forums—one of the key components Kollock and Smith (1996) claim is needed for creating a sustainable online community.

The approach this group took may suggest a way that teams in other settings (like work or school) can also take when working on a new task. Rather than focusing on the goal of doing the task right and reaping the rewards, teams can concentrate on building friendships and learning how to complete the task together. An analogy to schools, for example, could liken getting good grades to winning loot and that grades represent an individualistic notion of how students should approach school. If learning is the goal of school, however, and one thinks of learning as socially constructed meaning from practice, more emphasis should be placed on fostering self-sustaining cooperation in the context of individual and collective goals. To aid in this, dividing the labor up into specialized roles allows each individual to contribute to the shared experience, and developing efficient communication channels is necessary for coordinated work. This could only happen, however, in environments that allow the right kind of trust to be established among group members. The trust must be based on valuing the shared experience and forging relationships rather than individual grades. Fostering trust among group members in this way may actually lead to a more coordinated group, which is better prepared to handle future tasks and changing situations.

Additionally, a group formed on friendship is able to rebound from instances of poor performance and realign or rally itself for future tasks.

By examining player practice, I conclude with this: Good communication and coordination is necessary for a team to succeed. Good communication and coordination happens when team members trust each other in their specialized roles. For the raid group I participated in, trust based on shared goals and well-established relationships was stronger than trust based on individual incentives.

Role-Playing Takes So Much Time; We Could Be Killing Things Instead...

The account below attempts to demonstrate how interleaved in-character (IC) talk was with out-of-character (OOC) talk—that is, it shows how a few players maintained their role-playing practices in a world where not all players were role playing. To better disambiguate the fantasy and imagination involved in role-playing from OOC talk, I have reformatted the IC chat as prose and kept the OOC talk in chat log format. *[Notes like this]* are used to make editorial comments.

✽

Hannah, a dark, slender orc, was sitting on the dock inside Orgrimmar, next to the orphanages where Matron Battlewail kept house. She sighed a bit, eagerly waiting, as she noted the boy approaching with Leon and Leon's imp and said to Leon, "Ah... and... you do need him back?"

Leon, a graying orc, dressed in fine robes marked with intricate glowing sigils, glanced over to the young boy to make sure he still was in tow. He then asked his imp, "Grim, you didn't light him on fire did you?"

Hannah, getting ready to leave, shifted with amazing dexterity, able to place her very scanty armor on without being too revealing.

Leon, undistracted, watched Grim's needled teeth form into a smile, congealed with old blood. Then the imp merrily hopped about and shook its head. No. The boy was fine.

[05/01/05][21:41][Takai] says: would any of you kow where warriors guild hall mihgt be ? *["Takai" is an alias but my chat logs did not capture his character class, so I chose a name starting with "T" to signify that he was a troll.]*

[05/01/05][21:41][Takai] says: Know* *[Asterisks are used to denote a correction for a previous chat utterance. Though Takai was not engaged in role-playing, he still took the time to correct the spelling of one of his typos. He could have been attempting to conform to RP standards of talk where proper English spelling was the norm. Alternatively, it is possible he considered his talk undecipherable without this correction.]*

Leon waved at Takai, as Hannah said, "I do not, troll." *[Leon and Hannah continued to stay in character as they responded to Takai.]*
"Ask any guard," Leon added.

[05/01/05][21:41] Takai waves at Leon.

To clarify, Hannah told the troll, "They will point the way to your trainer."

[05/01/05][21:41][Takai] says: ok thank you very much

Another orc, this one dressed in black leather, knives sheathed at his sides, came into view. On his way to the orphanage, he spotted Hannah and waved at her.

As Leon nodded to Takai and the troll ran off, this new orc approached Hannah and noted, "It has been a long time Hannah."

Leon, recognizing the break in conversation as indication that Hannah was now whispering to the newcomer, subtly excused himself and headed to towards The Drag. Grim leapt after him but left the boy with Hannah.

Hannah briefly stared at the boy; the boy's eyes were illuminated with interest as he watched the imp excitedly. She frowned at this. Damn; he was interested in the demon now. No time to try to get his attention, though. A stranger addressed her. Facing him, Hannah greeted him with, "Throm'ka."

She then saluted him with respect as she said, "I regret... I've... forgotten your name..."

"I'm Thoguht, *[Thoguht was played by me, remember.]* friend of Hizouse," the stout orc said as he bowed down graciously. Then, nodding towards the young boy, noted, "Not sure I like these orphans under foot," to which Hannah quickly replied, "They've nowhere else to go... though this one behind me..."

Hannah frowned again, glancing down with a slight tightness to her jaw, knitted brows meant to chastise.

"You... I will speak to you in a moment about that imp," she addressed the boy, "Now go play."

The boy immediately obeyed and scurried away.

Watching the young orc chase after Leon and his imp, Thoguht said with a change of heart, "Well, I suppose it is for a good cause."

With a smile, Hannah said, "Well met, Thoguht. I didn't think any knew me... Or even my name for that matter..."

"I remember you had a pet wolf who let me pet him," replied Thoguht.

"Paws..." Hannah nodded slowly.

"But it was a few moons ago," Thoguht continued.

[05/01/05][21:44][Lara] has come online. *[I was notified by the game whenever one of my friends or guildmates logged into the game. Lara was another officer of my guild.]*

Hannah sighed, gruffly lowering down to flop onto her bottom, elbows propped onto her waiting knees.

"We were much younger then," said Thoguht.

"He is dead."

Looking surprised, Thoguht replied, "Oh! I am sorry."

[05/01/05][21:44] Lara joins the party. *[As described in the "Pugging" interlude, common practice among the officers of my guild was to invite each other to group up without asking for availability first.]*

[05/01/05][21:45][Party] [Lara]: Wow, the old crew is together again!

[05/01/05][21:45][Party] [Thoguht]: ha

Hannah shook her head, nodding downward a bit to signify mourning. Her eyes were briefly turbulent, showing a great pain... the female loved her animals. It did not last long however.

[05/01/05][21:45][Party] [Wilma]: Laaaarraaaa! *[Wilma was already in the group with me. Wilma and Lara have been playing online games together since well before WoW's time. By comparison, I was a late addition to their normal gaming group.]*

[05/01/05][21:45][Party] [Thoguht]: I'm tied up with Hannah.

[05/01/05][21:45][Party] [Wilma]: How was the movie?

[05/01/05][21:45][Party] [Lara]: i connect to alliance in the inn. *[The game remembers where an avatar is when the player logs out. When Lara logged in, she appeared in one of the games' many mostly faction-specific inns, common places to log out due to a buff they gave that let a player gain XP faster. Plus, being on an RP server, some players physically brought their avatars to a bedroll or cot at the inn to lie down before logging out. There were Alliance players in the Horde inn that Lara appeared in, which happened occasionally as players took a break from questing to harass players of or explore areas belonging to the opposite faction.]*

[05/01/05][21:45][Party] [Lara]: staring at me hatefully since they can't attack me. *[On our RP server, players had to "flag" their characters to engage in PvP. Enemy players could not target unflagged players.]*

Looking up, Hannah said, "He was a very valiant companion though..."

[05/01/05][21:45][Party] [Wilma]: ...What are you doing to Hannah?

"Never fled from a single beast I commanded him to attack. And for this reason he is now dead."

[05/01/05][21:45][Party] [Thoguht]: I said hi, but you know that can take forever with her.

[05/01/05][21:46] Jester is also dead.... it's not so bad! [*Another player running by saw our IC role-playing and decided to comment. I've called him "Jester" since I have no data on his character class.*]

Hannah glanced at Jester, the goofy intrusion to her and Thoguht's conversation noted, and wondered if the Forsaken corpse knew his jaw was hanging slack.

[05/01/05][21:46] Jester cackles maniacally at the situation.

Thoguht continued consoling Hannah, "Well, loyalty places him in the highest honor." He then gave Jester the evil eye and loudly remarked, "Those damned undead!"

Hannah sighed yet again, tongue licking her tusks as the undead man cackled then escaped.

"I was just discussing the subject of them with Leon. Do you know him? He's the orc I was talking with... a warlock though..."

"No, I do not... there are a lot of us... I am sorry if I interrupted."

"It's fine... My apologies for my mood... I set him off on accident with something I said..."

"Ah." Thoguht nodded thoughtfully.

Hannah lifted her chin and smiled, pale eyes gazing about the surrounding cliff walls of the Valley of Honor. She used to fear this place so much, but she was beginning to get used to Orgrimmar...

Thoguht, steering the topic back to the orphans, said, "Well, I suppose I should look into this adoption thing."

Almost immediately, Hannah replied, "They won't allow us to adopt... I already asked. I nearly got into a scuffle with the one in the dress over there." She pointed at Matron Battlewail with a snort.

"Oh?"

Large hands falling back down into her lap, Hannah continued, "I wanted a girl to adopt and she would have none of it. She dared challenge me on the matter, saying my armor was not appropriate... I didn't make this armor!"

"Well... ahem...," Thoguht yammered while trying not to stare.

Hannah then growled a bit, making eye contact with the pink-dressed Orphan Matron. Blah... Battlewail allowed her to be with the children, but not to have one as her own.

"They won't allow adoption, the children will be trained as grunts. 'Produce your own,' she told me."

Trying to understand Hannah's desire to be a permanent parent, Thoguht replied, "I see. Well, I honestly didn't know we had any children running about until today."

"The Warchief has kept them safely guarded... I had no idea either."

Hannah smiled a bit, full lips pulling into a rather pretty display upon her strong and lovely orc face.

"Imagine my joy when I thought I could adopt one. I wanted to train her to use a bow and speak with beasts...," she said with a chuckle.

"But instead, you get to babysit for a few days for free," Thoguht rationalized.

Hannah nodded and said, "Which... I don't mind."

Trying to further calculate the utility of taking care of an orphan for a day, Thoguht continued, "Well, I hear it's good politically."

Looking towards where the young boy took off, Hannah remarked, "Though I'm a bit worried about my charge... he seemed really eager about that imp that was skirting Leon."

Deciding that there was no rational reason to take on a charge, Thoguht finally said, "I say, let him learn the hard way. He should experience life and learn his own lessons." Perhaps Thoguht was bitter about his own hard life.

Changing topics, Hannah turned towards Thoguht again and asked, "Tell me... Thoguht... how is Hizouse? I've not seen him in such a long long time."

"Hizouse is good. He and his brother Hatfield are often fighting the Scarlet Crusade lately on the other continent."

"Yes well... I would not want him to become a crazed orc like Largahgl."

"Hmm, I do not know Largahgl, but I'll take your word for it."

[05/01/05][21:55] To [Hannah]: ((Hizouse and Hatfield might be quitting after this month)) [((Double parentheses)) were used by role players to mark OOC talk. I moved OOC talk to a private [whisper] channel.]

[05/01/05][21:56][Hannah] whispers: Yeah I know [real name] told me.

"Blah..."

[05/01/05][21:56] To [Hannah]: Ah, yeah they are seeing if Battlegrounds help.

Hannah smiled a bit, running a rough hand over the slick top of her head before chuckling. "I should be off... I didn't even get to say goodbye to Leon. He eluded me."

[05/01/05][21:56][Hannah] whispers: they need DSL is what they need.

"Alright, you take care. I am glad you are starting to like the big city."

[05/01/05][21:57] To [Hannah]: :)

[05/01/05][21:57][Hannah] whispers: IC weddings are freaking hilarious omg.

[05/01/05][21:57][Hannah] whispers: *reading Rosemary's post* [Hannah seemed to assume I had read the post under discussion, presumably on the WoW forums. On the contrary, I did not actually read the official forums much–not enough time to play, read guild and raid forums, consume other popular media, keeping up with the gaming Joneses... oh, and read and write papers for graduate school.]

Hannah nodded curtly, bright eyes flashing. Then she gave a low bow and said, "Lok'tar, Thoguht."
Thoguht replied, "Goodbye!"

[05/01/05][21:58][Hannah] whispers: lack of priests in PVP pisses me off.

[05/01/05][21:58] To [Hannah]: Yeah... isn't Hannah an alt of yours?

[05/01/05][21:59][Hannah] whispers: yes.

[05/01/05][21:59][Hannah] whispers: she's my horde main thoguh.

[05/01/05][21:59] To [Hannah]: Walt stopped playing to concentrate on a priest alt.

[05/01/05][21:59][Hannah] whispers: I'm starting a troll mage and I have a priest alt.

[05/01/05][22:00] To [Hannah]: If I see Hiz, I'll say hi to him for you.

[05/01/05][22:01][Hannah] whispers: thanks babe ^^

It is clear that different norms existed for different chat channels. Strict role-players recognized this and used private channels for non-RP talk. Additionally, this account shows how conversing in WoW was sometimes an act of "backwards talk" where players replied to another's previous utterance instead of the current one. This is because the nature of the chat is semi-asynchronous or syncopated even though players were online simultaneously. They could all be typing in responses, unaware of other new line(s) that were being typed.

Finally, as MacCallum-Stewart and Parsler (2008) point out, role-playing in WoW took a considerable amount of time and effort: "To the vast majority of *World of Warcraft* players a significant part of the game's appeal involves advancing their character, and role-playing does not facilitate this—indeed, it takes up valuable time and actually *slows* progression" (p. 227). Yet a player who chose to join an RP server and engaged in RP practice saw benefits in the collaborative construction of a persistent fantasy in which his or her character "transcend[ed] the mechanic of the game and [took] on a plausible, defined reality of its own" (p. 226). As described in the previous chapter, one of the common values for players in the raid group I studied was a desire to build on relationships through shared experience, but, by playing on an RP server, I could have been seeing an uncommon motivation for raiding. Many other players who raid (on non-RP servers) do it for character advancement and do not engage in role-playing practices.

In other words, my experiences on an RP server with The 7/10 Split MC raid group and my guild, the Booty Bay Anglers, where we valued the shared experience of co-constructing a persistent fantasy, could have been relatively rare in the whole landscape of WoW play. In fact, as will be described in Chapters 3 and 4, WoW play slowly evolved towards more narrowed views of what it meant to play, pushing players towards progression and loot. It may have been only a matter of time before my groups' values and larger normative ways of playing collided.

Assembling to Kill Ragnaros

In *World of Warcraft*, each individual actor in a raid group is in charge of certain tasks and responsibilities. At one point in the life of my raid group, a new actor was allowed into the group. The newbie served the players by rating the actions of the others in the group—that is, assigning a specified number value to their actions—and then remembering who did what to add up the ratings from each particular player. This newbie, though, did not actually care if these services were used by the others, and if a player decided to use them, thus having his or her rating displayed, that player had to abide by new rules associated with these new services. The newbie would not verbally announce others' ratings. Instead, a sign was held up and players had to make a point of looking over to read what their ratings were. In that way, the newbie did not only serve; it also demanded. It did not only take on the burdens assigned with this new role; it also prescribed new responsibilities on the others. Yet others in the raid group, first slowly then readily, came to adopt the use of these new services into their practice as the services' benefits became increasingly clear. The group came to consider the new tasks as essential parts of its raiding activity, and players could barely remember raiding without the rating-remembering services. The newbie became one of them—not a newbie but a veteran—and the group merrily went on its way. But this veteran was not one of them. In fact, it was not even human. It was a technological device, a program, a construct, an add-on modification to the game.

This chapter documents the enrollment of this nonhuman actor and its history within the raid group that I studied. The add-on was instrumental in helping the raid group become efficient and successful with many in-game battles. Interestingly, the add-on played only a temporary role in the raid group's assessment of the fight with Ragnaros, the last boss monster in the fiery cave system known as Molten Core. It helped the group by testing and ruling out a possible diagnosis of the problems with the group's strategy. After eliminating that possible diagnosis, its use was no longer necessary, since its original intended role never needed to be filled in the fight against Ragnaros.

The analysis in this chapter helps us see that, within a learning space or network, people and their material resources collectively share responsibilities, and that the distribution of these roles and responsibilities changes over time as the network encounters new challenges and as new actors enter the network. This is a story, in other words, of how unexpected events disrupted a network and of the reassembly and redistribution work done by the network's dynamic, adaptable actors to overcome those events.

Mangles, Networks, and Assemblages

In a nod to Pickering, Steinkuehler (2006) wrote a paper in the fledgling *Games and Culture*, titled "The Mangle of Play." In it she described the push-pull relationship game developers have with game players. The practice of gaming is an emergent one with multiple contentious parties attempting to steer what it means to play in certain directions, such that gaming is a complex arena of activity partially defined by its tensions—a mangle (Chen, DeVane, Grimes, Walter, & Wolfenstein, 2010). Pickering's mangle (1993) described the dialectic of resistance and accommodation that scientists engage in with the natural world, constantly tweaking their instruments and mental models of how the world works when existing measurements produce puzzling results. In other words, like the tension between gamers and game developers (and other parties in the mangle of play), scientists and nature push and pull at each other to form what scientific practice actually looks like. Both of these concepts about how gaming or scientific practice works come from a view of these practices as existing in specific settings and circumstances. They recognize that authentic practice "in the wilds" of science and gaming includes a multiplicity of parts or parties, acting separately yet collectively, so that collective roles and responsibilities that make the practice what it is are distributed across all of them.

I've lumped *parts* and *parties* together because these words mean the same thing within this way of looking at an activity system. The activity is composed of multiple objects or actors that act upon other actors, and the relationships between actors determine what the network of activity (i.e., practice) looks like. Applying this view to The 7/10 Split-led raid group, we can easily see how the group's members form a network, but less clear is that all of their resources, whether other people who aren't in the raid group but still contribute somehow or material things such as websites and add-ons, are also part of the network, and all of these parts within the network act and are acted upon.

Note that this possibly takes Hutchins's view of distributed cognition (1995a, 1995b) one step further, or at least makes more explicit the non-distinction between people and their material practice. In his descriptions of how a naval vessel navigates (1995a) and how an airplane cockpit remembers its speeds (1995b), the people in those activities offload many of their cognitive tasks onto their material resources, such as using pencil and paper to jot down numbers. Furthermore, these numbers are often put on display such that these external material resources are not only being used to help people remember certain things in the activity; they are also performing certain roles. The material resources are not only helping; they are also doing. This clarification flattens or equalizes the view of the various actors in the activity, making the distinction between whether an actor is human or nonhuman have little bearing on how specific tasks within an activity are accomplished. Think back to the example in Chapter 2 where Willy announced to the rest of the raid group that Molten Giants were incoming. All Willy did was hit a button; it was actually the CT Raid add-on that did most of the acting. Did the rest of the raiders respond to Willy? Or did they respond to the actions of the add-on?

Ian Bogost (2009) calls this line of thinking *object-oriented ontology*, where:

> Ontology is the philosophical study of existence. Object-oriented ontology ("OOO" for short) puts *things* at the center of this study. Its proponents contend that nothing has special status, but that everything exists equally—plumbers, cotton, bonobos, DVD players, and sandstone, for example. In contemporary thought, things are usually taken either as the aggregation of ever smaller bits (scientific naturalism) or as constructions of human behavior and society (social relativism). OOO steers a path between the two, drawing attention to things at all scales (from atoms to alpacas, bits to blinis), and pondering their nature and relations with one another as much with ourselves.

This is one of the main tenets of actor-network theory (ANT) (Latour, 1987, 2005; Callon, 1986; Law & Hassard, 1999). The roles and responsibilities within a network of activity are assumed by both human and nonhuman actors, or, in more precise language that forgoes the human / nonhuman distinction, the roles and responsibilities within a network are distributed across multiple actors. It should be noted that the various parts that can act and be acted upon are not necessarily objects or characters in the strict sense. Instead, known as *actants*, individual objects, a collection of objects, or parts of objects can be assembled to have one function that is related to or associated with other actants. Furthermore, these actants can be both material *and* semiotic; they can be the physical stuff in the mangle *and* the ideas, values, and structures involved in the mangle, such as those found to be

embodied or encapsulated in an organization or institution. For the purposes of this chapter, I will be referring to "actors" in the actor-network of raiding activity. In describing some of the "nodes" in the network, though, such as Blizzard Entertainment as an official group with certain values that force it to act, it may be more appropriate to use "actants."

A network stabilizes when all the actors within it are in agreement on how the responsibilities are distributed (Sismondo, 2004, p. 66). New actors—such as the new add-on my raid group adopted into its sociomaterial practice that I will describe shortly—are added to the network through a process of *translation* (i.e., getting the different parts of a network to agree on goals, values, and meanings). New actors are *enrolled* into assuming certain roles and responsibilities (and agree to let others take on the other roles and responsibilities that are needed for the activity to work). Think of the alignment work the MC raid group did after its unsuccessful night in Chapter 2. The players renegotiated and realigned group values the following day. This repair work could be thought of as "translation" work. When a person or book or whatever makes a convincing argument, he or she or it is translating the listeners / readers to a particular way of thinking. When they start to spread the word, when they even start to believe the argument, they have become enrolled into the argument's network. "At the end of the process, if it is successful, only voices speaking in unison will be heard" (Callon, 1986, p. 223).

So, my raid members agreed on their values and they agreed on their roles and responsibilities, but how can *nonhuman* actors *agree* to anything? One way of thinking about the kind of agency nonhuman actors have is by thinking of them as *delegates* for intentional work. Ultimately, a human designed and created the nonhuman to do something. In a way, as demonstrated in Latour's (1988) discussion of a door closer, both human and nonhuman actors take on the roles and responsibilities imbued onto them—transported to them so that they are transformed—by other actors.

Confused? Perhaps a better way of explaining the enrollment / translation process in ANT can be taken from positioning theory (Harré et al., 2009; Holland & Leander, 2004), which posits that people are both positioning themselves and being positioned by others into certain roles across their lifetimes of activity. If we expand the word "people" to the generic "actors," we can think of actors within a network as objects that are acted upon by other actors / objects; they are positioned into assuming certain roles and responsibilities. This is because as Sismondo (2004) says, "both humans and nonhumans have *interests* that need to be accommodated, and that can be

managed and used" (p. 65). Actors are, therefore, sometimes compelled into acting or agreeing yet are sometimes forced or positioned into agreement.

A network can become destabilized or disrupted when an actor rebels or when a new situation within the setting arises. This makes the previously stable system not sufficient to continue accomplishing its joint task. This necessitates a change in how roles and responsibilities are distributed if the network is to continue. Sometimes this is a matter of reassigning them. One example of this is when a timer add-on for my raid group became out of sync with our activity one night in early March. One of our human actors, Mandy, then took on the role of timekeeper and announced to the rest of us the time remaining until crucial moments of the fight with Ragnaros would occur (e.g., "1m30s," "1m," "30s"). Sometimes disruptions require a new actor to become enrolled into the network.

Again, how can a nonhuman rebel? Does that not imply agency? Is it not more appropriate to just say that the object broke or stopped working? To these questions, actor-network theory questions why intent matters. All that matters is what can be observed and the functional patterns of *relationships* between *things*, so ANT makes a point of this by using agentive language for both human and nonhumans. ANT and its ilk shine as ways of analyzing an activity system without assuming intent. Nicholas Taylor (2009) explained ANT very succinctly (pp. 99–100):

> Latour's project in elucidating actor-network theory is to propose an alternative social theory that preserves what he calls the "basic intuition" of conventional sociology: that humans are acted on by forces outside of their "local contexts" in which they go about their day to day lives. At the same time, actor-network theory resists explanations that reduce these forces to abstract theoretical constructs (Latour, 2005, p. 47). The task, instead, is to "trace associations" between and among assemblages of individuals, tools, and the material world, and to document the technologically- and institutionally-mediated relations that suture local contexts together across time and space (p. 65). In order to accomplish this task, Latour asserts, it is necessary to expand sociology's traditional notions around what kinds of entities can be considered as having agency. Instead of placing humans exclusively in the foreground of sociological accounts and relegating entire realms of material and technological objects to the context 'in which' humans act, Latour urges us to recognize the ways non-human objects act *upon* us, enabling, compelling, eliciting or demanding certain activities and practices while disabling, preventing or making difficult others (Latour, 2005, pp. 63–86).

What matters most is that certain objects / actors act and are acted upon. It's these relationships actors have with each other—process-based, time-dependent (due to the fact that something needs to be happening for the network to exist), dynamic relationships—that matter. Actor-network theory, as

a methodology, then, is about tracing these relationships (or associations) to make the network visible. By flattening the activity and treating all objects within it equally, OOO (and ANT) begins with evidence-based observations about the details of what's going on in a setting.

Flattening the setting allows T. L. Taylor (2009) to say, "we do not simply play but are played. We do not simply configure but are configured (Akrich 1995; Woolgar 1991)" (p. 6), emphasizing the fact that objects in a network exist in such a way as to be compelled to act or be acted upon. She calls these configurations assemblages, partially invoking Deleuze and Guattari (1987) who considered their *A Thousand Plateaus* to be rhizomatic, with the ability for the chapters to be read in any order, taking on multiple configurations or assemblages.

Open-ended and partially open-ended games, like WoW, are emblematic of the idea that any given player's history of activity is made up of a collection of unit operations—"modes of meaning-making that privilege discrete, disconnected actions" (Bogost, 2006, p. 3)—that form patterns of relations, arranged together into particular larger patterns, constrained by the game's underlying rule systems and the player's deepening understanding of those systems. A good gamer is someone who can recognize these patterns and understand the rules governing them well enough to exploit them to succeed in his or her in-game goals (Koster, 2004, pp. 14–34).

With a multiplayer game, many of these rules are tacit conditions of participating in a community of other players. As Malaby (2009) notes, the existence of rules about how to be or act is what makes online gaming spaces nontrivial (p. 87). They are contingent spaces where players build up cultural capital by performing or acting successfully. The more contingent an act—that is, the more risk involved—the more the act is meaningful and a marker of expertise. What Malaby says aligns very well with Lave and Wenger's (1991) ideas about how novices to a setting can go through a process of *legitimate peripheral participation* within a community of practice.

This process of learning the game, or, more precisely, learning legitimate gaming practice, occurs on multiple timescales. Much like Lemke's (2000) example of change in classroom practice, changes in gaming practice can be seen on multiple levels, ranging from scales that measure from month-to-month, showing relatively slow changes, to scales that measure from minute-to-minute, showing split-second decision making based on in-the-moment changes to a given gaming session's configuration. These split-second decisions and the experiences that result from these decisions have a way of narrowing-down and tightening-up future performance where players have learned what works and what doesn't work for particular patterns of arrangements. This

process is social in that players share their experiences with each other and make arguments about what they think is happening. It is also interdiscursive (Silverstein, 2005) in that players refer to previously shared experiences, sometimes from months ago, in an indexical fashion (e.g., "this part of this new boss fight is like this part from this other boss fight"), to help them manage and negotiate their dynamic roles.

Roles, Responsibilities, and Aggro

Each character in WoW fit into an archetypal role based off of historical precedent in the fantasy role-playing game and MMOG genres. In representation, characters were warriors, priests, rogues, etc., but for the purposes of the underlying game mechanics, these various hero classes could be roughly categorized into a function-based tripartite consisting of tank, healer, and DPS (shorthand for damage per second, a way of valuing damage dealers) (see Table 1). Each of these categories had specific duties and responsibilities to carry in a raid battle. Tanks, with their plentiful Health points and massive armor, had to keep the monsters occupied and focused on them while healers continually spent Mana points, casting spells to make sure the tanks stayed alive. DPS could then go about actually killing the monsters.

Each category of roles in the tripartite was therefore necessary to be filled for a raid group to be successful. Without tanks, the healers could not possibly cast spells fast enough to keep whoever was being attacked alive, and the monsters would kill everyone rather quickly. Without healers, the tanks would die, and the monsters would, again, chain-kill everyone. Without DPS, the healers would eventually run out of Mana, the tanks would die, and the monsters would ultimately kill everyone.

Table 1. Roles in *World of Warcraft* by Character Class (Horde-side, Spring 2006)

Role	Classes
Tank	*Warrior (defensive stance), Druid (bear form)*
Healer	*Priest, Shaman, Druid*
DPS	*Rogue, Warrior (non-defensive stance), Druid, Hunter, Mage, Warlock, Priest (shadow form), Shaman (elemental spec)*

The problem was that a monster generally attacked whomever it deemed the most threatening to its survival. If a DPS player hit a monster particularly hard or a healer healed too effectively, the monster could have taken notice and decide to hit back. As described in Chapter 2, whoever had the monster's attention was said to have aggro. Additionally, the monster switched targets when players "stole aggro" from others. Tanks could try to prevent this by activating various abilities meant to maintain aggro, while the DPS and healers tried to keep their performance at an even, consistent, predictable level without spikes that would make the monster take notice. In other words, many of the encounters in WoW, and indeed most MMOGs, were a balancing game where the three roles of the tripartite worked to maximize their efficiency while keeping the tanks the focus of the monsters' attention. The fights, therefore, were engineered by the game developers to test and destabilize the tripartite. This was a core dynamic that drove the mangle of play where players tested and retested the limits of their abilities based on models of how they thought fights worked—fights that were designed and redesigned by the developers to meet the changing practice of the players.

Each role in the tripartite (tank, healer, DPS) had specific responsibilities in a fight, yet healers and DPS could not "go nuts" with their abilities, spamming their most powerful ability over and over again. Rather, they were constrained by the need to make sure the tanks maintained aggro.

Threat Management

These games must obey some sort of algorithm, and, in this case, the way in which a monster decided who to attack was completely reactionary to the actions of the raid members. One way to think about how the underlying "brain" of the game calculated monster behavior is to imagine that it created a table that included a row for each raid member, and in each row was a number that started off at zero and increased a certain amount every time that particular raider activated an ability (see Table 2). The amount increased depended on the ability. This number was called the "threat level." One of the jobs of the raiders, then, was to make sure that the tank(s)'s threat level was higher than everyone else's.

When the raid group I was part of first started, we each had to internalize our threat level and "play it by ear," so to speak. There was no common resource or explicit knowledge of specific numbers associated with specific abilities. In fact, many of us did not really know that threat was based on a constant cumulative number. This is important to note: Many of us surmised

that threat was loosely based off of damage dealt, but we did not know that it was a cumulative count of all damage over the course of a fight, no matter how long that fight lasted. All we knew was that sometimes we would do too much damage and gain aggro. We knew from experience that some abilities generated more threat than others, and we had to weigh their costs against the benefits of the abilities. Very often, when a player died, it was because he or she stole aggro from the tank(s). That is, he or she misjudged how much threat was being generated and accidentally raised his or her threat to a higher level than the tank(s)'s threat level. If this happened enough times during an encounter, it usually ended up as a raid wipe.

Table 2. Hypothetical Threat Table

Time 1				
Player	Ability Activated	Threat Generated (hypothetical)	Existing Threat	Total Threat (hypothetical)
Wendy (tank)	Sunder	260	780	1040
Rand (DPS)	Sinister Strike	140	560	700
Shaun (healer)	L. Healing Wave	400	400	800
Mandy (DPS)	Frostbolt	500	0	500
Time 2				
Player	Ability Activated	Threat Generated (hypothetical)	Existing Threat	Total Threat (hypothetical)
Wendy (tank)	Sunder	260	1040	1300
Rand (DPS)	Sinister Strike	140	700	840
Shaun (healer)	L. Healing Wave	400	800	1200
Mandy (DPS)	Frostbolt	500	500	1000

Note: Hypothetical table at two different points in time (Time 1 and Time 2) that the underlying algorithm of the game created during a battle, keeping track of how threatening characters were to the monster being fought. Monsters attacked whoever had the highest threat, which was generated whenever players activated character abilities.

Looking at rogues in particular, since I know the game best from their point of view, I can say that, although we did not know exactly how much threat each of our abilities generated, a good rogue did know that certain abilities generated much more threat than others. We believed that these were roughly correlated to the damage output of the various abilities. For example, we knew that our main attack, Sinister Strike (SS), generated a consistent,

predictable amount of threat that was safe to use, whereas, Eviscerate generated much more threat since generally its damage output was much higher. Even though it did much more damage, the use of Eviscerate was limited by the fact that we could not use it as often as Sinister Strike.

Rogues operated on a mechanic of building up or chaining "main" attacks that enabled the activation of what are known as "finishing" moves. Sinister Strike was one of these main attacks that could be activated in a sort of rhythmic fashion every three seconds or so, building up a "combo point" with each successful hit. Rogues could build up to five combo points with these main attacks. Eviscerate was a finishing move that spent or used up the built-up combo points, and it did more damage with more combo points, giving rogues incentive to build up five combo points before using Eviscerate. Thus, Eviscerate was generally used less often than SS, in a more syncopated rhythm, but when it did get activated, it did more damage.

Going along with how many rogues, such as Roger, conceived of threat, if we were to graph the damage output of a rogue using SS and Eviscerate over time, we would see a baseline level of damage from SS and spikes in the graph every twenty seconds or so from Eviscerate (see Figure 4). As illustrated by the left-hand graph in Figure 4, this way of thinking about damage meant that threat was also a baseline that fluctuated over time. This threat model was closely related to DPS (damage per second), as a raider's DPS tended to be flat with fluctuations. If instead, threat was to be graphed as a by-product of total damage over the course of a fight, the graph we would see more closely matches the second one in Figure 4. Since we were conditioned to thinking about damage as a consistent value over time and not thinking about accumulated damage, many of us had the misconception that threat looked like the left-hand graph with periodic spikes whenever a hard-hitting ability was activated.

These spikes in threat generation were known as danger zones where we needed to be cautious and alert in case the mob aggroed on us. Roger was especially vocal about how the other rogues should manage their own aggro (e.g., "no bursting, bursting will get you aggro"). It was general consensus that for certain fights, especially with boss mobs, we shouldn't use Eviscerate at all. Instead we used Slice and Dice (SnD), a different finishing move that did not output damage in spike form. Rather, SnD made our non-activated attacks faster.

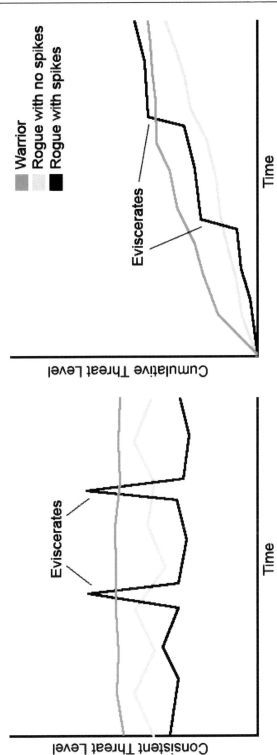

Figure 4: Two hypothetical charts showing different concepts about how threat worked in *World of Warcraft* created to illustrate this chapter's analysis. The chart on the left displays threat as a consistent level. Performing certain high-damaging abilities like a rogue's Eviscerate would cause a spike in the graph that would cause monsters to aggro since those spikes surpassed a warrior tank's threat level. The chart on the right displays threat as a cumulative value over the duration of a battle. Note that in this second view, the first spike is not enough to gain aggro.

Every character had a default attack that didn't require any input from the player. The level of damage from this default or "white damage" (so called because it was displayed in white in the in-game combat logs) attack from rogues was determined by the speed of how often a rogue swung his or her weapons, which was determined by the speed factor or attribute of each weapon, multiplied by how much damage the particular weapons could do with each hit. The resulting number was known as the weapons' damage per second or DPS, a term that, as mentioned earlier, had been co-opted as the name of the role rogues and other damage dealing classes assumed. So, the baseline in the graph in Figure 4 was actually a combination of the white damage plus the consistent damage from SS (a form of "yellow damage," the color of damage coming from activated abilities in the combat logs).

Slice and Dice temporarily sped up a rogue's default attack frequency, thereby raising the baseline damage by increasing white damage without adding spike yellow damage to the graph. Therefore, for many boss fights, the rogues would generally avoid using Eviscerate and instead use SnD because we did not want to have spiky damage graphs for fear of having spiky threat graphs.

The concept of threat was present, yet it was not fully understood, so using SnD was not strictly adhered to by all rogue players. This was especially true while we were learning new boss fights. To succeed, we frequently had to push the limits and continuously ride on the edge of too much damage / threat. If we were not on the edge of our ability, like an Olympic skier, then we were under performing, which could lead to a raid wipe if the raid healers were going to run out of Mana trying to maintain our current (s)low DPS. Yet, like all the Olympic skiers who wipe out, which happens quite frequently, we were always in danger of going over the edge or pushing too hard.

The first few times we encountered a new fight, raid wipes were expected. This allowed us to learn what mechanics were involved with the new monsters and gave us time to reflect on our performance (similar to the reflection Meep did in the "Pugging" interlude and the reflection the raid group did described in Chapter 2). Just like the aforementioned skier, who when learning a course for the first time would need to adjust speed when first attempts were too fast or too slow, our first attempts at a fight allowed us to test the limits of how much damage or threat we could generate. This is not to say that failure was always welcome, though. Even though early wipes were seen as learning opportunities, it was frustrating to wipe over and over again in the same game session.

All this led up to our fight with the last boss in Molten Core, Ragnaros. When we first encountered him, it was generally agreed upon by the rogues in

the raid that we should stick with using SnD to maintain a consistent, predictable level of threat. While we were learning the fight, however, something completely new changed raiding in *World of Warcraft* forever.

KLH Threat Meter (KTM)

About four months into our raid's life, in March of 2006, we started using a new add-on called "KLH Threat Meter" or "KTM." Created by a player named Kenco, KTM did the work of keeping track of which abilities a particular player used while fighting a monster, how much threat those abilities generated, and then visually displayed that information to that player. What's more, any instance of KTM could talk to other instances of KTM installed on other people's machines and thereby aggregate all of the threat data for all players who had the add-on installed, displaying relational charts of everyone's threat level to each player (see Figure 5). This allowed the offloading of human cognition to a nonhuman resource, effectively eliminating much of the guesswork that went into *World of Warcraft* threat mechanics.

Before the add-on, my raid group had progressed to the last boss in Molten Core. The write-up about our practice found in Chapter 2 describes how our chat was multi-threaded and interleaved, hierarchical and specialized, roughly divided by class role. Among many other things, one thing this configuration allowed us to do was to be highly coordinated in our tactical takedown of a raid boss. By the time KTM was introduced, we had become quite proficient in dividing up our attentional resources and communicating along certain channels, escalating which channels were in use when necessary. After KTM became the standard, the necessity of using those chat channels was not as acute as before. Suddenly, any player of any class could keep track of the threat generated of all the other players.

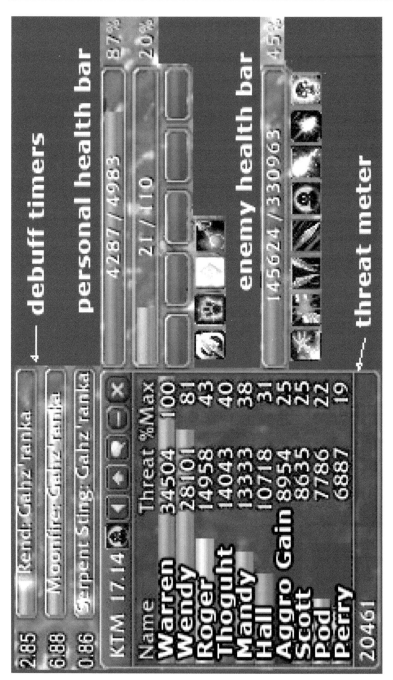

Figure 5: A section of my user interface during a raid battle, showing various add-ons in use. KLH Threat Meter (KTM) can be seen on the left side, displaying the top ten current threat levels of various members of the raid group. Warren and Wendy, at the top, are the main tanks for the group. Roger, Thoguht, Mandy, and Hall are all damage dealers (DPSers). Their threat level is nowhere near the tanks', thus they can up their damage output without fear of drawing aggro.

Not only did the add-on help us with our cognition, its use also changed who communicated with whom and about what, most notably allowing raid leaders to caution specific raiders about their threat generation. For example, before the MC raid group started using KTM, it was common for Maxwell to include warnings about aggro in his fight briefings (e.g., "melee, watch your aggro" on March 10). After mid-April, he no longer warned the raid or parts of the raid as a group to watch for aggro, instead calling out specific players *during* a fight when they got too much threat (e.g., "Roger!"). This effectively substituted knowledge-based trust in others with a technological advancement where trust or faith in other players' ability to manage their threat didn't matter. Yet, at the same time, KTM let us be much more efficient in our monster killing. We could ride the moguls much more effectively, thereby taking down monsters faster than we had been before, which also lowered the learning curve associated with new encounters.

Kenco was one of the early theorycrafters for *World of Warcraft*. In January 2006, he posted to the WoW European web forums that he thought it was possible to run a number of in-game tests, systematically accounting for different variables, to uncover how WoW calculated threat. (Kenco's archived post can be found on WoWWiki at http://www.wowwiki.com/Kenco's_research_on_threat) At the time of his posting, in fact, he had run several of these simulations, and he proceeded to discuss his findings, dispelling quite a few myths about threat generation. This was counter to the general thought that exact threat mechanics were forever going to be hidden from the player community. An excerpt:

> It's often said that we will never be able to work out the way threat and hate lists and mobs' AI works, because it's too complicated and unknowable, that we'll only ever have crude approximations and guesses. I've conducted some decent, rigorous tests, and i have what i believe is a good list of hate values and explanations of gaining and losing aggro and the behaviour of taunt. I am also able to debunk a few myths about how threat works.

After carefully describing his major findings, he gave a list of suggestions for strategies to use in future fights and then ended his post with this:

> There's no amazing super secret randomised blizzard aggro algorithm. The concepts are simple and the values can be fitted with nice numbers. Even formulas for threat-reducing knockbacks can conceivably be worked out, if threat values are carefully monitored.

In February, players started testing out Kenco's first stabs at a threat meter add-on, and on March 1, 2006 (according to Curse's records), he released the

first public version of KTM to Curse.com, a website devoted to hosting a *World of Warcraft* add-on repository.

In the years since then, theorycrafting became common practice, probably most popularized by the site Elitist Jerks (http://elitistjerks.com/), where class-based discussion boards devoted to damage and threat calculations feature players using sophisticated spreadsheets and custom tools to model and number-crunch every known in-game variable. Figuring out threat and then exposing the underlying model to all players via the add-on became so successful and so widely adopted into common raiding practice that for a few years Blizzard Entertainment designed new raid encounters to depend even more on players' ability to manage their threat and aggro levels. Blizzard Entertainment also made changes to the default user interface to include many of the tools the add-on community had created such as showing whom monsters were targeting at any given moment and making threat gains transparent. The game designers, in other words (as a coherent actant), became enrolled into the network, compelled to change the basic game and forced to agree with the player community.

Soon after my raid group started using KTM, a new in-game practice came about. The raid began using the threat meter as a metric for performance and efficiency monitoring. If DPSers were nowhere close to generating as much threat as the tanks, for example, they knew they could "lay down the smack" without fear of gaining aggro and therefore be more efficient with their fights. The damage meter, a precursor to the threat meter add-on, already existed for at least half a year, but it was not widely adopted into raiding practice. The damage meter kept track of the damage output of various players, which was easily calculable since WoW explicitly let players know how much damage each of their successful hits did. All Kenco did was figure out the hidden (but, again, very correlated) threat values of those abilities and include threat generation from non-damaging abilities. Saying "all" implies it was an easy task. It was not necessarily difficult but running the simulations involved in figuring out the correct numbers must have been time consuming.

Using KTM for its designed role—letting it assume its delegated responsibilities—to keep track of threat, I was able to monitor my threat gain against the diminishing Health bar of the monster we were fighting and determine whether it was safe to go "b2twdps" (balls to the walls DPS) or if I should hold back a little. The actual decision depended in part on how much DPS the monster could do to me if I gained aggro. Gaining aggro was fine so long as the raid could kill the monster before it killed me, which is why I needed to estimate how long the monster could survive given our current performance.

If I was generating threat too fast, where I would gain aggro long before we could kill the monster, I needed to hold back. The most common way for most players to reduce threat generation is to simply stop attacking. Everyone else would continue to generate threat so an individual player would become less threatening in the meter. Some character classes, like rogues, have abilities that reduce threat (Feint) or erase threat level completely (Vanish).

To add to this, rogues have an ability called Evasion that makes it harder for opponents to hit them. If I gained aggro purposefully or unavoidably—for example, when the tanks died—sometimes instead of hitting Vanish to clear my threat, causing the monster to go after someone else, I would hit Evasion since I knew the next person in line on the threat meter was not a tank either. When it caused us to avoid a wipe, this move was generally appreciated by the rest of the raid with words of cheer: "evasion tanking, ftw!"

Managing threat, relying on the tripartite class roles, was the paradigm for how fights worked in most fantasy MMOGs. There were variations to the fights, however, such as presenting players with multiple monsters to fight at once, necessitating the use of multiple tanks or the use of crowd control (CC) abilities like the mage's Sheep spell, which temporarily takes a monster out of the fight by turning it into a small, white sheep. Blizzard Entertainment, to their credit, has been relatively creative in trying to alter or escape from this paradigm. It seemed like with each new encounter, especially with the raid locations from the second expansion, *Wrath of the Lich King*, the game developers asked themselves, "how can we nuance the paradigm and change things up a bit so that players have to adapt quickly, adjusting to different dynamics that they aren't expecting?"

Even before the threat meter existed, though, Blizzard Entertainment was already designing encounters that tested out different ways to alter threat mechanics—the developers were attempting to steer the mangle of play towards tightly scripted encounters that depended on player positions as well as threat. One example is the Ragnaros fight (which I'll cover in more detail soon) that my raid was learning when KTM came out, in which Ragnaros would Knockback all melee characters and then throw fireballs at random ranged players. This specific mechanic was unexpected, and what I find most interesting is not how KTM became incorporated into our practice but how it played a temporary role in helping us diagnose problems we were having with the fight. In other words, for the encounter with Ragnaros, KTM's instrumental role was not, in fact, its designed role. (Users adopting new technologies in ways that were not originally intended by the designers is a story that is played over and over again (cf. Oudshoorn & Pinch, 2003).) Instead, once the problems of our tactics were fixed, we practically didn't need

to use KTM during the fight at all, since we discovered that keeping track of threat in that fight was unnecessary.

Using KTM as a Temporary Actor to Kill Ragnaros:

April 28, 2006

Figuring out how KTM was enrolled into our system is an exercise of inferences due to the nature of my data collection and how multi-layered the game-playing experience was. For one thing, there's the normal problem of human existence as being isolated yet communal. On that layer, I existed as an individual within a physical setting, interpreting things through my eyes, attempting to understand the meaning-making of other participants through shared experience. The fact that everyone sees things differently is something ethnographers in general always have to grapple with.

Yet participating in an online space forced me to see things with an additional mediated lens or layer. My screen was both a window to the world but also a surface with a head's up display (HUD). These 2D unit frames that gave me an augmented view of the 3D space were only available to me, just as another player's HUD was only available to that other player. The shared experience occurred in the 3D physicality of the virtual space while the Health bars, minimap, action bars, etc. were all extra-diegetic elements to my experience—that is, elements that were not part of the fantasy world within the frame of the game but instead came from outside of the frame to add to the experience of engaging with the media.

As a shared tool, each player used an instantiated version of KTM. We trusted that we were all seeing the same chart values, but each player had control over the add-on's size, location, and KTM specific settings such as the number of raiders to display in the chart, the colors to use for each character type, whether to show cumulative values on the meters or difference values between raiders' current threat level, etc.

KTM's adoption into our network of raiding practice was a slow process and spanned several weeks across multiple raid zones and groups. It was difficult to understand KTM's usefulness without seeing it in action, and, even then, the demonstration would only be convincing if a critical mass of people were using it. At first, Warren, our main tank, learned about it through the *World of Warcraft* forums and add-on communities, but it was still in beta, so many of the raiders did not feel comfortable installing it. In other words, the

micro-network made up of this nonhuman actor and its enrolled human players could not yet translate the larger network into adopting it. The first time KTM appears in chat logs is not when the MC group first started using it in earnest but when Warren and I were just testing it out. At the time, Warren was still a member of the Booty Bay Anglers. He would later join The 7/10 Split to gain access to more raid activities. Our testing occurred on February 23, 2006, while we were just killing random monsters outside:

2/23 19:24:03.218 [Party] Thoguht: works great!

2/23 19:24:05.046 [Party] Warren: hehe it works

2/23 19:24:12.046 [Guild] Warren: Threat Meter WORKS! *[Warren was so impressed, that he announced it to the other Booty Bay Anglers who were online at the time.]*

2/23 19:24:14.125 [Party] Thoguht: feint works and all

2/23 19:24:25.843 [Guild] Hizouse: Good to hear.

2/23 19:24:34.406 [Party] Thoguht: super easy for me to tell if I will get more aggro than you now sweet

2/23 19:24:41.046 [Party] Warren: yah this rocks

2/23 19:24:48.578 [Guild] Warren: but everyone needs it

2/23 19:24:59.937 [Guild] Thoguht: well, everyone who cares... :) I do!

2/23 19:25:35.781 [Party] Thoguht: useful to non MTs like me for personal reasons... not as useful to you unless everyone gets it

2/23 19:25:46.234 [Party] Warren: yah I dig this

The next day, however, we did not introduce KTM to the MC raid group. Perhaps we thought there was too much inertia and not enough time to introduce a new add-on to 40 people from different guilds. On February 25, the two of us were in the Ruins of Ahn'Qiraj (AQ20), a 20-person zone located in the arid deserts of Silithus, with a sub-group from the main MC raid. While we were encountering a boss named Kurinnaxx and hearing the description on how to kill it, I mentioned that "threat meter would come in handy here." Wallace, another warrior from The 7/10 Split, agreed, indicating that at least one other raider was starting to hear about this new add-on and what it could do.

In other words, KTM was first mentioned to a subset of larger raid group in a different raid zone than Molten Core. The next day, February 26, 2006, two rogues had decided to test out KTM's usefulness with our fight in yet

another raid zone. It was during our encounter with Onyxia, a massive black dragon, protective broodmother to many whelps, sister to the Black Dragonflight faction leader Nefarian, and serious business (that required many dots). Though the rogues had KTM installed, without any tanks or healers having also installed it—for some reason, Warren had it turned off—the threat meter was not of much use, since it was only able to show threat generation from the two rogues. The lack of uptake at this point may have been because the raid group had already successfully killed Onyxia in the two prior weeks. Onyxia was effectively on farm status. Since it was pointless to be the only players with KTM, we uninstalled the add-on.

After the add-on was officially released on Curse.com on March 1, 2006, another attempt at getting people to try it happened on March 8, when four of us had it installed for our MC run. Still, there were not enough instances of KTM to be useful, but we could see how including the add-on to our network of activity would be useful for fights we were still struggling with. During the following month, most of the MC raid group would install KTM (see Table 3). By April 2, 2006, starting with our fight with Onyxia—because in the previous week we actually suffered from some aggro problems with her—most of us were using KTM, and it was generally assumed that everyone was using it. This is implicit in a statement made by Marcie during that evening's session:

> 4/2 18:15:37.000 : [Raid] Maureen: ((For the KLH threat, do I just need to have it loaded or do I need to set anything up?))

> 4/2 18:15:51.781 : [Raid] Warren: just type /ktm raid show

> 4/2 18:15:58.687 : [Raid] Wendy: ((just loaded to send us info, but if you want to see it, then you should show it))

> 4/2 18:16:30.812 : [Raid] Maxwell: test

> 4/2 18:16:41.984 : [Raid] Marcie: ((apparently a new one came out yesterday, so we all need to get it for laters))

By late April, most of the raid group had incorporated KTM into its network of raiding, and it proved instrumental in helping us diagnose problems the group was having with the fight with Ragnaros.

Table 3. History of Raiding Activity with Regular Raid Group and Separate
Guild Group

Wk	Date	Zone	Boss Wall	Notes
1	10/19/2005	MC		First time regular raid group in Molten Core (MC)
	10/21/2005	MC	Gehennas, 29%	First time Thoguht got in MC with regular raid group
2	10/26/2005	MC		Second time Thoguht in MC, maybe a regular now
	10/28/2005	MC	Baron Geddon	
3	11/2/2005	MC		
	11/4/2005	MC	Baron Geddon	
4	11/9/2005	MC		
	11/11/2005	MC	Baron Geddon	
5	11/16/2005	MC		
	11/18/2005	MC	Golemagg	Baron Geddon down! Shazzrah down!
6	11/23/2005	MC		
	11/25/2005	MC	Golemagg	Thanksgiving weekend
7	11/30/2005	MC		
	12/2/2005	MC	Baron Geddon	Raid ended after Garr
8	12/7/2005	MC		
	12/9/2005	MC	Garr	Only had one warlock = death with Garr
9	12/14/2005	MC		First madrogues usage
	12/16/2005	MC	Baron Geddon	Raid ended after Garr
10	12/21/2005	MC	Golemagg	
11	1/4/2006	MC		
	1/6/2006	MC	Golemagg	
	1/8/2006	Ony	Onyxia	First time in Onyxia's Lair (Ony) with raid group
12	1/11/2006	MC		
	1/13/2006	MC	Domo	First Majordomo Executus (Domo) encounter
	1/15/2006	Ony	Onyxia	
13	1/18/2006	MC		
	1/20/2006	MC	Domo	
	1/22/2006	Ony	Onyxia	
14	1/25/2006	MC		
	1/27/2006	MC	Domo	
	1/29/2006	Ony	Onyxia	

Continued on next page

Table 3 (Continued)

15	2/1/2006	MC		
	2/3/2006	MC	Domo	Raid ended after Golemagg
	2/5/2006	Ony	Onyxia	
16	2/8/2006	MC		
	2/10/2006	MC	Rags	First Domo kill, first Ragnaros (Rags) encounter; not serious
	2/12/2006	Ony		First Onyxia kill
17	2/15/2006	MC		
	2/17/2006	MC	Rags	Not a serious attempt at Rags
	2/19/2006	Ony		Onyxia on farm status
18	2/22/2006	MC		
	2/24/2006	MC	Rags	First serious attempt at killing Rags
	2/23/2006	na		KTM testing with Warren
	2/25/2006	AQ20		First time in Ruins of Ahn'Qiraj with raid group, KTM mentioned to raid
	2/26/2006	Ony		First use of KTM in Onyxia by Rand and Thoguht
19	3/1/2006	MC		
	3/3/2006	MC		First use of KTM in MC, only Thoguht
	3/5/2006	Ony		Stopped using KTM
20	3/6/2006	ZG		First time in Zul'Gurub with the Booty Bay Anglers; didn't use KTM
	3/8/2006	MC		First use of KTM in MC by Rebecca, Rand, Thoguht, and Pliance
	3/10/2006	MC		
	3/12/2006	Ony		
21	3/15/2006	MC		
	3/17/2006	MC		
	3/19/2006	Ony		
22	3/20/2006	ZG		Anglers ZG with no KTM
	3/22/2006	MC		
	3/24/2006	MC		
	3/26/2006	Ony		
23	3/27/2006	ZG		Anglers ZG with no KTM
	3/29/2006	MC		
	3/31/2006	MC	Rags	Ragnaros fight wouldn't reset properly.
	4/2/2006	Ony		Tanks, raid leaders, and some others using KTM regularly.

Continued on next page.

Table 3 (Continued)

24	4/3/2006	ZG		Anglers ZG with no KTM
	4/5/2006	MC		
	4/7/2006	MC	Rags	KTM part of standard practice now
	4/9/2006	Ony		
25	4/10/2006	ZG		Anglers ZG with no KTM
	4/12/2006	MC		
	4/14/2006	MC	Rags	Ragnaros fight buggy
	4/16/2006	Ony		
26	4/17/2006	ZG	Panther	First use of KTM in ZG with Anglers
	4/19/2006	MC		
	4/21/2006	MC		
	4/23/2006	Ony		
27	4/24/2006	ZG	Raptor	
	4/26/2006	MC		
	4/28/2006	MC	Rags	Diagnose rogues' aggro problem with KTM
	4/30/2006	Ony		
28	5/1/2006	ZG		Panther down!
	5/3/2006	MC		
	5/5/2006	MC		Wendy leaves raid
	5/7/2006	Ony		
29	5/8/2006	ZG		
	5/10/2006	MC		
	5/12/2006	MC		No data, but first Ragnaros kill
	5/14/2006	Ony		
30	5/15/2006	ZG		
	5/17/2006	MC		
	5/19/2006	MC		Ragnaros killed on 3rd attempt
	5/21/2006	Ony		

Note: The "Boss Wall" column details which boss we were attempting to kill that night. If none is listed, the raid was not attempting a new boss and ended after routine fights. The "Notes" column displays significant moments when a boss was killed for the first time and/or when the groups started using KTM. Raiding activity ramped up over thirty weeks, starting from two nights a week and ending at four nights a week by the time the regular group completed Molten Core.

Presented next is a description of the Ragnaros encounter and how the raid group used KTM to diagnose a problem the raid was having with the fight on April 28, 2006.

The fight with Ragnaros had two phases to it. In the first phase, he emerged from a pool of lava in the center of the cavern chamber and engaged in melee combat against those close to him while throwing fireballs at raiders who were at range. In phase two, he hid under the lava surface and sent eight of his Sons of Flame to battle us instead. This process was repeated until either he died or killed all of the raiders. Here's a more detailed summary of how the fight worked and the strategic moves of my particular raid group (see Figure 6):

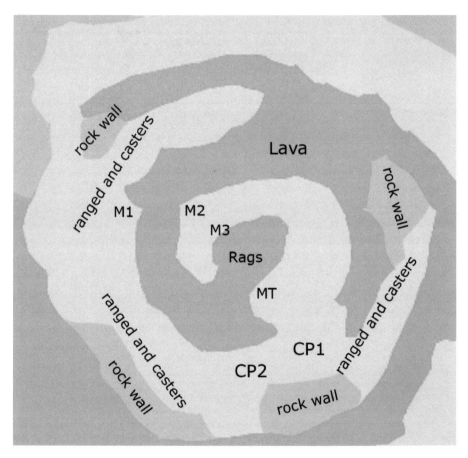

Figure 6. Overhead map of Ragnaros's chamber in Molten Core, a fiery cave system in *World of Warcraft*, detailing the positions of players during the fight with Ragnaros. M1, M2, and M3 are melee positions. MT is where the main tanks stand. CP1 and CP2 are the collapse points for the players during Phase 2 of the Ragnaros fight.

1. This happens for about two and half minutes when the raid leader calls for ranged and casters to collapse to a common point (CP1), followed by the melee collapsing at the same point.
2. At the 3-minute mark, Ragnaros submerges himself back into the lava and summons eight Sons of Flame who rush the raid group and start attacking.
3. The melee grab aggro from the Sons and then the ranged and casters run to a different point (known in the raid as the Caster Pit [CP2]). This is because the Sons do AoE damage and Mana burn.
4. Some of the Sons get banished by our warlocks, just to help limit the number we have to handle initially to a manageable level.
5. We focus fire and kill all the Sons in methodical order.
6. Rags reemerges and we go back to our phase 1 positions.
7. Rinse and repeat until Rags is dead.

Some of us knew how the fight was supposed to work from reading online strategy guides about it. Actually, unlike the practice for many mature "hardcore" raids, only a few of us had read the guides; the rest of us depended on the raid leader to summarize the fight for us (Walter & Chen, 2009). Partially this was because some players didn't want "spoilers" while solving the fight's puzzle. Reading and hearing about the fight did not directly translate into successfully enacting the fight, though. It took embodied knowledge—visceral, physical, rhythmic knowledge—coordinated knowledge developed through gaming. In fact, the word "knowledge" seems an odd way of describing it. Saying, "I know how the fight works" doesn't seem like enough. I know how the fight feels. I've felt how the fight works. To gain this type of knowledge required practice. It took time to get a sense of the groove—the rhythm of well-coordinated action—we needed to be in. To illustrate this, here's an excerpt from one of my fight synopses using Rogoff et al.'s (2002) first step in functional pattern analysis as a model for descriptive summaries of events:

> A lot of information floods my senses once the fight starts. Both visual and audio indicators come at me. Furthermore, these are both diegetic (such as the animation of all of us swinging our weapons or the grunt of my character as he attacks) and non-diegetic (such as various panels and buttons on my screen representing the game's UI or the various alert sounds coming from our installed add-ons).
>
> Some of this info: The "Bong" sound from our CT Raid add-on that happens in sync with the words "AE Knockback" appearing in the center of my screen. The raid leader's "Melee attack!" command issued in several text channels, also facilitated by CT Raid. SCT (another add-on) sending a constant stream of text up as I gain energy,

take damage, activate abilities, etc. My custom timer bars popping up (from yet another add-on) letting me know how long dots and other effects last. KTM, the threat meter add-on, keeping track of all our threat levels. Custom UI enhancements (yep; add-on) showing me the Health and Mana of the whole raid, showing me my Health and energy gain and CP build-up, Ragnaros's Health and all of our buffs / debuffs. Specific windows showing MTs (CT Raid) and their targets. The screen flashes with lava bursts and waves every once in a while. The "snick snick whoosh" of Sinister Strike and a miss. The sound effects of other abilities including those of the raiders around me. When I mistimed something, my character, Thoguht, saying "not enough energy." The sharper "ding" sound of incoming Knockback and the melee DPS backing up as a group to our corner of the spiral peninsula. After the next "Bong," rushing back in with the group.

A semi-regular sequence of indicators and my reactions to them emerges from the chaos bracketed by the Bongs of Knockback. The first time we fought Ragnaros, this pattern was noisy, but this night it is getting refined and less noisy. A month from this night, the pattern starts to stabilize, and I start to feel a rhythm to the fight. SS, SnD, SS, SS, SS, Feint, SS, SnD, ad infinitum. Sometimes an Eviscerate thrown in there if SnD hasn't expired. This goes on until the "ding." Move back. "Bong." Move forward. SS, SnD, SS, SS, SS, Feint... Rinse and repeat. In forums, other players have used another way of visualizing the actions rogues take, referencing the keyboard buttons needed for the actions: 2422262242262223 repeated.

But in this particular iteration of the fight, we don't yet know the pattern, haven't yet found our groove or gotten into the flow.

There's an addictive quality to this embodied knowledge once the groove is found and enacted / experienced time and time again, though I would hesitate to call it "addiction" from the media effects standpoint: It is not a sinister, time-sinking, life-destroying activity. Instead, the knowledge is so much a part of me now that I can slip into reenacting the activity very easily, using what Norman (1993) calls _experiential cognition_—a form of automated or routine thinking and acting made possible through expert knowledge— something that may be more important with self-taught expertise. The physicality of my thinking-acting gives support to the idea that cognition is situated and cannot be separated from the body (Wilson, 2002). Moreover, I long for it; it sustains me. It has become part of who I am. My identity depends on this cultural knowing of what it feels like to be raiding in Molten Core. But rather than taking away from my life, it enriches my life. My identity is built up in layers that are semi-transparent such that underlying layers are still visible and a part of the whole—what Holland and Leander (2004) call laminated—by all my gaming experiences through a lifetime of _being_. Through gaming, I know nostalgia and melancholy, joy and triumph, success and failure, sadness and anger, and the physical, inexplicable-through-words, embodied, muscular-impulse knowledge of specific game-playing activities.

Gravitating towards these activities is only addiction in the sense that people are compelled to engage in the activities that define who they are—activities that build up cultural capital by taking place in contingent spaces and that are born out of bone-deep understandings of being in the world.

Gamers bring our cultural-practice-informed identities, both laminated through other gaming experiences and non-gaming experiences, to new play spaces, as Andrew at Little Bo Beep (2010) says

> When we play a game, no matter how ornate or simple, we are automatically imbricating it with layers of personal meaning and inherited signification. The game occurs therefore in a non-linear sequence of events that extends back to the beginning of our lives, and even beyond that to the earliest inception of consciousness.
>
>
>
> We are who we are in the becoming of ourselves. By engaging with the world and its manifold variations we are simultaneously defining who we are. Games contribute to this definition in more ways than I can describe.

This is true of everyone. Everyone engages in activities in everyday life that is locally meaningful. People care about their pursuits that are consequential to their cultural identities and positions in the world. People's identities—people's activities—can be beautifully, sometimes exquisitely, complex, such that to call any of it addiction without deeply examining the meaning behind the actual practices, actions, and relationships in people's lives shortchanges them as humans. Obviously some people spend a lot of time with games and gaming, but that does not necessarily pose a danger to their offscreen / nongaming lives nor are their gaming activities meaningless. For my participants, these activities gave them the feeling of achievement, strong camaraderie and friendships, success in a contingent space, and deep bliss in finding the groove of raiding.

Unfortunately, for this particular night of raiding, the rogues had not yet experienced the embodied groove of making the fight routine. We knew what was supposed to happen in the Ragnaros fight. Yet, for some reason, we kept dying. Ragnaros would, once in a while, focus his attention on one of us and hit us. This resulted in almost instantaneous death ("insta-death") for a rogue.

Naturally, we thought that our dying meant we had an aggro problem, leading Roger to tell the other rogues how to play:

> this is a steady high dps fight, no bursting, bursting will get you aggro, in my experiance, anything over 1000 gets rags to say hi to ya unless you are feint everytime its up, and a split second after your burst.

It seems like Roger believed, however, that threat was not an additive measure and that gaining aggro was simply a matter of moment-to-moment damage output (see Figure 4). If damage output was ever too high in a particular instant in time (e.g., over 1000), aggro would be gained. This goes against the tests done by Kenco that resulted in his relatively accurate threat meter—accurate because it treated threat as a persistent, cumulative number representing the sum of all threat generated with all abilities used during a particular fight.

Since I had the threat meter add-on installed, I had an idea that it wasn't our threat generation that was the problem. Yet my personal understanding of how threat and aggro were calculated was still forming, so I could not recognize Roger's misconception. Also, all I knew was that *some* of our threat levels were nowhere near the tanks' levels, but since not all of the rogues had installed the add-on at that point, I could not say for sure if it was true for all rogues. So when the shaman in our party mentioned that he could buff us with a totem that reduced our threat generation, I suggested to the rogues that I thought we could do more sustained damage if we didn't have to use Feint, which used up our valuable Energy that our main attacks also used. Roger, unfortunately, misunderstood me. Unfortunate because he had a tendency to be curt and had little patience for others who disagreed with him. Thinking that I was complaining about not being able to skillfully and efficiently activate my abilities, his reply was, "well, lern2manage ?"

After our second attempt at killing Ragnaros for the evening, Rand said, "I got aggro on that one. Not sure how, was using the same technique as last time." To this, I replied

> so, I have threatmeter on... noticed I wasnt very high up and did a cold blood evis just fine. I strongly suggest you get the mod... so you can judge how good you are on aggro

This response was further indication that I could not say for sure that Rand did not have a threat level problem, but I did confirm that aggro was not gained simply by doing burst damage. It is interesting to note that, at this point, I had already enrolled KTM into my personal actor-network, placing my whole trust into this nonhuman actor for certain responsibilities. I knew that my previous practice of keeping the *feeling* of threat in my head was inexact, and I assumed that this blackbox of a tool could do it better than me. KTM, in turn, gave me permission to push the limits of DPS, and it also let me enroll it as evidence for why threat wasn't the rogues' problem.

During our third attempt for the evening, Roger himself gained aggro and died after the first Knockback event, responding to the other rogues with, "lol.

he must dump most agg at Knockback. i think i got to him quicker then the tanks." He assumed that Ragnaros reset his threat table when Knockback occurred, thus getting to Ragnaros before a tank meant it would have been easy for a rogue to generate more threat than a tank since he or she had more time to generate threat.

Eventually, on our fourth attempt, it became clear that the rogues were pulling aggro even though they were nowhere near the threat level as the tanks. This was demonstrated when Roger again died after the first Knockback. When Roger used the general [Raid] channel (instead of just commenting to the private rogue channel) to say, "i hit him once. that made no sense," the raid leader, Maxwell, replied with

> Roger, they [the tanks] may have been out of position for just a second which is enough for anyone else to get aggro who is in melee range.

Elevating his talk to the larger chat channel elicited new information from Maxwell that further helped the rogues to diagnose our aggro problems. Maxwell was correct. Ragnaros attacked whoever had the highest threat within melee range, and the reason why rogues were being killed was because they were running into position and getting within Ragnaros's melee range before any tanks had gotten in range. Roger's (and the other rogues') misconception was not quite dispelled, yet, though, as Roger replied with

> wtf. i didnt even hit him, it was a miss. lol. "Your sinister strike misses Ragnaros"

This indicates that Roger was still working under the assumption that threat by way of damage level had something to do with why he was hit by Ragnaros when all that mattered was that he was in range when no one else was.

By the end of this gaming session, the rogues *almost* realized that Ragnaros hit whoever had the most threat *within range*. This new information from Maxwell added to the information that I presented to the other rogues in the previous fight from the threat meter add-on. By the time we fought Ragnaros again the following month, we had put it all together and delayed our approach to Ragnaros after a Knockback so that a tank got within melee range first.

By using KTM to see that our threat level wasn't high enough to theoretically pull aggro, we had to think of other possible reasons why we were being targeted for attack by Ragnaros. Thus, KTM played a role as a temporary actor within this raid encounter. We only used KTM to diagnose problems, not to actually alert us of threat level dangers throughout the fight. Once we figured out that threat wasn't the problem, we essentially no longer needed

KTM for the Ragnaros fight. A month later when we were starting to kill Ragnaros routinely, our raid leader gave this as part of his pre-battle speech:

> get in poisiotn on the pull, but DO NOT ATTACK until AFTER tank is back on Rags after a knockback

While this does not specifically say "do not get in range" it may be implied, given how the players had come to understand the mechanics of the fight from the previous attempts.

In summary, the raid group I played with had reached Ragnaros by the time the new threat meter add-on KTM arrived on the WoW gaming scene. It took us several weeks, however, to incorporate it into our assemblage of play. It completely changed how the task of keeping track of threat was distributed in our system. Yet the Knockback events in the Ragnaros fight forced us to reconfigure or renegotiate dynamically how KTM was enrolled into our network. It added to our body of evidence that threat was not actually the reason rogues were gaining aggro, and, weeks later, we were able to incorporate this new knowledge into our successful strategy.

The idea that we assigned a new role to KTM in-the-moment may seem to complicate actor-network theory's concept of delegation where nonhuman actors are meant to take on specific responsibilities by their creators. Instead, we see that this actor-network was dynamic and the translation process—the negotiation and agreement process—necessitated constant reworking and retranslating. Latour (2005) understood actor-networks as ever-changing, though, which is why the work of the actors within the network leave traces of their associations to be followed and examined and why, once described, the network *as described* may no longer exist.

KTM and Networks

Actor-network theory is an attempt to describe how an arrangement of objects in a network are acting on others and are acted upon by others so that the activity does what it does. It tells a story about practice within situated contexts, involving historically-based interrelated actors. At the basic level, this network ANT describes is an assemblage of parts, but it is also dynamic. This dynamism is what makes it a mangle with vying interests and constantly renegotiated relationships and distributions of responsibilities. The reassembling occurs across multiple layers of complexity and multiple timescales.

On the surface level, the whole landscape of *World of Warcraft* play was determined by designed constraints from the game developers, who were, in turn, affected by the historical evolution of MMOG play. Digging deeper, individual players assemble and arrange the objects and resources in their specific in-room, on-screen settings. KTM is just one of these objects.

Between the work that occurred on the surface level and the deeper individual player level lays the mangle that Steinkuehler (2006) wrote about: a messy set of practices emerging from the constant clash and negotiation between the designed experience, players' exploration and meaning-making in that experience, and all the ways in which various parties exploit, modify, and change the system. In the larger WoW community, KTM and other player-created add-ons that helped raids manage raiding was becoming so normative that Blizzard Entertainment was forced to incorporate many of their user interface tweaks into future iterations of the base game.

My raid group and its activity across the locations in which it assembled represented one tiny sub-mess—a microcosm of the mangle—and yet this small mess could be broken down further. Each character class was grouped together and those groups independently assigned internal roles and responsibilities, engaged in scientific argumentation about strategies and tactics, and theorycrafted with a larger class-based WoW community. Furthermore, as stated earlier, each player had his or her own local configuration to manage. Just as Stevens, Satwicz, and McCarthy found with their young gamers (2008), these arrangements would sometimes extend beyond the computer screen and into the room. I personally distributed bits of info onto sticky notes on my desk to help me remember, for example, how much fire resistance I should have.

The existence of networks within networks is something Latour spoke of when he described the anatomy of a door-closer (1988), but as Lemke (2000) notes, different measurement scales can be used to look at time in addition to size.

KTM was designed by a player in Europe within an emerging theorycrafting community of WoW players. He then released it to the larger WoW community. Specific to my raiding experience, the use of KTM started off in one raid zone with one group of players who were a subgroup of the larger Molten Core raid group. Its use then migrated over to MC. It took about two months for the diffusion of KTM to reach some sort of critical point of usage so that it was accurate enough to help raiders keep track of threat and predict aggro gains. This was slow, at first, because its effectiveness was difficult to demonstrate without enough people using it to begin with. Partly, it was the situated knowledge problem of trying to describe a bicycle to

a fish (Bransford, Brown, & Cocking, 2000). The very idea of a bar chart showing threat level was completely new to some players. Roger and most of the rest of the rogues had the misconception that threat level wasn't additive, for example (see Figure 4).

The two months can be broken down into weeks, each week representing a fresh start in Zul'Gurub (ZG) (with the Booty Bay Anglers), the Ruins of Ahn'Qiraj, Onyxia's Lair, and Molten Core (see Table 3). From week to week, a subgroup of players was using KTM and, at least, managing threat effectively within the subgroup. When aggro was stolen by another player during a threat-dependent fight, it was done so by a player without the add-on, reinforcing the importance of having more and more players use it.

In a given week, such as the week of April 28, 2006, we can see how the rogue class group used KTM to diagnose problems with Ragnaros. Not all the rogues had KTM installed, but enough had installed it to start to understand that threat wasn't the problem with gaining aggro in that particular fight. This diagnosis was actually done on a single night across multiple attempts at confronting Ragnaros. Each attempt lasted about 6 minutes plus about 20 minutes of pre-planning and post-debriefing—time reserved for reflective thought (as opposed to experiential thought) that helped us learn (Bransford, Brown, & Cocking, 2000; Norman, 1993).

Each attempt can be looked at using a scale of seconds identifying specific chat utterances that show changes in conceptual thought about how to successfully fight Ragnaros. These individual utterances, sporadically spread out over a single attempt and even more sporadically spread across multiple attempts, occurred on multiple communication levels, interwoven between the rogue chat channel and the larger general raid group chat channel.

The actual practice we were engaged in was informed by a raiding tradition in the MMOG genre that spanned at least a decade (e.g., raiding in *EverQuest*). The instantiated version in WoW was affected by players' understanding of the particular mechanics of WoW raiding, but this second stage of WoW was affected by what players knew about general WoW encounters, which they learned after months of leveling up and participating in smaller player groups during the first stage of WoW. I think it also matters that we were on a role-play server, in that players tended to type in full proper English, to not stand on top of each other, to wave and greet each other, to make comments about the game world, etc. One of our raid members, Wallace, for example, in thinking that someone in the game world would not needlessly exert energy, would sometimes walk from fight to fight while the rest of us ran, making us wait for him to catch up before we pulled. It also mattered that the raid group's membership was not from a single guild because

this added another layer of negotiation and management that needed to occur to align players from multiple guilds and affiliations who brought with them their particular practices and norms into those of the raid group. All these different levels and timescales of experience serve to position and frame future work of individual actors and groups.

Narrowing Play and Exposing Disruptions

In summary, the enrollment of KTM can be broken down into several stages:

- We raided without KTM for 4 months, keeping track of threat on our own.
- When we first tried KTM, it proved ineffective and its affordances were unseen when only two of us had it installed.
- A couple of months later, KTM reached a critical mass of use and was starting to be used in MC, mostly because we had installed it for non-MC fights.
- KTM became temporarily in-the-moment enrolled to diagnose Ragnaros fight problems that the rogues were having.
- Once we diagnosed the problems, KTM no longer was needed for the Ragnaros fight, though KTM was still useful for other fights that required careful threat monitoring.
- KTM became a surveillance tool for raiding in general.

The enrollment of KTM into my raid's standard practice brings up a number of issues. First, though it was nominally being incorporated to an existing network, it took on a sort of agency itself by imposing new responsibilities to the other actors in the network (e.g., it shifted communication patterns, it drove changes in strategy). Giddings (2007) uses Dennett's (1971) concept of *intentional systems* to describe the key difference between agency ascribed to humans versus nonhumans:

> So this intentionality does not assume that complex systems have beliefs and desires in the way humans do, but that their behaviour can, indeed often must, be understood *as if* they did. Or perhaps, and Dennett hints at this, their "beliefs" and "desires" are not so much metaphorical as analogical.
> This "unmetaphysical" notion of the intentional system both resonates with Latour's nonhuman delegations and suggests ways in which we might theorise our material *and conceptual* engagement with complex computer-based media, sidestepping a whole range of largely unhelpful speculations on imminent realisation of actual machine consciousness. It suggests that the experience of playing (with) these

game/machines be theorised as one of engagement with artificial intelligence without slipping into naive anthropomorphism or frenzied futurology. (p. 122)

KTM, on a micro level, required us to give it attention and then adjust our behavior based on what it displayed. It did not care, of course, whether we actually changed our behavior, and neither did it enforce its use. Yet, by being a transparent tool, showing everyone's threat level to all players, it did not need to enforce its use. We did that on our own. This is both good and bad. Its benefit was clear: some of the players appreciated being reminded by others to be cautious about their threat level. Yet this came with a price. While KTM served as a threat meter add-on to warn us of impending aggro change, it also served as a surveillance tool that we could use to make sure each of us was playing efficiently to help the common task. As Taylor (2006b) noted (p. 329):

One predominant trend that has arisen in WoW through mod development... is an extensive network of tools and functions that consistently monitor, surveil, and report at a micro level a variety of aspects of player behavior. Worth critically noting here is that these developments are instigated, promoted, and adopted by participants themselves.

Some players from my guild, the Booty Bay Anglers, for example, used a backchannel once to discuss the low performance of a "problem" player in our weekly Zul'Gurub runs, citing threat and damage meters as evidence for her free riding. What used to be monitored individually had become distributed to the collective, making it open and transparent, essentially transforming the trust needed for group work (and social dilemmas) that was based on friendships and camaraderie into trust based on surveillance and technology. Furthermore, on a more macro-historical level, KTM helped narrow the legitimate experience of playing World of Warcraft by reinforcing the threat paradigm and the tank-healer-DPS tripartite found in MMOG encounters. Playing WoW has consistently become more and more a game of numbers, efficiency, and theorycrafting, buying into the notion that the end goal of playing is to win loot and progress.

The second issue brought to light in analyzing KTM's adoption is the issue of communication levels. The rogues were internally attempting to make sense of Ragnaros's aggro changes, but it was only after Roger voiced his dissonance in the general [Raid] chat channel that the rogues began to understand what was happening. This occurred when Maxwell replied to Roger, letting him know that the melee DPS needed to wait for tanks to be in position before getting in range. Indeed, it seemed like Maxwell, a non-rogue, already knew about Ragnaros's melee targeting preferences. If it is necessary for group members to make available to others their misconceptions before the group

can become aligned or translated to a common understanding, how can we compel individual players to speak up? The raid assumed character-class-specific expertise in all its members. Displaying evidence of a lack of understanding could have been seen as a risky move. What's more, this assumes the rogues could identify and be metacognitive about their lack of understanding and need to elevate their talk from their private rogue channel to the larger [Raid] channel. Yet the onus of opening up appropriate communication channels so the raid could repair itself seemed to be taken up by happenstance through flabbergast and flailing. What do we make of this? In future endeavors or other group work, some way to insure that dissonances that occur on the micro level are elevated to the whole group would be necessary.

Still, the raid's eventual adoption of a new actor into the network is an example of how local practice is emergent and dynamic and heavily dependent on available technomaterial resources, which are assembled and configured in and around the activity. This example pushes on this idea, leading us to redefine expertise development not as changes in activity, but rather, as changes in how the assemblage is configured—to consider practice as more than a way of doing things, but also, as ways in arranging the space in which things are done. Local practice is also dependent on communication among actors in the network that is open enough to expose possible areas of disruption. Only after the network is in alignment on negotiated roles and responsibilities (i.e., translated and configured successfully) is it stable or durable enough to do its work—that is, until a new disruption occurs.

Walt and Thoguht "Theorycrafting" Amidst a Server Shutdown

While not as thorough or well-informed as Kenco's theorycrafting practice described in the previous chapter, an instance of rudimentary "theorycrafting" done by a guildmate and me before we knew it was called theorycrafting is presented in this interlude. It is also an example of limitations imposed by the game apparatus, clearly evident when the server needed to be rebooted by the game developers for maintenance.

❊

Before websites like Elitist Jerks (http://elitistjerks.com/) and WoWWiki (http://wowwiki.com/) existed, my friends and I would do some rudimentary simulations when we needed to choose between two different weapons or armor pieces. These tests were held in the battle cage (think *Mad Max Beyond Thunderdome*) found in Gadgetzan, the goblin neutral city in the desert wastes of Tanaris. We would engage in one-on-one combat—use the in-game dueling function that allowed two characters regardless of faction allegiance to fight each other. In the transcript below, taken from January 2005, we can see how interleaved chat channels could be. Much of the switching from channel to channel that Walt and I did was to distinguish the combat analysis chat from other talk that was happening in previously used channels. Distracting talk from [Guild] chat and from other party members who were not at the same in-game location as Walt and Thoguht has been removed from this transcript for the sake of ~~sanity~~ brevity.

[18:4][4319][Walt] says: Let's do this!

[18:4][4321][Thoguht] says: Ok.

[18:4][4335] Walt cheers!

[18:4][4337][Thoguht] says: Like my daggers?

[18:4][4345][Walt] says: Oh my yes.

[18:4][4352][Party] [Thoguht]: [Dirk]

[18:4][4368][Walt] says: Now... I'm going to go into Defensive Stance.

[18:5][4372][Party] [Thoguht]: I get more attacks with them but do the same amount of dps as unarmed.

[18:5][4382][Walt] says: I want you to hit me as hard as you can.

[18:5][4400][Walt] says: Aah! I found block.

[18:5][4405][Thoguht] says: No, you want me to hit as often as I can... well maybe as hard... we'll see what this block is about.

[18:5][4413][Thoguht] says: Oh yeah?

[18:5][4420][Party] [Walt]: I'm currently at 12.4%

[18:6][4435][Party] [Walt]: Now at 10.4%...

[18:6][4440][Party] [Thoguht]: and with the new shield 10.4.... hmmm

[18:6][4440][Party] [Walt]: Okay, that doesn't tell us much.

[18:6][4441][SERVER] Shutdown in 15:00 *[In the early days of WoW, Blizzard more frequently had to hotfix bug or balance issues with the game, necessitating a server reboot. This was always a jarring event, forcing players to see the machinery behind the game. It also seemed to happen at just the worst moments.]*

[18:6][4446][Party] [Walt]: Oh for pete's sake!

[18:6][4447][Party] [Thoguht]: damn!

[18:6][4453][Party] [Thoguht]: fight!

[18:6][4456] Duel starting: 3

[18:6][4457] Duel starting: 2

[18:6][4458] Duel starting: 1 *[I start hitting Walt's shield.]*

[18:6][4483][Party] [Thoguht]: switch shields about halfway thru

[18:7][4501][SERVER] Shutdown in 14:00

[18:7][4512][Party] [Walt]: getting ready to switch shields!

[18:7][4517][Party] [Walt]: switching!

[18:8][4555][Walt] says: Hurt me! Yeah!

[18:8][4561][SERVER] Shutdown in 13:00

[18:8][4568] Thoguht has defeated Walt in a duel

[18:8][4571] Walt cheers!

[18:8][4589] You cheer!

[18:8][4593][Walt] says: What did we learn?

[18:8][4597][Party] [Thoguht]: now to read the log!

[18:8][4598][Party] [Walt]: Booyah!

[18:9][4620][SERVER] Shutdown in 12:00

[18:9][4628][Party] [Thoguht]: sometimes it says Walt blocks.

[18:9][4641][Party] [Thoguht]: sometimes it says You hit Walt for 1. (24 blocked)

[18:9][4649][Party] [Walt]: Hmmm.

[18:10][4674][Party] [Walt]: \"Strength\" says \"Increases the amount of damage you can block with a shield.

[18:10][4680][SERVER] Shutdown in 11:00

[18:11][4741][SERVER] Shutdown in 10:00

[18:12][4801][SERVER] Shutdown in 9:00

[18:13][4861][SERVER] Shutdown in 8:00

[18:13][4908][Officer] [Thoguht]: Ok. Well it seems that the first shield i missed more often, but the second blocked for higher amounts.

[18:14][4921][SERVER] Shutdown in 7:00

[18:14][4925][Officer] [Walt]: would my defense rating have an effect on your missing?

[18:14][4940][Officer] [Walt]: er, AC

[18:14][4943][Officer] [Thoguht]: except that the actual difference was 23 vs. 24... so maybe I need to use higher damage weapons to see a bigger diff.

[18:14][4961][Officer] [Thoguht]: dunno

[18:15][4976][Officer] [Walt]: willing to go again!

[18:15][4981][SERVER] Shutdown in 6:00

[18:15][4982][Officer] [Thoguht]: if the server goes down for a while, maybe I'll try to research attack and AC and all that crap

[18:15][4986][Officer] [Danny]: I think the defense skill might, against his attack skill? In theory, the armor rating is just soak. *[After we had switched to Officer chat (so our party members weren't inundated with our duel analysis spam), another officer, Danny, could see our talk and helpfully chimed in with his understanding of various combat terms and ratings.]*

[18:16][5040][SERVER] Shutdown in 5:00

[18:16][5046] You have requested a duel.

[18:16][5052] Duel starting: 3

[18:16][5053] Duel starting: 2

[18:16][5054] Duel starting: 1

[18:16][5055][SERVER] Shutdown in 4:45

[18:16][5070][SERVER] Shutdown in 4:30

[18:16][5085][SERVER] Shutdown in 4:15

[18:16][5089][Walt] says: switch!

[18:17][5101][SERVER] Shutdown in 4:00

[18:17][5116][SERVER] Shutdown in 3:45

[18:17][5122] Thoguht has defeated Walt in a duel

[18:17][5131][SERVER] Shutdown in 3:30

[18:17][5131][Thoguht] says: 3 min to decipher!

[18:17][5146][SERVER] Shutdown in 3:15

[18:18][5157] Walt cheers!

[18:18][5161][SERVER] Shutdown in 3:00

[18:18][5176][SERVER] Shutdown in 2:45

[18:18][5191][SERVER] Shutdown in 2:30

[18:18][5206][SERVER] Shutdown in 2:15

[18:19][5221][SERVER] Shutdown in 2:00

[18:19][5236][SERVER] Shutdown in 1:45

[18:19][5247][Thoguht] says: Ok here's the deal.

[18:19][5251][SERVER] Shutdown in 1:30

[18:19][5255][Walt] says: Deal?

[18:19][5266][SERVER] Shutdown in 1:15

[18:20][5281][SERVER] Shutdown in 1:00

[18:20][5286][Officer] [Thoguht]: It looks like the second shield that time blocked more often, but the difference is negligible!

Our tests showed that, at least at the power level we were dealing with—I think about level 35, well before the level cap and tiered items—the two shields provided roughly negligible difference in protection. In honesty, we were engaging in these duels to try to get at the underlying mechanics of the game, not to actually walk away with optimal equipment configurations. We knew that items of about the same level during the leveling-up stage were roughly equally serviceable and that what mattered more for power gain was to keep questing and leveling to gain access to much higher-level items. This is partly why I never understood when players ran lower-level dungeons over and over again to get specific loot. That loot would be replaced in less than a week of leveling.

Death of a Raid

Changing Schedules and Changing Roster

After The 7/10 Split-led MC raid group had stabilized its strategy and defeated Ragnaros several times, the raid leaders decided that the group should progress further with *World of Warcraft* by moving Molten Core (MC) to just one night a week: Fridays instead of Wednesdays *and* Fridays. Our intent was to free up the raid to then delve into a new dungeon called Blackwing Lair (BWL) on Wednesdays. There were several complex, sometimes overlapping motivations for this move. Some raid members were starting to align themselves more with game-mechanics-based goals—goals that were designed into the game, as opposed to socially emergent goals (see Chapter 2)—and saw raid progression as a way to gain better loot, making their characters more powerful. Some raiders wanted to move on to new game content so that they could experience more of the designed events in the game. Finally, some were fine with whatever activities the raid decided to attempt since they just wanted to continue engaging in shared experiences.

This change to one night per week in Molten Core and one night in Blackwing Lair came too late for some of the regular raid members. About a dozen of our group of about sixty players decided to leave the raid group to join other groups that were more focused on quick progression and using more standard DKP loot rules (Malone, 2009) to incentivize cooperative behavior (see Chapter 2). Though we had a regular pool of about sixty players, roughly thirty of those were considered the "core" group who came every week. Most of the players who left the raid group were from this core group of raiders, necessitating changes to our group strategy and structure.

Because we had larger numbers of players who were not yet regular raid members starting to show up each week, raid leaders had to spend time explaining how this raid group approached certain boss fights, how the raid divided loot, etc. Additionally, these new members required some time to learn the norms of the group and become enculturated to our common

raiding practice. Some players, for example, needed to install and set up the external voice chat program, Ventrilo (also known as "Vent"), that we used to complement the communication afforded by the in-game text chat. This meant that often we could not fully complete all of MC in one night.

Another reason we could not reach the end of MC each week was that one of our main tanks, Wendy, quit the raid in early-May, the same week we killed Ragnaros for the first time. Usually a tipping point was reached once a boss monster was killed. Before killing it, the task could seem insurmountable, but, after killing it for the first time, having a combination of the right strategy, coordination level, and powerful enough equipment meant killing the monster became a frequent occurrence—put on farm status. Once a boss was on farm status, most raid members wanted to stay with the raid because they knew the raid would succeed in winning valuable loot. Wendy, however, was likely motivated by a falling out with the raid leader with whom she had an offscreen relationship. I never interviewed or collected data for my studies that was outside of regular game chat and activity, though, so I cannot say for certain why she left and joined a different raid group. Regardless, this example highlights how outside factors could impact the success of in-game activities, mirroring what scholars have come to realize about the importance of out-of-school life for students (Heath, 1983; Lee, Spencer, & Harpalani, 2003; González, Moll, & Amanti, 2005).

There were also technical reasons why we did not progress as far into MC as we had done previously. The Molten Core raid zone sometimes suffered from software bugs where planned events would not trigger. This happened twice to our raid group. For example, one time Ragnaros did not reset correctly after a raid wipe, meaning we had to wait until the following week after the server was refreshed on Tuesday to try to kill him again.

All of these issues—both technical and social—made our progression in MC, as well as our progression with BWL, slow going. This frustrated a subset of our core group of raiders. The purpose of raiding for a growing number of players was to progress through game content efficiently and win loot rather than stated earlier goals of hanging out and having fun. With these tensions in place, the raid finally broke up in September 2006 after suffering an *irreparable* meltdown—a permanent dissolution of the raid group.

Death by Drama

As mentioned in earlier sections, this raid group was composed of players from many different guilds. One of the guilds, The 7/10 Split, however, did play a

leadership role with members of The 7/10 Split ("Splitters") in charge of management and administration. Our raid leader, Maxwell, was from The 7/10 Split, and he along with another Splitter were the ones who originally gathered all of us together, crossing guild boundaries to form the alliance. They used their guild's online space, a web message board, to post schedules and discuss preferred start days and times, inviting potential raiders to create an account with their message board system and participate in the discussion. This was supplemented with in-game chat between players, plying their existing social network to advertise that a new raid group was forming. This initial planning work took several weeks of negotiations to figure out which days worked best for the highest number of potential raid members.

On September 10, 2006, one member of the raid group, a mage named Matt, from one of the allied guilds, Eat at Chaos, noticed that many of the raid members from the management guild were all in Molten Core. He could see this because the game lets anyone see whether others are online and which zone they are playing in when they are on. The problem was that they were all in the cave system on a Sunday, during a non-scheduled raiding time. He also noticed that many other non-raid affiliated players from The 7/10 Split were also in the dungeon with the regular raiders. In other words, the raid group had reformed without many of the allied-guild raiders for an additional outing. Matt feared that the Splitters were planning to sever ties with their allied guilds, so he posted a question about it on the raid's online forum the next day, Monday, September 11, 2006:

Matt <Eat at Chaos> (12:07 p.m.)

So, the Molten Core raid is happening on Sundays now? I have been told that it was posted on the forum but I must be just missing it.

I logged in on Sunday and saw all of you in MC and wondered what was going on. Apparantly there was a discussion about this in vent that I missed and a post on the forums that I also missed and still can't find. Seems the rest of Eat at Chaos missed it too, along with some Booty Bay Anglers people that I have spoken with.

Obviously I'm missing something here but I still have to ask...am I missing something?

This prompted a response from a sub-leader, Lori, and our main tank, Warren:

> **Lori <The 7/10 Split> (12:13 p.m.)**
>
> I think it was discussed on Friday

> **Warren <The 7/10 Split> (12:18 p.m.)**
>
> our calendar was not updated ..so I managed to do it fastlike on sundat morning.
>
> It was discussed on friday. That was it. It wont happen again ☺ sorry for the confusion folks. It happens sometimes.

Warren framed it as a mistake in communication, leading to some confusion from raid regulars. He then noted that "it" would not happen again, but it is unclear if he was referring to the miscommunication or to holding a raid event without regular raid members. Another raid member from the Booty Bay Anglers, Marge, countered this official word, prompting a reply from the raid leader, Maxwell:

> **Marge <Booty Bay Anglers> (12:24 p.m.)**
>
> I don't remember it being discussed on Friday...

> **Maxwell <The 7/10 Split> (12:28 p.m.)**
>
> This was discussed at Friday's BWL, but basically, here's the deal:
>
> Recently, due to a bunch of people either not showing up or showing up very late, I have had to start raids rather late. This has also been aggravated by a few people leaving to join Battle Wounds/Judgment. Also, people are having a hard time doing MC in a single night, and for new folks who are taking the spots of those who left, it's difficult to have the gear to do a single night run. I had set aside Sundays for MC part 2 for Domo/Rags, OR if we decide to put in more time on BWL, use sunday as a run to get as far as we can to gear up new folks.
>
> It comes down to this, I'm pretty unhappy at being forced to take a step back from BWL right after we killed Vael [the second boss in BWL]. I would have preferred to keep our old schedule, but if making some changes to gear up new people is the only way to make it work, so be it. Wednesday will continue to be BWL night, and Friday will be either more BWL or MC, depending on progress, with Sunday as an additional day to finish a clear or start one.

Maxwell had assumed some clarification about the future of the raid group needed to be made. He had been particularly unhappy with the raid group's step back in progress and thought that pushing for an additional raid session on Sundays would help make up for the fact that we had so many new raiders who needed to "gear up." This explained why there was a group in Molten Core on a Sunday. Unfortunately, he did not clarify why regular raid members were not invited to the added raid event, only stating that the event was discussed on Friday. This backed up what Lori and Warren had provided: that it was discussed over Ventrilo and that they forgot to update the message board until Sunday morning.

A few posts later, a relatively new raid member from The 7/10 Split, Todd, posted a clarification, supporting Maxwell's statements and giving evidence that there was definitely talk about Sunday's Molten Core run during Friday night's voice chat:

Todd <The 7/10 Split> (2:02 p.m.)

We had talk on Vent for very long time on Friday. I am not sure who were there on vent but we had discussion there.

We did BWL on Wenseday and Friday last week. which means there wasnt actual MC this week but, Alot of us needed MC for gears to actually make diffrense in BWL.

That is why Max and our officer made quick few boss clear on MC before our regular Onyxia raid.

W = BWL

F = BWL or MC (Depends on how we do on W)

S = (Also Depends on How we do on W and F)

I dont think you missed any we just got few new 60s few gears here and there.

This finally triggered what was the root of the problem for Matt:

Matt <Eat at Chaos> (2:25 p.m.)

Thank you Todd for leading into my next question. How is it that a "few new 60's" knew about this but a lot of the LOYAL regulars did not? Was any effort

made to invite the non-Split regulars who were online at the time?

If you guys want to run a purely Split raid, that's fine...but you need to tell the non-Splitters so we aren't wasting our time. I did a /who The 7/10 Split on Sunday when I saw you were all in MC and noticed a lot of names I've never seen before. New Splitters I'm assuming. Is your goal to start running a completely Split raid?

On a side note, I had people in Eat at Chaos cancel plans to go to MC last week and that raid got cancelled at the zero hour in favor of an AQ40 raid. These same people didn't even get notice of this past Sunday's raid into MC in which a bunch of new 60's participated. I think I speak for more than just myself when I say WTF.

Matt's ultimate worry was that the regular raid members from his guild, Eat at Chaos, and other allied guilds would have to find another raid group to join because The 7/10 Split was working on making the raid a Split-only raid. He believed this to be happening because of previous rumors he had heard (which he mentions later in the thread) combined with the fact that he saw that many non-regular Split members were in the Molten Core run on Sunday.

Warren quickly replied, but he responded to an earlier concern about whether the raid event had been announced on the message boards:

Warren <The 7/10 Split> (2:25 p.m.)

Matt there was no post for this past sundays run. It was talked about friday. That was it. I locked that one post cause I didnt want people to confuse with who was gonna go . The calendar was not updated till sunday morning, and I should have made a post about it too. I was being lazy though and thought someone else was gonna do it.

EDIT: Last weeks MC was cancelled becuase not enough people showed up. Thus we decided to see what AQ40 was like.

Warren mentioned a thread on the message board that discussed the previous Sunday's run. Since it was not up to date, Warren locked that thread. He also mentioned that instead of creating a new post, he updated a shared calendar that could also be found on The 7/10 Split website. It should be noted, however, that many raiders had not incorporated visiting the calendar page into their regular activity—the calendar had only been installed the week before—so it is possible that Matt did not see the calendar change when he noticed the Molten Core run on Sunday.

Looking at the timestamp, this post came in the same minute as Matt's previous post. Likely, Warren did not read Matt's post until after he had already posted. When he did read Matt's post, rather than address Matt's main concern—fears that The 7/10 Split was planning on running a Split-only raid—Warren focused on explaining why the raid group visited Temple of Ahn'Qiraj (AQ40) the previous week.

Matt wanted clarification because of the different accounts he was hearing:

Matt <Eat at Chaos> (2:48 p.m.)

Ok...let's all get on the same page here. Warren, I was told directly by your guild leader on Sunday that the change was posted on the forum. That's where I got the idea that it might be....you know...actually posted somewhere here.

That aside, and I know you don't OWE me any answers, but what about my other questions? All the new people in the raid....all the missing regulars....regulars not knowing about the raid taking place on Sunday...etc. You say you discussed in on Friday in vent but when? No one in Chaos heard any of this conversation and I'll again point to the fact that it was not posted on the forum.

I hope you can understand my frustration with this, I don't feel like I'm getting the straight story here.

It seems clear that Matt was beginning to be frustrated with the lack of "being on the same page" to all of his questions. He then pointed out that the raid leaders did not "OWE" him any answers, which shows that he perceived an inequitable power relationship between The 7/10 Split and non-Split raid members.

Sven, another Splitter, and Warren reiterated that there was a failure in general communication and getting the word out about the additional raid on Sunday. The communication problems may have stemmed from not all raiders belonging to the same guild. Guilds had several in-game tools that could be used to broadcast messages to all guild members. The group members, however, had become so familiar with each other over the last 10 months that it was probably easy to assume that news of raid events would spread as if the raiders were all in the same guild.

Warren recognized that guildmates could communicate with each other more effectively and posted his response to Matt. Unfortunately, Warren tended to post ambiguous messages without reading them over first, perhaps

exacerbated by the asynchronous, textual web medium, and this time was no different:

Warren <The 7/10 Split> (3:29 p.m.)

Why did Split peopel know about the raid? Cause it was mentioned during a guild meeting on saturday. So of course there were lotsa new Split folks. Who do you think is gonna replace the peopel who left us? BB Anglers? Chaos? Theyr were on..other folsk werent. We also got alot fo new folks from other guild as well like Talking aint easy. I would reckon to say we had more new OOGers than new Split people show up.

Was just a lack of communication on the boards.

First, Warren stated that The 7/10 Split had a guild meeting on Saturday in which a raid to Molten Core was mentioned for Sunday. To him this explained why many Splitters were online and were invited to the raid event. Warren then asked who else would fill in the raid roster. With this question, he was probably referring to the exodus that had occurred in the previous couple of months ("the peopel who left us") and was asking who would become new regular raid members. In the next statement, however, he moved back to the topic at hand, referring again to Sunday's raid: "Theyr were on..other folsk werent." He was using this to justify new Split invites. Splitters were online; other players who were regular raid members were not online. He also said, however, that the raid group had to fill in most of the empty spots on Sunday with out-of-guild (OOG) players.

Due to Warren's rapid move from Sunday-specific talk to general raid composition and back to Sunday, Matt misinterpreted the middle question about who would fill in the raid:

Matt <Eat at Chaos> (3:52 p.m.)

Why yes, I WOULD expect you to invite Anglers and Chaos regulars over new Splitters or people from other guilds....silly me. Is there a problem with that? If there is, change the name of the damn raid to the "Split Raid" and we'll find a new raid. I'm only speaking for my guild but I've heard from others that there were other regulars on that didn't get invited. Do you think I'm just being an ass here?

Don't answer that.

Lori stepped in with reassurances that The 7/10 Split had no intention of moving to a Split only raid. She felt the need to play a mediation role, trying to quell accusatory posts and apologizing for the miscommunication:

Lori <The 7/10 Split> (5:47 p.m.)

Serioulsy, let's stop with the accussations that we're trying to out a bunch of people not in The 7/10 Split. That is simply not true nor do we have any intentions of ever doing that.

This is simply a misunderstanding and obviously poor communication on our part. I wasn't even in Friday's raid, but I was in vent and I did hear this being discussed. Some people apparently did not. We should have posted the change to the schedule that night, but that did not happen. As far as Sunday invites go, I'm not sure exactly how those were handled. I do know that I showed up late, there were plenty of spots, and plenty of non-splitters there at the time. Because of those empty spots were turned to the people we knew were waiting.

If the altered time was not properly communicated, then Sunday was a mistake on our part, simply put.

So please, let's learn from the mistakes and move on and not make this into a bigger deal than it really is.

Lori also took this time to reiterate that there was a misunderstanding going on, born from the assumption by those who were in the voice chat that talking about the raid there was sufficient to spread the word to all regular raid members. She then mentioned that the organizers should follow a set protocol for announcing raid events and implied that this lesson was learned and future events would be handled differently.

Perhaps detecting that Matt was suspicious of the motivations of The 7/10 Split leadership, Maxwell created a lengthy post, arguing that he had been continually considerate of out-of-guild raiders:

Maxwell <The 7/10 Split> (6:17 p.m.)

Interesting. I know for a fact I mentioned this at least a couple times during Friday's raid, and then there was a long discussion following the raid that I know you were present for at least part of, Matt. How do I know? I alt-tabbed out to see who was in channel to make sure people were still around to hear it. If you were afk, my apologies, but from my perspective, there was adequate warning. Also, this was discussed the previous week as well.

Furthermore, the raid -I- run was recently handed a bunch of traumatic

> changes that I am not to happy about (namely people leaving for Battle Wounds/Judgment/Enemy, or just not coming) that have forced me to try new things with the schedule AND find new people for their slots in order to make things happen. This is not easy to do, and has been TREMENDOUSLY stressful for me. My apologies if I have been absent-minded about some things, but I am doing what I can.
>
> You guys have been very constant, and in return, I usually invite Eat at Chaos and Booty Bay Anglers before my own Splitters. Have you never noticed I tend to grab you all before anyone else? Matt, have you forgotten I hold spots for you and Rapa even when you're 30 minutes late? I apologize if you think I am intentionally excluding you, but nothing could be further from the truth, and if you cannot believe this, then I do not know what to tell you.
>
> I believe there was some miscommunication here, and I think this has been blown way out of proportion, but please do not accuse me of trying to get rid of you. I have worked my ass off to make this raid work, and I feel I have gone to great lengths to include Eat at Chaos and other guilds and make the raid welcoming and fair to them, even when it has been to The 7/10 Split's disadvantage. I may be a lot of things, but I don't lie, and I try to treat people fairly. If you still feel there is an issue, please take it up with me directly.

It is clear Maxwell was feeling stress from the last few weeks of organizing a faltering raid group, dealing with newcomers and attendance issues. As the raid leader, he felt the onus of management, assuming responsibility to do all the organizing. A different raid leader might have just given up where Maxwell was compelled to continue. Maxwell also began to point out actions of his that might have been unnoticed or underappreciated by Matt and other raiders (e.g., "grabbing" non-Splitters first and "holding spots" for them instead of filling up the group to 40 players before engaging monsters).

After Maxwell invited him to talk privately, possibly because he did not want this thread to become more stressful or possibly because he was frustrated with the asynchronous nature of the forum, Matt instead chose to reply publicly:

> **Matt <Eat at Chaos> (9:01 p.m.)**
>
> Interesting indeed. I know I was on your vent server that evening, I may or may not have been there during your "discussion" of this. But that's beside the point, I did take it up with you personally when I logged in on Sunday and was told, by you, that it was posted on your forums. I have yet to see this post. Other regulars have yet to see this post or hear about the changes in vent.
>
> Yes, -you- have been very generous in asking us into -your- raid. I'll try to avoid making comparisons to a certain warlock raid leader with your tone there but

the thought did come to mind. I'd just like to remind you though that I had to constantly ask you to save Rapa a spot even after he proved he would show up consistently. Even then I usually got "maybe" type answers from you. It wasn't until I started pressing on the issue that you started consistantly saving him a spot. I recall a couple of times where I left the raid to give Rapa my spot because you wouldn't save him one....so please don't hold that over my head as some shining example of your benevolence. /sarcasm

Yes, now I have noticed that we're some of the first to be invited, but shouldn't you be inviting the people who show up consistently and stay until the end? All I know is that you ran an MC raid on Sunday and a lot of non-Split regulars weren't there while a lot of newbie Splitters were. That doesn't look good to a few people who have noticed.

No, I don't believe that you're intentionally excluding us right now, but I do believe that is eventually the plan. I've heard from someone that I trust that it's your goal to keep things "in house" to avoid future problems with other guilds. Problems like the one I'm creating now I'll wager. It's just my opinion but I think you'll be better off sticking with people who have been loyal friends to the Splitters instead of gearing up a bunch of new people you don't even know will stick around.

If you do intend to clean house, you need to be up front about it and tell the other guilds now instead of leading them on until you have enough people to run a full Split Raid.

Oh, and I'd rather keep this discussion on the forum. If I have something to say, I don't mind stating it publically.

This post was clearly confrontational, highlighting language that framed opposing positions (e.g., putting quotes around "discussion," emphasizing Maxwell's egocentrism: "Yes, -you- have been very generous in asking us into - your- raid," and using the /sarcasm marker). Matt believed he was fighting for his and other raid members' rights to be rewarded for loyalty and friendship. He was worried that the social capital between non-Splitters and Splitters was of little value.

The next morning, Tuesday, September 12, 2006, Lori, sensing the escalation in talk, posted a message meant to clarify positions, defend Maxwell, and calm things down:

Lori <The 7/10 Split> (7:25 a.m.)

For all the people who are confused by Sunday, all I can say that has already been said is that we did not communicate enough and we NEVER had the intention to not include anyone. We thought the vent chat would bevenough warning, but apparently it was not. This was not a stealth run or any sort of

test run to see if we could handle things on our own, as we have been so accussed.

Furthermore, we DO NOT have any intention of using anyone outside of The 7/10 Split for our personal gain only to dump them after a year of hard work. We are NOT trying to transition the raid to "keep things in house", and unless you can sit there and tell me, "Yes, Maxwell, on our jolly jont through the plaguelands, told me he's gonna dump these mo fos and move things completely in house," then I really, REALLY don't want to hear that claim anymore. It is baseless, unfair, and completely hurtful. We have never thought of anyone outside the guild as extras.

I don't know what else can be said to appease anyone. I have a feeling we're being backed into a corner. We're either liars or dirty scumbags and that was already determined before this thread was even started. Next time, check the facts before you start flinging poo and quit relying on "trustworthy" sources.. This raid has already been through enough drama and setbacks, and I don't think it takes a genius to figure out that we're sick of it.

Lori recognized that raiding was "hard work" and that raid members had put in almost a year of this effort it took to make a successful raid. She was also the first raider to use the word "drama," which may have served to frame the whole thread as another drama event that the raid group had to endure. By doing so, she may have prematurely signaled the end of the raid. Given enough drama, eventually, any raid group would collapse.

Maxwell also defended himself with another lengthy post. In it he denied that he ever said that he wanted to "keep things in house" and claimed that in the private officer section of the message boards, many conversations had occurred where he argued for The 7/10 Split's continual loyalty to out-of-guild raiders, recognizing that the raid would never have been possible without them.

The following few posts took a more lighthearted tone. It appeared that most raid members who commented had learned enough about the situation to be satisfied that it was just a momentary break in communication and trusted the raid leaders when they said that they acknowledged the mistake and would endeavor to prevent it from happening again. The tension and worries over whether The 7/10 Split was planning on dropping non-Splitters from the group were unfounded, exacerbated by recent attendance issues.

A common occurrence with asynchronous media is to read topic threads, whether they are message board posts or email threads, sporadically throughout the day or week, as time allows. The message board software that The 7/10 Split used (phpbb) defaulted to showing new posts in chronological order. The problem with this was that readers could be compelled to reply to a

post before having a chance to read the rest of the message thread. Whether this was true of Warren is unclear, but what came next in the thread was a post from him that clearly did not recognize the cooling down of the thread. He posted:

Warren <The 7/10 Split> (12:14 p.m.)

I dont know whats going on Matt..or who told you..but I think you're being poisoned by someone with the intent of sabotaging our raids.

You feel like you're being lied to and distrust people.. welcome to our world..welcome to ours.

Matt, who had stated earlier that he was done posting to this thread, needed to defend his accusations and replied:

Matt <Eat at Chaos> (1:26 p.m.)

I'm not a gulible idiot, Warren. I've formed my own opinion of the stituation over several months and several incidents, not from one person telling me the Splitters are bad people. This past Sunday is just the straw that broke the camels back.

I think it's great that you Splitters stick together and defend each other. Loyalty is a good thing. Loyalty to the point of denial or discounting legitimate concerns is not. Seriously, do you guys think I just woke up one morning and said "Gee, I think I'll $#@* with the Splitters today"?

This post angered Warren who was already prone to sending rapid-fire missives. Notably irate, he posted:

Warren <The 7/10 Split> (2:12 p.m.)

ok Heres the deal. I am posting this for all to see. I dot care how pissed Max will be at me, I dont care if he kicks me out of the guild. This is retarded. Its a game. I am done with you drama queens

Last week, I was FURIOUS at certain things that went down. I told all the officers, Max, Lucy and Will (lori wasnt there).. I was done doing 40 mans. I am sick of OOGers using US to gear up and leave. I went so far as to tell Max to find himself another MT becasue unless it was a Split raid, I wasnt gonna do it anymore.

You know what he said? He asked me if I felt Eat at Chaos was part of the

OOGers I refused to play with anymore. I said Yes... I made NO exceptions. It wasnt because I was POed at Chaos or even the Anglers..but because I was done being made a workhorse for people who dont appreciate the amount of effort that goes into leading a raid.

I drew a line in the sand. Max, I think got pissed at me. He went sofar as to convince me that I need to allow for Chaos as an exception to my Split only rule. That was for now and into the expansion. I relented. Eventually.. I realized that Chaos, BB Anglers and some other guilds really werent out to get us, but to have fun and progress and really just play and see what happens after the expansion hit.

But because of all this, I woudl like to thank you Matt..for showing me that line I drew. Its back.

Every OOger. You guys wanna raid with us? Fine..find a new MT. You wanna take a step back and apologize for calling Max a tyranical read leader..fine, i'll come back and tank for you and treat you like a brother again.

I'm done.

Warren was clearly feeling frustrated with the slow progress of the Molten Core raid group and with recent departures from the group ("last week"). He also saw the effort that he and Maxwell put into organizing and taking on in-game responsibilities (main tanking, for Warren) as real work that was underappreciated. His post exemplified a tension many players had with thinking about *World of Warcraft* as a game (e.g., "Its a game") versus the amount of management and social negotiation needed in order to be in a successful group (e.g., the effort that Maxwell had been eluding to). For Warren, successful raiding should not have required drama. Drama came out of conflict players had with each other while trying to come to a shared understanding of group goals and the purposes for raiding. If too much work—too much drama—was required for a group to maintain its identity, many players including Warren could not see the value of sticking with that group, opting instead to quit and possibly attempt to join a different group.

Helio, a member of the Booty Bay Anglers who had contributed to the more lighthearted banter before noon, gave evidence of a change in how out-of-guild raiders felt about the raid group after reading Warren's message. He posted:

Helio <Booty Bay Anglers> (2:47 p.m.)

Wow, things got a whole lot more real while I was getting my burrito.

I'd just like to take this moment to sympathize with Warren. I know and understand the frustration of seeing people join, and leave, even though it is part of the life cycle of a raid.

To lower that burden - and also because we really don't care to raid where we're not wanted - Marge and I wish Split all the best in MC and BWL and with Ony. You guys are a strong guild and will do well, I have no doubt.

For myself, thanks for letting me see the most end-game in WoW I have to date. If you ever need me for Ony, I'll come along (got to pay back that hood a bit, eh?). Other than that.. good luck, and thanks for all the fish.

See you on the flip side.

Like Warren, Helio began to recognize that there was too much drama happening. He understood and sympathized with Warren's frustrations. In an effort to lessen the group drama and to avoid dealing with it, he and his girlfriend, Marge, decided to leave the group. He also recognized, however, that leaving so suddenly could be construed as shortchanging the raid group since he had recently won the loot roll for a hood that Onyxia dropped. He felt like he owed the raid group his time and labor to pay for the hood that he had won.

Less sympathetic, Matt saw resentment in Warren's tone and decided to focus on it in his next post. Matt believed that Warren was positioning himself as performing a service to other raid members, and he didn't think this was necessarily accurate. He then highlighted Warren's use of language, similar to how he emphasized Maxwell's use of first person in an earlier post. Matt's post:

Matt <Eat at Chaos> (3:19 p.m.)

Sorry Warren that you think we're so unappreciative of your god like tanking abilities. Perhaps we should pay homage to you for lending your valuable time to us peons? After all, your efforts far outweigh anyone elses and for that, you deserve special treatment.

"We" did this for "you", or "We're" tired of being taken advantage of by "you" or my favorite "All OOG'ers. You guys wanna raid with us? Fine...find a new MT". GG.

> This whole thread isn't about ME, Warren....I couldn't give a damn if I EVER go
> on another MC raid. I wasn't angry that -I- missed the raid if you haven't
> gathered that by now.
>
> I already knew there has been discussion about forming a completely Split
> MC/BWL raid. That's no surprise to me but thank you for at least affirming
> what others in The 7/10 Split have been denying.

This thread began to affect the raid group's chances of retaining new regulars that had recently been recruited. Min, a new member to the raid group from the Booty Bay Anglers demonstrated how easily these new linkages could be severed when she also wrote a response to Warren:

> **Min <Booty Bay Anglers> (3:33 p.m.)**
>
> Hey Warren... Eff you. I tried to stay neutral. But that's too damn much. If I'm
> not wanted, either, then I'll go the way of Helio and Marge and wish y'all luck.
> Find me if you change your mind. I refuse to stick around with this kind of
> drama. I'm gonna go have fun now.

Min had originally been invited due to the social and cultural capital she possessed by virtue of her guild affiliation. This capital came with obligations and responsibilities, as demonstrated above with Helio who was also from the Booty Bay Anglers. Min, however, felt betrayed by Warren and her obligations to the raid group were not compelling enough for her to stay. Warren, after all, was a former Angler and had clearly decided to relinquish his capital with the rest of the Anglers. People move in and out of social circles over time, so it was not surprising when he had chosen to leave the Booty Bay Anglers and join The 7/10 Split, but it was surprising to see a complete disregard of his year-long history with the Anglers.

The three responses to Warren from out-of-guild raid members signaled the end of the raid. Maxwell recognized this with his next post:

> **Maxwell <The 7/10 Split> (4:52 p.m.)**
>
> Matt, I don't know what the hell your problem is. I'm serious, I don't
> understand this. Every time we have ever talked privately you have
> commended me on how I was doing as a raid leader. I never heard a word of
> negativity out of you, and you'd been supportive of just about everything I've
> done. In fact, you were usually the first person to offer support in a whisper
> any time anything came up. Every time I've talked to you you've told me how
> Chaos was behind me 100%. Now over a misunderstanding over a single raid
> which I DID tell people about you're freaking out and calling me a liar to my

face? Well, in all honesty, to me now it looks like you were the dishonest one, the one who has been two-faced. I did everything I could to include you and your guild and this is how you treat me? Last week Lester gave me his phone number to call him and chat any time, as he thought of me and the splitters as friends, so where did all this animosity come from? I thought of you as a friend, and now you treat me like this? Insult me to my face? I don't understand it.

....

You're helping destroy a raid a lot of people have put a lot of time and love into over some paranoid delusion that only exists in your own head, and honestly, it looks as through you're intentionally ignoring what I have said here to continue spewing venom. Again, this is not the Matt I know, and I do not understand.

So Matt, I am telling you here and now, and finally. You are wrong in your assumptions here. I know that in your current frame of mind this will only anger you more, but it's true. If you wish to continue ignoring what I and others have said here, so be it. If you wish to call me a liar, so be it. How can I argue with you, defend myself to you when you won't listen to reason? I can tell you until I am blue in the face what the reality of the situation is, but unless you open yourself to reason, you won't even hear it.

Helio and Marge, Min,I've really enjoyed having you here and despite what others have said here in an emotional, I do welcome you, and bear no ill will towards you whatsoever, but if you do not want to stay, I understand and that's cool.

Everyone else from other guilds, thank you for your efforts and for everything you've done, but I doubt that the 40 man raids will be able to run now. See Matt? Watch our roster, see if we'll have 40 people in MC or BWL. We won't, ever. I don't know why you've done this rather than try to rationally discuss problems, but it seems to have had the desired effect.

Maxwell began by emphasizing his confusion and astonishment at Matt's accusations and suspicions about The 7/10 Split's future plans for non-Splitters. He then retaliated by blaming Matt for the destruction of the raid group ("You're helping destroy a raid"), followed by a last hopeless attempt at reason ("I know that in your current state of mind this will only anger you more, but it's true."). Maxwell then took the time to say goodbyes to the out-of-guilders who were leaving the raid, and then, understanding that the raid group was dissolving completely, said goodbye to every out-of-guilders. Finally, he put blame on Matt again before ending his post.

After this post, the forum administrators—the raid leaders—opted to lock down the thread so new posts could not be made. Ostensibly, they did this to

prevent people from irreparably damaging their relationships with each other, but the unfortunate side effect was the silencing of legitimate concerns, especially from raiders who may have missed checking the forums within this 29 hour period. In reality, blaming Matt one last time and then locking down the thread may have been a deliberate (but completely understandable) exercise in power. The raid leaders' fear of "drama" led them to shut down communication paths. Unfortunately, this was an act that served to alienate the various parties in the discussion even more.

I was one of the raiders who did not see this whole meltdown thread until the next day. I learned through my guild's web forum—Booty Bay Anglers forum, not The 7/10 Split's forum where this meltdown discussion was occurring—that many of my guildmates were upset. The biggest concern was that Warren's blanket attack on non-Splitters was hurtful and not countered by any of the Split leaders. In a different thread that I had started a week earlier (announcing my temporary resignation from the raid group starting in the fall due to my conflicting class schedule), I posted on Wednesday, September 13, 2006:

Thoguht <Booty Bay Anglers> (11:45 a.m.)

I've decided to leave this raid now rather than wait until the end of the month. Why? Because of this:

> Warren <The 7/10 Split> wrote:
>
> > ok Heres the deal. I am posting this for all to see. I dot care how pissed Max will be at me, I dont care if he kicks me out of the guild. This is retarded. Its a game. I am done with you drama queens
> >
> >
> >
> > I'm done.

I have no clue what the hell Warren is talking about with regards to Chaos and Anglers... I was not aware that I've been in this raid since the BEGINNING just to get loot and run. I don't *think* that is what Helio and Marge were thinking when they joined a few months ago. The reason Sam, Hizouse, and Hatfield left a while back has nothing to do with them getting gear and USING you guys. WTF?

It is ironic that Warren basically geared Lotharia with us and then ditched

> while our GMOTD still said grats on 60.
>
> But do we actually care that much? Not really. People move in and out of circles of friends. It happens. People become busy or not busy at different times in their lives. It happens. Sheesh. To think that our social movements are planned just to affect your life, Warren... wow that is quite vain.
>
> If any of you read my paper, you would have seen how highly I praised this raiding group's ability to emphasize having fun and hanging out. I am not certain what happened over the summer but I believe the falling out going on right now is emotional and NOT due to loot, but rather due to the fact that we're just getting slightly tired of each other and the difficulties with Vael/Rags.

As an officer for the Booty Bay Anglers, I saw the need to defend each of them who were regular MC raid members, noting that none of them had used the raid group for personal gain and that some of them who had left had done so amicably and for good reasons. The summer was a particularly tumultuous time when many regular members had to change their gaming schedules due to offscreen seasonal schedules.

I also saw the need to point out that Warren was being hypocritical. When the raid group first started in late 2005, Warren was a member of the Booty Bay Anglers. He switched over to The 7/10 Split in early 2006 but had left one of his alternate characters, Lotharia, with the Anglers. Warren had been taking Lotharia to the Anglers' Zul'Gurub raids on Mondays, gaining many useful equipment upgrades, and had recently leveled up to 60. As was customary, guild officers congratulated Lotharia for reaching level 60 by posting it on our guild message of the day (GMOTD). It is unclear whether he had planned the timing, but shortly after reaching 60, Warren took Lotharia over to The 7/10 Split. Yet the Anglers did not mind. They understood that affiliations were transient.

At the time I was trying to grapple with the fact that I had just finished my first paper on the group, citing their collegial nature and camaraderie as their basis for trust and success. I could not believe that the raid group was breaking apart in part due to changing player motivations, and my recommendation was to "take a breather" and "come back refreshed."

Warren replied to my post ambiguously:

> **Warren <The 7/10 Split> (12:00 p.m.)**
>
> Thog I'll clue you in..it wanst Anglers or Chaos

This was universally confusing to all the Anglers I talked to. Why, if we were not the problem, did Warren name us as problems in his original post? Before I could ask for clarification, however, the forum administrators decided to lock this thread as well:

Lucy <The 7/10 Split> (12:01 p.m.)
We dont need more fuel to this or any fire. Thoguht, emotions are running very high due to several issues right now. You have not been present for some of the latest fireworks and perhaps do not know the entire story. Regardless, in the spirit of forward thinking, I will not let this thread turn into another "who said what to whom" Locked.

Again, rather than explain what had happened to me and other raiders who may have not been present during "the latest fireworks," the forum administrators chose to sever communication lines.

Making Sense of the Meltdown

The way the raid group dissolved clearly shows how quickly a group meltdown could occur. Two months of frustrations had already existed, but the critical moment in which the raid died was sudden and full of spite, anger, and paranoia. It was so sudden, in fact, that many raid members did not even know what was happening on the message boards until a few days after the fact. This let a vocal minority dictate the tone of the argument, which was on the verge of becoming an all-out flame war—when disagreements turn into verbal abuse and ad hominem attacks, a type of discourse commonly associated with web message boards.

Contrast this with the previous alignment work done by the raid group following the poor-performing night, about five months prior, detailed in the "Communication" chapter. In that case, the group was able to realign itself after that night's dispute over loot in a thread on the web forum—the same web forum where this final meltdown discussion happened. Members of the group were able to remind others that they were in it because they were "family" and that conflict was expected, just as with offscreen families, noting that those conflicts were temporary and not grounds for dissolving the group. Furthermore, most of that alignment work came from regular raid members who were not in leadership positions. One key difference between the talk in

that previous forum thread and this one was the use of "drama" as a framing point (Goffman, 1986). In the previous case, the forum was used to repair the raid through restating group goals and framing the setback as simply a to-be-expected temporary clash between family members. This time, however, multiple raiders (e.g., Lori, Warren, Min) had positioned the raid amidst drama, and the simple act of calling it drama may have turned it into drama.

The raid members needed to play a meta-game of learning how to resolve conflicts born of the differences between individual goals and expectations versus group goals and expectations. By the time the raid group finally broke apart, many players had moved away from the group's stated goals of "hanging out and having fun" and onto more individualistic goals of obtaining loot and progressing with raid encounters. It is possible that these motives and goals were a natural change after the group became successful with completing Molten Core. Perhaps, it was necessary for the group to have a new, shared task that had not been mastered—to have an external threat to the group that required collaboration and coordination among group members—for the group to build and maintain a strong group identity and trust between members. Even though Blackwing Lair was new, the fact that the group was struggling with Molten Core, which had previously been made routine, represented a step backwards for the group. If, as Malaby (2009) claims, successful performance of contingent actions nets people cultural capital, failure while performing an act that was not supposed to be contingent anymore could be seen as a blow to the group's self-esteem and did not add anything to its members' cultural capital.

The cost of raiding without progress and dealing with drama was too much for some players, since the loot rewards were not coming quickly enough to offset these costs. Mandy, long before the meltdown, had calculated the cost of raiding in U.S. dollars. She posted on the Booty Bay Anglers' forum:

Mandy <Booty Bay Anglers> (June 10, 2006 5:39 p.m.)

Let's consider that the Split raid can do six bosses in a 4 hour MC run. This is a minimum of 8 BoP epics (probably closer to 10), plus associated BoEs, greens, mats, etc. Let's call it a total of 12 epics, plus 500g worth of materials (cores, essences, etc.) and another 400g in flat cash. The greens, mats [raw materials needed to brew potions and create other consumable items that buffed the raid before a fight], etc. are effectively the property of the raid (and go for repairs, potions, enchants, or improved raiding gear). The 400g means each raider gets about 10 gold per run (seems high but I'm basing it on getting about 1.4g per boss plus trash cash), which doesn't quite cover the cost of raiding.

This means that each epic takes 3.33 people 4 hours of work. At an assigned

> cost of $10 per person per hour, an epic is worth $133 in labor alone. This doesn't include raid leader time, guild officer time, farming time outside the raid for materials, etc. This is with a mature raid that normally one shots [killing a monster on the first attempt] bosses and is looking at being able to condense all of MC into a 5-7 hour run. The labor cost per epic in a new raid is much, much higher. Thus, loot drama, and the reason for DKP and any number of other loot distribution systems that concentrate very hard on being "fair", or oriented toward "raid efficiency."

Item names in WoW were color-coded depending on rarity and power. Regular non-magic items were colored white, common magic items were green, rarer items were blue, and *epic* items were purple. BoP items *bound* to a character as soon as they were picked-up by a character, which meant they could not be traded to another character. BoE items bound once they were equipped.

While the raid group prided itself in using an informal loot system and emphasizing a laid-back attitude where relationships mattered more, it was clear that the cost of raiding (e.g., "$133 in labor alone") was starting to take its toll and erode the stability of the raid group.

After the raid meltdown, the Booty Bay Anglers started a thread on their web forum theorizing about why the group dissolved. In it, Helio noted that even family raids must have raided for loot and progression:

> **Helio <Booty Bay Anglers> (Sep 13, 2006 6:10 a.m.)**
>
> As to my own theories on failure, I think Maxwell said it best when he said "Vael breaks raids".
>
> This is just one boss in one instance, but the deeper truth is this. If you are not PROGRESSING.. if you are just beating your head against the same boss for an extended period.. stress levels rise. Cost levels rise. Thoughts of "why the hell am I going to X dungeon tonight to spend 15g in repairs to see nothing.. I could be with the missus or playing with my kid or getting some REALLY GOOD PORNOGRAPHY downloaded.." spring to mind. (The last one is mine).
>
> If you are either progressing or clearing content, the stress level is much lower and as a result, people have more stamina to roll with the punches. When we were working on panther, I think we did it the smartest way. We worked on her, then went to do something we COULD do (Snakey), so it didn't feel like a total waste of time. If all we had done was go to Panther for 5 hours and then go home, I think people would have been a lot more stressy.
>
> Let's face it. You can have fun with your guild while fishing, or PvPing, or 5 man BRD demolition runs (hoot). You do not need 40man instances to have

fun. You go to those places for 2 reasons.

1) See content.

2) Get loot.

If neither one is being achieved, the questions start coming up.

Now, as to Split in particular, I feel really bad for them, and Maxwell in particular who is in my opinion a really stand up solid guy and a great leader. But I think they lost sight of a fundamental point. They were trying to raid like they were a BWL raid guild with MC on farm, when in fact, they have not cleared (or even been capable of clearing) Rags in over a MONTH. The reality check is due.

....

I think some 'family guilds' fool themselves when raiding in a way that 'Hardcore guilds' do not.

Family guild : Oh we're all friends and this is no stress and we're just here to enjoy the game and if we get loot, great'.

Hardcore guild : People want loot. Here's how you get loot. You are not a bad person if you go somewhere just for loot.

I think one expectation of human motive is more honest than the other, when push comes to shove.

Helio makes a point that a raid is always about loot and progression to some degree. Some "hardcore" groups may be more explicit about those goals, but if they were not goals to begin with, the group could elect to do some other activity together. Note that Helio holds Maxwell in high regard, seeing that a "stand up guy" was placed in a stressful position. Note also that Helio is conflating "guilds" with "raids," as is often done, even though he was a member of the non-guild specific MC raid group.

An alternative explanation could just be the simple fact that the raid group had been engaged in MC / BWL / Onyxia raiding for almost a whole year at 15 hours a week. I sometimes find it difficult to hang out with the same people for an extended period of time, and rarely do I spend that amount of time with offscreen friends engaged in joint activity. It is possible others are like me and we were just tiring of each other. When I asked if this was true of other Anglers, Sam replied:

Sam <Booty Bay Anglers> (Sep 13, 2006 7:16 a.m.)

I think tired of each other is definitely part of it Thoguht. Part – like most things, it is a large combination of factors. I maintain my argument that no matter how much people protest, it is to at least some degree about the loot – who isn't happy to get upgraded gear? That doesn't mean that the overriding interest isn't to 'see content' and beat new bosses, have new accomplishments while hanging out with friends. Certainly I think Helio is on to some important points re: held up / backwards moving progression.

....

Sam recognized that many factors played a role in why the group dissolved. Part of it was that we were getting tired of each other, but he agrees with Helio that the biggest reason was that raiding was at least in part fueled by the desire to gain better equipment and make progress with new bosses. It seemed that over the summer of 2006, more and more raiders were focusing on this aspect of their motivation for engaging in raid activity. When the raid failed to progress and, in fact, actually regress, the raid was bound to dissolve.

The translation work that goes into constantly repairing the network of the raid—renegotiating responsibilities, enrolling new actors, aligning members to a group identity—was so effortful for some players that it became extremely emotional. Maxwell hit upon this with his last post: "I thought of you as a friend, and now you treat me like this? Insult me to my face? I don't understand it." Matt's attacks were seen as betrayals to their friendship and trust. They were unexpected and could not be understood, ending only in sadness and confusion.

This sequence of events also played an emotional toll for me. I had just finished writing my first paper, arguing that the success of the raid group depended on its ability to align its members to the group goals of hanging out and having fun. I did not know how to interpret the raid's meltdown, and it seemed hypocritical of me to be publishing something that lauded the group's success while simultaneously watching its sudden downfall. The speed and finality of it came as a complete shock, and I admit writing this account was cathartic. I am perhaps following a path tread by other researchers, such as Kolko and Reid Steere (1998) when they write in a paper describing the dissolution of an academic online community: "this story comes down perhaps too heavily on the participant side of the participant-observer relationship. This chapter grew out of nearly 3 years of trying to make sense of what happened during those months" (p. 215). Like Kolko and Reid Steere, it took

me several years before I could start making sense of my raid group's meltdown.

Ultimately, the raid meltdown was a combination of many factors. There was increasing tension between different player goals, certain players were tiring of each other, and frustrations existed from our changing roster of regular players and slow progression in dungeons where we had previously been successful. Eventually, all raid groups end. Whether the end is amicable or is brought about by too much drama does not matter. Both of these conditions represent the raid network's inability to repair itself. They both exist when group members are not in agreement on how roles and responsibilities should be distributed and who should be included in the network. In other words, even when the break up is amicable, the various members of a raid group are no longer a network into which all actors have been translated; there is no longer a shared understanding of roles and responsibilities.

※

Years later, all of the raid members have moved on. I know that later in 2006, about half of the members of The 7/10 Split decided to switch servers. My guild, the Booty Bay Anglers continued to delve into smaller raid zones and was relatively successful with organizing a new raid group for the 25-person endgame content in WoW's first expansion, *The Burning Crusade* (BC). I stopped playing for half a year, started again with a new raid group in Karazhan (one of the new raid zones in BC), quit "for reals" for another half a year, and now play sporadically with a new guild on a different server. Thus, the microcosm of the mangle, represented by my original Molten Core raid group, exploded to be absorbed by the macro mangle of play. We became leet noobs in new settings, part of the continual reassembling of networks.

Tension Between the Roles I Play

I am a researcher. Following the tradition of online games ethnography (Steinkuehler, 2004; Taylor, 2006a; Nardi, 2010), I observe and participate in player practice and write what I see. I watch people make friends and enemies both in the context of the game and on a more personal level. Sometimes I see things happen between players that I find distasteful or even detrimental to one or more of the players' emotional state. Yet, I am hesitant to intervene because I fear it may jeopardize what may occur and what I may observe.

I am an educator. I believe in equitable access to education because education is empowering and can lead to social mobility as well as the skills to engage critically in the social world. I feel a compelling need to intervene, when I can, to help people understand key points about their games and their social interactions and to help them socialize into a community of practice. In fact, when I observe in-game antisocial behavior, this educator role sometimes prevents me from distancing myself and avoiding offensive parties.

I am a gamer. I just want to play and have fun. I don't have, nor do I feel I should have, the authority to tell other gamers how to play. As one gamer out of many in a huge social world, I have to follow the norms set by the community.

These three roles I play in WoW presented me with several situations in which I had to decide whether to intervene. In a few instances, I felt the urge to introduce ideas from scholarly literature to the other players, but I held back. I became acutely aware of my position as an educator / researcher and whether it caused me to treat the game and the other players any differently than I would have if I were simply playing a game. Moreover, negotiating the balance between these roles has also changed my personal understanding of what "play" means.

These tensions came to the forefront because I was one of the founders and initial leader of my guild, a position with authority and power. This mini-chapter covers an example of the ethical dilemmas I encountered that question

my identity as a gamer who also identifies himself as an educational researcher and the responsibilities that arise from that role and the role of a guild leader.

Yar

One day while playing, I received an in-game private message from a guild member saying that he met two players who wanted to join our guild. I asked him to have the two of them contact me. When one of them, Yar (I failed to capture Yar's character class in my field notes, so I'm not using my standard naming convention for his alias), did contact me, he did so very informally with no punctuation or capitalization and with many words spelled incorrectly. I should have known from the get go that he would not have fit in the guild.

The Booty Bay Anglers's policy on potential new recruits was first to inform them about the guild and its purpose and to ask why they wanted to join. The guild would then have them group up or party with existing guild members for a few hours. The existing guild members could then recommend whether we invite the potentials into the guild. This way of screening our members ensured that all its members share the same focus on cooperation and a friendly environment. We also could tell how the players performed in a group situation and whether they knew how to party with a group effectively and conscientiously. Unfortunately, this screening method had a major flaw.

In order to get a good sense of a player and his or her performance and social behavior, it is important to have the player interact with other players of about equal character level. If this doesn't happen, then the obstacles the party must overcome are either too difficult or too easy for a particular character and so the player may act differently than he or she would normally behave in natural in-game situations.

The Anglers at the time had no characters of about the same level as the two potential members. I decided that they should not be denied membership due to a failing of the guild, so I invited them to the guild on a probationary period. If, after a week or so, it was clear that they fit in nicely then they could become full members. It became quickly apparent, however, that Yar did not fit in.

Yar tended to ask a lot of questions that one could discover the answers to from just a few hours of playing and socializing. He or she also continually begged for gold to buy equipment when all the other guild members knew that for a character of his or her level, the best way to acquire better equipment was to complete quests and kill monsters. Any items purchased would be made obsolete within a few hours of playing. Furthermore, Yar tended to use leet

speak more than what the guild thought was socially acceptable and spam the chat channel with questions about what to do next. Finally, it was discovered that Yar's player and the other player who joined the guild were 13 and 10 years old. Ironically, the 10 year old was the one who socialized just fine. After a couple of days in the guild, Yar's player decided to make a new character, Tla. In fact, Yar's player created many new characters to try them out and get a feel for which class he or she wanted to stick with. For each new character, the player wanted a guild invite. The guild is composed of characters, not players, so a specific player could have multiple characters in the same guild. Most other players, however, tried out different classes or characters on their own and asked to join the guild only after finding a combination that they wanted to stick with for at least several weeks.

The educator in me wanted to encourage Yar's player to try out different roles and eventually learn the social norms of the game community and why he or she didn't fit in. I did not want to kick someone out of the guild just due to his or her age. There was discussion about Yar on the guild's website, however, which changed my mind. Here's a reason given by Rage, a veteran of the Anglers, on why the guild should filter by age:

Rage <Booty Bay Anglers>
I mean some of the conversations we have in guild chat...are inapropriate for kids 13 and under. I mean Penfold hits on Robinia and Lily 24/7 and I was thinking (what if they are like 13 years old in RL thast not really good.

There was also concern among guild members that they would have to censor what they say or somehow lessen the impact of their utterances for fear of emotionally damaging a minor. One member said, "...I don't want to feel 'driven to silence' inside our own guild for fear of harming someone...." The most compelling reason, though, why the guild should have dropped Yar was that he or she did not fit in, regardless of age. Lott, a guild officer said:

Lott <Booty Bay Anglers>
Yar, it seems, isn't learning the rules. I am not the most patient of people, I know this, but long years of tech support have trained me to give everyone one 'get out of stupid free' card. Not everyone knows everything, so I'll explain once fully and with small words. My issue comes up when the same question is asked over and over and over. What class is best? Can I have...? And so on. I have nothing against most 'Can I haves', to keep that clear. We offer stuff on guild, someone wants it, it goes. We need a resource, we ask those who have it. So long as things are kept reasonable, there's no problem. Where I started

> getting irked was in the wanting of everything, usable or not. Of being level 10, and wanting gold, above and beyond that used to buy a tabbard. Attitudes like that risk destroying the freeflow environment we've got set up, because those who are generous with their time and supplies would become less so.

I decided to (gently) remove Yar and the friend from the guild. I explained to them why they didn't fit in, and I found them another guild to join because I did not want them to feel like there was anything inherently wrong with them. I had to remove both of them since they came as a pair and wanted to stay together. A few days later, Tla sent me an in-game message and we had a conversation which squelched some of the guilt I was experiencing. Here's part of the transcript with my [comments in brackets and italicized].

[Tla] whispers: and I just turned 14 today

To [Tla]: Happy bday!

[Tla] whispers: hehe ty [laugh, thank you]

[Tla] whispers: maybe bday present? hehe

To [Tla]: Was the tabard not enough? [I had given Tla money for a guild tabard (featuring the guild emblem and particular design) when Yar first joined the guild not knowing the player would later be kicked out. The tabard once purchased stays with a character even if that character joins a different guild. It then takes on the attributes of the new guild's tabard. In other words, one doesn't have to purchase it ever again.]

[Tla] whispers: maybe some hard cold w [I think he meant "cash" but not sure exactly what "w" means.]

[Tla] whispers: hehe , well that's just out of niceness with u are ["with" is probably "which"]

To [Tla]: If I remember right, it cost 1 g. [1 gold is quite a bit to a character of his level.]

To [Tla]: Yes... :)

[Tla] whispers: u are right shoot u never wrogn [I wish.]

Even after telling Yar/Tla why the guild asked me to drop him or her, the player persisted in asking for in-game money and favors and continued not to understand that proper English counted in our guild. I now realize that removing Yar from the guild was the wise decision if only to keep the guild together and support our "freeflow environment."

Due to this experience, the Anglers adopted a new screening criterion. If we thought we could tell that the potential guild member was a kid, he or she

was not allowed. In other words, if someone acted as if they were 10, even if offscreen they were 45, they were not allowed in the guild. The problem with our new criterion is that now we may be too critical of new recruits. More recently, someone wanted to join who we found out was 14. Our initial reaction was no, based on his age. Since I was "in charge" that day and because I'm such a "softie," I eventually persuaded the guild to let him go through our normal membership process of having him spend time with others at about his character level. This worked out fine.

Socialization and Inclusion

It has been argued that online spaces are less risky and allow for a wider range of behavior because users can start anew very easily by changing their screen name (cf. Clark, 1998, though she was talking about online dating). These arguments, however, use instant messaging and online chat communication as examples. MMOGs, like MUDs before them (Turkle, 1995), do not lend themselves to the same sorts of persona abandonment due to the amount of time and effort needed to cultivate one's avatar or on-screen character. Miroslaw Filiciak (2003) writes (p. 91):

> There are enough niches in the Internet to deconstruct one's identity, giving it a transparent form through the placing of various identities in a number of environments.... However, maintaining only one, long-term avatar seems to be an optimal variant [in MMOGs], because of the advantages that follow from its development, which also leads to a deepening of the player's investment in and identification with the avatar. It clearly shows that the residents of virtual lands treat their net-life much more seriously than it would seem to people from the outside.

Yet, some players, like Yar's player, freely abandon their personae when they have not yet established very strong ties to them. In other words, Yar's player was trying different characters and classes early on in his WoW experience. I think if he or she had spent several weeks on a particular character (and exhibited some patience), he or she might not have been so keen to treat his or her avatars as loosely as he or she had.

Other players don't quite fit in even if they place much value in their avatars' identities. I've come to the conclusion that some people, in any community—there were three problem guildmates over the years who stand out—will never "get it"; they will never socialize. This is depressing news for educators. Additionally, approaches to help others socialize have to be nuanced. Some things about the game could be taught through mentoring, but socialization seemed to be outside of the purview of direct instruction. In

my guild, the preferred way of learning—engaging in legitimate peripheral participation—was by personal observation. Lott wrote on the Anglers's message board

> Most people adapt to our attitudes quickly, I've found. They join, stay quiet for a bit, then once our 'social rules' are observed they feel out talking with us. And everyone wins!

This makes it difficult to intervene and help people socialize authentically. Authentic practice in this case emphasizes having fun. Things that appear to be hassles or frustrations make the game no longer worth playing.

In an attempt to be inclusive, some form of mediation needs to develop other than outright rejection from the group. Somehow, designers of communities need to legitimately introduce rules and boundaries. Too many specific rules from the start about how to interact and communicate with others would seem to limit the amount of "fun" players could get out of a game they purchased. Instead, these guidelines may have to emerge from within the player base for its members to value them. This mediation work really is about getting members of a group to find alignment with or translation to a particular network and its values, as framed by veteran members of the group. Once explicitly framed, such as stating that the group is like a family in Chapter 2 or stating that the conflict occurring during our meltdown was drama, the group can negotiate and agree on its endeavor and identity. The group can build trust and do work—build trust while doing work.

As a researcher, I was keenly interested in the development of the emergent culture and socialization process of my fellow gamers. As an educator, I wanted to intervene and help people out when I saw that they were not socializing well. As a gamer, I just wanted to immerse myself in the fantasy of the game and leave work behind. The tension between these stances was partially based on a mythical image of a social science researcher who has a responsibility to not affect what he or she is studying. This, I realize now, is completely ridiculous and unethical if the changes are beneficial and relevant to the participants. Tom Boellstorff, a pretty good authority on ethnographic research, for example, felt that it was his duty to help set up HIV centers during his research on gay and lesbian Indonesians (personal communication, 2011).

These tensions also come from a simplistic misunderstanding of what it means to play a MMOG successfully. In hindsight, it seems completely ridiculous for my guild and me not to expect that part of what makes for a successful guild is the management and negotiation of roles and norms. In other words, to put it in ANT language, any new actor (player) to the network

(guild) needs to be translated and enrolled into the network. This management is necessary for any social endeavor, and the time spent on a setting up a new group can initially eclipse the actual activity the group is setting up to do. New actors, in turn, need to legitimately participate and build up their social and cultural capital with the group.

I've come to see the value of management work as integral to lasting "fun" involved with MMOG playing. Nick Yee (2006) writes: "video games are inherently work platforms that train us to become better workers. And the work being performed in video games is increasingly similar to actual work in business corporations" (p. 68). Yee refers to the work of playing the game—of leveling up and interacting with the game system—as well as the work of managing, dealing with politics, and negotiating social issues. These are foundational to the design of progress-based MMOGs. As outlined in Chapter 1, social networking is an important part of MMOGs, and the development of social and cultural capital in some ways defines progress and success more so than purely interacting with the game system.

Yet, the fact that the development of social skills and the ability to socialize are necessary to be successful in MMOGs is problematic. This would seem to indicate that some players will be more successful than others. Furthermore, there still exist relationships based on power and dominant ways of being that may marginalize the efforts of specific players. Whether players like Yar are not socializing successfully or are, in fact, being socially marginalized needs to be explored. Do they have power over their own position, or are they being positioned by others? In light of this, it is even more imperative that players who believe in inclusion and the protection of their fantasy as a place of escape, where social injustice doesn't exist, have to fight— ironically, *to work*—for what they believe.

Conclusion

Growing up, I had always been a gamer, but it was always in the shadows, after school, after work. Never did I think it would become part of my professional life. Then, about 10 years ago, something funny happened. People started valuing the knowledge I had about games. They wanted me to make exhibits that were based on games. (I used to design software exhibits for a science museum before graduate school.) I started thinking about games for learning and realized that all this gaming knowledge could be put to good use.

To be sure, there's still this dark part of my gaming practice that I rarely share with others. I am addicted to new experiences and stories with games. I'll pick up a new RPG and basically have to call in sick if it's extremely engaging, or, for whatever reason, feel the need to obfuscate how much it consumes my life outside of work for a few days. When a new game that I am particularly excited about finally arrives, sometimes I can put over 10 hours a day into the game. I'm not ashamed about it; it's just easier to not have to mention it to others. Easier to not have to explain myself or attempt to justify my time spent on games. What's more, I know others who spend yet more time than I do on gaming. 10 hours? Pshaw.

When *World of Warcraft* came out, my online gamer friends and I thought it'd be fun to check it out. Little did I know it would consume my life. Yes, for a while it threatened to jeopardize my graduate studies. But then I started reading what others had to say about games and learning, and not everything I read aligned with my personal experiences with games. I felt compelled to push at these ideas and theories, culminating in the book you read now.

When I started to study the game I was playing, I came to understand playing WoW in terms of new literacy studies and other sociocultural learning theories: Playing and meaning-making occurred in situated contexts where learning and becoming literate meant participating with a group, negotiating roles and responsibilities and engaging in dynamic practice. Essentially, players accrued social and cultural capital while playing, building their social networks and finding like-minded / like-practiced players to play with. After leveling up

and participating in this first stage of play, players then moved onto the "real" game: raiding. The activity of raiding was also dynamic and emergent, affected by new tools and developments within the larger mangle of play.

All of this describes group work in general! People come together to form teams to work on hard problems in many different settings. Many of these people are experts in their own fields. My research suggests that for those teams to be most successful, they have to share the same values and be aligned in their actor-network. The team members have to be able to trust each other to play their roles. A particular team becomes an entity unto itself, changing as group dynamics change and new challenges are met. The fact that I'm studying this teamwork in an MMOG is incidental. Leet noobs can exist in any domain of activity. Keep this in mind as you read my summary of this book's findings.

The Major Assertions of This Book

- Expertise in **World of Warcraft** is the ability to configure one's local setting with available sociomaterial resources in a way that supports efficient play. Expertise is not the ability to remember the exact numbers and "math" underlying the game. Rather, it is the ability to assemble and arrange the play space so that the work required in completing in-game tasks is distributed across all the various objects in the play space.
- Expertise is socially defined through player practice that emerges from the push-pull relationship between constraints and workarounds. This emergence builds upon itself with mostly tiny changes in practice based on a history and tradition of raiding that has roots in MMOGs, MUDs, computer role-playing games, tabletop role-playing games, war games, etc. At the same time, developers continue to tweak underlying code for the game, narrowing play towards numbers, normalizing such game practices as theorycrafting and min-maxing.
- Therefore becoming an expert really depends on access to the mini-cultures in which these practices emerge. Without this access, a player is ignorant of emergent raiding and non-raiding norms and the details of their dynamic social and material practice. Access depends on successful buildup of social and cultural capital. These two forms of capital build off each other. The emergent culture means that contingent embodied acts that are of value are collectively defined. Without this collective, historical backdrop, social capital cannot

accrue. It is the experiences that players have with each other that define the culture and build social capital and social networks. This may have strong implications for traditional schooling. If becoming an expert—*becoming* a participant in general—depends on engaging in legitimate practice, what does it mean for our schools that traditionally teach content and facts rather than processes and activities that are situated in specific contexts?

- **Yet social and cultural reproduction and enculturation continue the narrowing or normalizing aspects of game play.** An example is how certain player-created modifications to the game served as ways to give players both better awareness about fights, letting them be more aggressive in their game play, *and* as ways to place players under surveillance, pushing them into certain ways of playing.

- **My raid group's success could be understood through the concept of trust.** We trusted each other to play our agreed-upon roles and be responsible for necessary tasks in our raiding network. Again, this trust was based on our collectively accrued social and cultural capital.

- **Thinking about how roles and responsibilities were distributed lends itself to an object-oriented ontological way of analyzing the setting.** Actor-network theory, the mangle of practice / play, and distributed cognition—all of these were useful for understanding the ecology of raiding and group expertise. The emergent practice was a collective social and material endeavor.

- **Disruptions and failures required repair work and renegotiation of roles and responsibilities.** This repair work was done through multiple communication channels over various timescales. Disruptions also helped me trace associations between actors in the network. Failures and the right framing of them as opportunities for reflection are the most efficient way to learn how to raid / do group work.

- **Over time, as raiding became more mature and more narrowly defined by standard sociomaterial practices, the basis of trust changed from trusting others to play their roles to trusting others to use communal technomaterial objects—to distribute certain responsibilities of raiding to a common set of nonhuman actors.** In other words, the cultural capital changed from embodied knowledge to capital in the form of artifacts and credentials. This was still based on our emergent practice, but the shift to number crunching had a lasting effect on the family-feel of the group. Game designers take note: This does not mean I suggest you deliberately design games that

enforce mechanics-based trust or solutions to social dilemmas. Rather, I think there was something lost in the strength of the bonds of The 7/10 Split-led MC raid group as they moved into mechanics-based trust. We changed from being friends and family to just co-workers. Do you want your players to be co-workers or would you rather they be friends?

• **Shared, negotiated goals are necessary for the continued existence of an online team.** Eventually the raid group broke up. We lost our collective goal of hanging out and having fun. How this happened could be explained in a few different ways, but, primarily, I believe that the increasingly narrow ways of playing the game changed the goals of some of the players to gaining loot and maximizing progress with raid fights, and these differing player motivations could not be reconciled. Nor could it be framed productively: We had drama!

That the importance of the development of in-game communities and individual social skills is not as immediately obvious as the mechanics-based part of the game is a detriment to the MMOG genre. Very little, in fact, is in place by the developers for the management of guilds and other groups, such as raids. For example, Blizzard Entertainment has made an online tool (known as the Armory) available to track raid progress in the various endgame dungeons found in the game (Blizzard Entertainment, 2008). These raids, however, are tracked by guild, conflating raids as single-guild affairs, marginalizing the efforts of the multi-guild raiding that were done on my server. The Armory overemphasizes guilds as vehicles for progressing in in-game content. Rage described the problem succinctly by posting, "We're not a raiding guild. We're a guild full of raiders."

What's worse, back then there were no official tools to measure the success of or even support the other kinds of activities guilds may value, and the ones that exist now are still all about progression and competition. There's no easy way to track, for example, guild attrition, happiness, or strength of social relationships. There's no way to schedule in-game parties, role-play events, or meetings other than to appropriate new tools Blizzard introduced years later to help schedule raid events. These are all left to individual groups of players to manage via third-party tools or outside web packages.

This reminds me of the "hegemony of play" that Fron, Fullerton, Morie, and Pearce (2007) talk about in their paper of the same name, in which they describe the gaming industry's "complex layering of technological, commercial and cultural power structures" (p. 309) that serve to marginalize "minority" players. What I saw in WoW adds to their argument by showing that these

structural forces can also change within a game's space over time—several years in WoW's case—to slowly increasingly marginalize players who value non-normative ways of being in the world. Furthermore, these forces were not driven solely by WoW's developers. They emerged and were reproduced out of the mangle between progress-minded players, profit-minded "players," developers, add-on creators, theorycrafters, and hordes of players who were "just players having fun."

One of the reasons I left the Booty Bay Anglers was not because I was tired of the guild, but more that I was tired of what it meant to play. I found that once the guild became a stable community with our own sub-culture, there was no game to support it. The cooperative, inclusive group that I was a part of seemed almost inappropriate for how the game had evolved, as the gaming community overemphasized raid and loot progression. Since our guild did not inherently value these things, concentrating instead on being supportive of *values* whatever endeavor individual players valued, many players found that there was a mismatch between the game and the Anglers's all-inclusive attitude towards emergent ways to play the game. And this extended to the overall player community that I participated with on my RP server. The Molten Core 7/10 Split raid group's meltdown was just a symptom of this larger problem. Where before we found alignment in valuing our emergent goal of hanging out and having fun, we became fractured as WoW matured and its narrowing play squeezed us into a meltdown. Some players went with these structural forces and began to value loot and progression. Realizing that the Anglers and Splitters were not a right fit anymore, many of those players chose to leave, meltdown or no. In mid-March 2005 (a year before my raid group's activities!), Lott, an officer for the Anglers—who in hindsight was particularly good at being prescient, probably from his years of experience playing MMOGs well before WoW—put it very plainly in [Officer] chat when he said

> The game mechanics are geared towards raiding and loot whoring, so socialites suffer... It's not worth our stress being "everything for everyone." If people want to move on, I say let them. Then they will miss what they had here.

Having come to understand better the (in)distinction between work and play with *World of Warcraft*, I've also come to realize that it's not the perfect game for me. When I want to lose myself in a game fantasy, focus on understanding the game mechanics, and work within a rule-based system, there are far better single-player games to play, where I won't have to deal with the social issues that come up with the inclusion of other players. When I want to socialize with others, collectively participating in shared activities, *World of*

Warcraft provides good raiding activities but it does not provide support for non-guild-based raid groups or support for non-raid activities.

Putting it another way, while it may seem that the problem with multiplayer games like WoW is dealing with other people (ironic!), in fact, the problem is that participating in the mangle of play takes work. It involves a lot of (virtual) blood, sweat, and (real) tears. But it also promises real triumphs and semi-virtual glory.

Victory!

This is the text chat log from the first recorded Ragnaros kill (starting mid-fight), May 19, 2006. I still tear up when I read this:

21:12:54.984 : [Raid] Maxwell: *** 15 seconds until Ragnaros emerges. ***

21:13:02.171 : Maxwell yells: ATTACK!

21:13:02.171 : [Raid] Maxwell: ATTACK!

21:13:03.000 : Maxwell yells: ATTACK!

21:13:03.140 : [Raid] Maxwell: ATTACK!

21:13:07.421 : Ragnaros yells: TASTE THE FLAMES OF SULFURON!

21:13:07.671 : [Raid] Maxwell: *** AE Knockback ***

21:13:10.250 : [Raid] Maxwell: *** Ragnaros has Emerged. 3 minutes until submerge. ***

21:13:12.484 : Ragnaros yells: DIE, INSECT!

21:13:12.734 : [Raid] Roger: 33%

21:13:20.937 : [1. madrogues] Roger: dump on him, just dont draw aggro.

21:13:24.328 : Rand has died.

21:13:38.343 : Ragnaros yells: BY FIRE BE PURGED!

21:13:38.890 : [Raid] Pall: out of mana

21:13:41.671 : Ragnaros yells: TASTE THE FLAMES OF SULFURON!

21:13:42.312 : [Raid] Maxwell: *** AE Knockback ***

21:13:56.921 : [Raid] Paula: down

21:13:57.671 : [Raid] Mandy: 1m 42

21:14:00.093 : Ragnaros yells: DIE, INSECT!

21:14:02.515 : Ragnaros yells: BY FIRE BE PURGED!

21:14:04.703 : [1. madrogues] Roger: pay attention to the knockback.

21:14:05.015 : [Raid] Maxwell: *** 5 SECONDS UNTIL AE Knockback ***

21:14:05.890 : [Raid] Dierdre: oom

21:14:10.687 : Ragnaros yells: TASTE THE FLAMES OF SULFURON!

21:14:11.234 : [Raid] Maxwell: *** AE Knockback ***

21:14:14.218 : Ragnaros yells: BY FIRE BE PURGED!

21:14:23.703 : [Raid] Mandy: We're good

21:14:32.828 : [Raid] Pall: Will's healers are down!

21:14:34.109 : [Raid] Maxwell: *** 5 SECONDS UNTIL AE Knockback ***

21:14:37.609 : [Raid] Paula: 5%!!!!!

21:14:41.000 : Ragnaros yells: TASTE THE FLAMES OF SULFURON!

21:14:41.437 : [Raid] Maxwell: *** AE Knockback ***

21:14:41.671 : [Raid] Woz: Go go go!

21:14:41.906 : Rapa calls out for healing!

21:14:44.625 : [Raid] Thoguht: Ironically, I have two healthstones.

21:14:48.906 : [Raid] Roger: its not over yet.

21:14:52.593 : [Raid] Paula: 1!!!!!!!!!!!!!!!!!!!!!!!!!!!!!!!!!!!!!!

21:14:52.859 : Ragnaros yells: DIE, INSECT!

21:14:53.921 : [Raid] Woz: *Cheers from the deathpile* GO!

21:15:00.093 : [Raid] Pall: nice

21:15:01.781 : [Raid] Helga: phew

21:15:01.843 : [Raid] Mandy: WOO!

21:15:02.656 : [Raid] Heather: yaaaaaaaaaaay

21:15:03.093 : [Raid] Maxwell: WOOOOO!

21:15:04.734 : [Raid] Shaun: jesus

21:15:04.734 : [Raid] Roger: thank fucking god.

21:15:08.671 : [Raid] Shaun: JESUS

21:15:11.078 : [Raid] Wong: YARRRR!!

21:15:11.296 : [Raid] Shaun: MY HEART

21:15:13.359 : [Raid] Roger: <3 Shaun

21:15:15.265 : [Raid] Shaun: I'M DYING

21:15:18.171 : [Raid] Matt: /cheer

21:15:22.578 : [Raid] Shaun: MY HEART IS LITERALLY OUT OF MY CHEST

21:15:26.734 : [Raid] Shaun: I BOTH HATE AND LOVE YOU ALL

21:15:28.687 : [Raid] Shaun: hahahah

21:15:29.609 : [Raid] Shaun: <3

Raid and Guild Members

Class	Alias	Sex	Race	Alt (Known)	Guild
Druid	Dashiel	M	Tauren		Crazy Vikings
Druid	Derek	M	Tauren		The 7/10 Split
Druid	Dierdre	F	Tauren		Crazy Vikings
Druid	Drusella	F	Tauren		The 7/10 Split
Hunter	Hala	F	Orc		The 7/10 Split
Hunter	Hall	M	Troll		The 7/10 Split
Hunter	Hannah	F	Orc		no data
Hunter	Hatfield	M	Orc		Booty Bay Anglers
Hunter	Hattie	F	Orc		The 7/10 Split
Hunter	Heather	M	Troll		The 7/10 Split
Hunter	Helio	M	Orc		Booty Bay Anglers
Hunter	Henry	M	Troll		The 7/10 Split
Hunter	Hizouse	M	Orc	Doug	Booty Bay Anglers
Lock	Lara	F	Orc	Sheila	Booty Bay Anglers
Lock	Larry	M	Undead		The 7/10 Split
Lock	Lauren	F	Undead		The Woodwhisper Clan
Lock	Leon	M	Orc		no data
Lock	Lester	M	Undead		Eat at Chaos
Lock	Lev	M	Undead		no data
Lock	Lex	M	Orc		The 7/10 Split
Lock	Lily	F	Orc		Booty Bay Anglers
Lock	Lori	F	Undead		The 7/10 Split
Lock	Lott	M	Orc	Danny	Booty Bay Anglers
Lock	Lucy	F	Orc	Helga	The 7/10 Split

Mage	Mandy	M	Troll		Crow Sight
Mage	Marcie	F	Troll		Crazy Vikings
Mage	Marge	F	Undead		Booty Bay Anglers
Mage	Mary	F	Troll		no data
Mage	Matt	M	Undead		Eat at Chaos
Mage	Maureen	F	Undead		The 7/10 Split
Mage	Maxwell	M	Undead		The 7/10 Split
Mage	Meep	M	Undead	Darren	Booty Bay Anglers
Mage	Min	F	Undead		Booty Bay Anglers
Priest	Pall	M	Troll		no data
Priest	Pat	M	Troll		no data
Priest	Paula	M	Undead		no data
Priest	Penfold	M	Undead		Booty Bay Anglers
Priest	Penny	F	Undead		Booty Bay Anglers
Priest	Perry	M	Troll		The 7/10 Split
Priest	Peter	M	Undead		Crazy Vikings
Priest	Pliance	M	Undead		The 7/10 Split
Priest	Pod	M	Undead		Eat at Chaos
Rogue	Rage	M	Troll		Booty Bay Anglers
Rogue	Rand	M	Orc		unguilded
Rogue	Rapa	M	Undead		Eat at Chaos
Rogue	Rebecca	F	Troll		The 7/10 Split
Rogue	Rita	F	Undead		The 7/10 Split
Rogue	Robinia	F	Undead		Booty Bay Anglers
Rogue	Roger	M	Undead		The 7/10 Split
Rogue	Rory	M	Troll		The 7/10 Split
Rogue	Thoguht	M	Orc	Mark	Booty Bay Anglers
Shaman	S	M	Troll		Booty Bay Anglers
Shaman	Sam	M	Tauren		Booty Bay Anglers
Shaman	Scott	M	Tauren		The 7/10 Split
Shaman	Shaun	M	Tauren		Crazy Vikings
Shaman	Shepard	M	Tauren		The 7/10 Split
Shaman	Sherrie	F	Troll		The 7/10 Split
Shaman	Slab	M	Orc		The 7/10 Split

Shaman	Sven	M	Troll		The 7/10 Split
Warrior	Wallace	M	Undead		The 7/10 Split
Warrior	Walt	M	Undead	Steve	Booty Bay Anglers
Warrior	Warren	M	Orc	Lotharia	The 7/10 Split
Warrior	Wei	M	Troll		Crazy Vikings
Warrior	Wendy	F	Undead		The 7/10 Split
Warrior	William	M	Undead		The 7/10 Split
Warrior	Willy	M	Undead	Red	The 7/10 Split
Warrior	Wong	M	Tauren		no data
Warrior	Woz	M	Orc		The 7/10 Split

Glossary

add-on – third-party modifications to *World of Warcraft*'s user interface

actor-network theory (ANT) – Basically, a way of looking at the world and activity in the world through an "object-oriented" lens. Things act upon other things, forcing those things to act. Sometimes these things are people; sometimes they are not people. Sometimes these things are groups of people and/or nonpeople, while sometimes they are parts of people or nonpeople. These "actors" or "actants" are defined by their relationships or associations with each other and by their functional roles. See Chapter 3 for much lengthier description.

AoE – *area of effect* damage that was spread out over an area instead of directed at a single target

afk – *away from keyboard* or *away from keys*

aggro – Short for *aggravation*; monsters attacked whichever character had aggro, usually gained by having the highest threat level. Can be used as a verb (e.g., "He aggroed the monster.").

AQ20 – Ruins of Ahn'Qiraj, a 20-person raid zone

AQ40 – Temple of Ahn'Qiraj, a 40-person raid zone

buff – a temporary boost to a character's power; opposite of debuff

BWL – Blackwing Lair, a 40-person raid zone, usually done after Molten Core

contingent acts – performative acts that have non-trivial risks associated with them. Successfully pulling them off can lead to accrual of cultural capital

cooldown – the time it took for an ability to recharge, allowing players to activate it again

CT Raid – CT_RaidAssist or CTRA, an add-on that helped with raiding

cultural capital– value in the reputation one has within a particular community or culture. This reputation can be based on (contingent) performative acts, on accolades or credentials, or on acquired cultural artifacts. A WoW player, for example, could gain rep by successfully pulling off a tricky move, by receiving certain titles through engaging in PvP battles, or by acquiring a tiered item set. (Within WoW, these three types of cultural capital become blurred, where, for example, tiered items have particular ratings associated with them that could be considered part of a credentialization system.) In other words, legitimately participating in a particular culture builds up one's cultural capital with it. See Chapter 1.

DPS – *damage per second*, a statistic valuing items and performance and a term used to classify characters whose role is to do damage to a monster

debuff – a temporary decrease to a character's power; opposite of buff

distributed cognition – Term used to describe how people work by offloading memory tasks to their available material resources. For example, I became a better player by enrolling third-

party add-ons into my play space and relying on them to keep track of in-game metrics. When other players talked about me as a player to add to their team, it did not matter to them that it was me plus my tools. Experts are experts because they know which tools and other resources to use.

dot – a debuff that did *damage over time*

drop – equipment that was "lootable" after monsters "dropped" them when they died

high-end – also called "endgame," content or loot that players experienced or acquired after reaching the level cap

IC – in character, used to describe talk that was done while role-playing; opposite of OOC

IM – *instant messaging*

IRL – *in real life*. Used to signify things that happened outside of the game, such as, "my irl work means I need to go to sleep now."

itemization – systematic valuation of loot and the process of acquiring more valuable loot

KTM – *KLH Threat Meter* or *Kenco's Threat Meter*, an add-on that kept track of threat

leet – *elite* or expert

leet speak – gamer lingo originating from hacker culture

level cap – the maximum experience level that characters could achieve before having to rely on more and more powerful equipment to "progress"

loot – equipment that was "lootable" after monsters "dropped" them when they died

Mana – magic energy reserves that spell casters used to cast each of their spells

mangle of practice / play – term used to describe an activity that has many parties with different motivations and goals such that their push-pull relationships and the resulting complexity of resistance and accomodation is a mangle

MC – Molten Core, a 40-person raid zone that was the focus of the group in this manuscript

metacognition – the ability to assess where one is in relation to a goal and identify next steps towards that goal

min-maxing – minimizing resources spent on useless attributes to free them up and maximize spending on useful ones

MMOG – massively multiplayer online game

mob – monster object, shorthand for monster or game-controlled enemy

MT – main tank, the primary tank for a fight that receives priority healing

new literacy studies – considers being "literate" as the ability to participate fully in a community of practice or affinity group

new literacies – People can be literate in a variety of settings with a variety of "texts." WoW gaming is one of these new literacies.

noob – *newbie* or novice

Onyxia – serious business that requires more dots, more dots, more dots

OOC – out of character, used to describe talk that was not limited to the fantasy of the in-game setting; opposite of IC

party – a small group of up to five players

PD – prisoner's dilemma, a hypothetical social dilemma in which two prisoners must decide whether to testify against the other

PUG – pick-up group. Can also be used as a verb (e.g., "I went pugging with some strangers.")

PvP – player vs. player

raid – also, *raid group*, a large group of players, composed of up to eight parties.

raiding – a high-stakes, joint-task activity that required careful coordination

rational – in game theory, players make "rational" decisions when they choose the most self-serving ones

repop – also *respawn*. When a monster died, it would get reinstantiated by the game server in a few minutes. In raid zones, repopping usually happened after a longer period of time, such as an hour.

rez – resurrect

SD – social dilemma, a hypothetical situation in which multiple participants decide to either cooperate or defect / free ride

social capital – the value in relationships or affiliations with friends, family, etc. because they are obligated to honor these connections

sociomaterial – resources that include both social connections (such as friends who know certain things or can do certain actions) and material objects (such as add-ons or website strategy guides). The lumping of the two words fits well with ANT, which considers "social" as the relationship of things (not necessarily people) to each other. Additionally, websites and add-ons are authored by people, making responsibilities that used to belong to people rest on nonpeople.

solo – as opposed to party, used as a verb to mean playing alone (e.g., "I'm going to solo that dungeon.")

spam – to activate an ability over and over again in rapid succession

tank – a character role meant to maintain aggro from monsters during a fight

theorycraft – modeling and testing theories about the underlying mechanics of a game

threat – Each ability activated during a fight generated a threat value. The total threat usually determined who had aggro.

tier – High-end equipment in WoW fell into ranked levels of power. In some cases, collecting a full set of armor from one of these "tiers" offered additional bonuses or abilities, which would help players as they moved onto tougher raid zones where the monsters dropped loot from the next tier up.

WoW – *World of Warcraft*

ZG – Zul'Gurub, a 20-person raid zone

Bibliography

Akrich, M. (1995). User representations: Practices, methods and sociology. In A. Rip, T. J. Misa, & J. Schot (Eds.), *Managing technology in society: The approach of constructive technology assessment*. London: Pinter Publishers.

Andrew. (2010). Video games and consciousness. *Little Bo Beep*. http://littlebobeep.com/2010/video-games-consciousness/

Axelrod, R. (1985). *The evolution of cooperation*. New York: Basic Books.

Barron, B. (2003). When smart groups fail. *The Journal of the Learning Sciences, 12*(3), 307–359.

Blizzard Entertainment. (2004). *World of Warcraft* guide [website]. http://www.worldofwarcraft.com/info/basics/guide.html

———. (2008). The *World of Warcraft* armory [website]. http://www.wowarmory.com/

Boellstorff, T. (2006). A ludicrous discipline? Ethnography and game studies. *Games and Culture, 1*(1), 29–35.

Bogost, I. (2006). *Unit operations: An approach to videogame criticism*. Cambridge, MA: The MIT Press.

———. (2009). What is object-oriented ontology? A definition for ordinary folk. http://bogo.st/32

Bourdieu, P. (1986). The forms of capital. In J. G. Richardson (Ed.), *Handbook of theory and research for the sociology of education* (pp. 241–258). New York: Greenwood Press.

Brandt, D. (1998). Sponsors of literacy. *College Composition and Communication, 49*(2), 165–185.

Bransford, J. D., Brown, A. L., & Cocking, R. R. (2000). *How people learn: Brain, mind, experience, and school: Expanded edition*. Washington, DC: Commission on Behavioral and Social Sciences and Education, National Research Council. National Academy Press.

Bricker, L. A., & Bell, P. (2008). Mapping the learning pathways and processes associated with the development of expertise and learner identities. In P. A. Kirschner, J. van Merriënboer & T. de Jong (Eds.), *Proceedings of the Eighth International Conference of the Learning Sciences* (vol. 3, pp. 206-213). Utrecht, The Netherlands: International Society of the Learning Sciences, Inc.

Callon, M. (1986). Some elements of a sociology of translation: Domestication of the scallops and the fishermen of St Brieuc Bay. In J. Law (Ed.), *Power, action and belief: A new sociology of knowledge* (pp. 196–223). London: Routledge & Kegan Paul.

Chen, M., DeVane, B., Grimes, S. M., Walter, S. E., & Wolfenstein, M. (2010). The mangle of play: Game challenges and player workarounds. Presentation at the Digital Media and Learning Conference (DML), La Jolla, CA.

Clark, L. S. (1998). Dating on the net: Teens and the rise of "pure" relationships. In S. Jones (Ed.), *Cybersociety 2.0* (pp. 159–183). London: Sage Publications.

Collins, H., & Evans, R. (2007). *Rethinking expertise.* Chicago: University of Chicago Press.

Cooper, G. (1998). Research into cognitive load theory and instructional design at UNSW. http://dwb4.unl.edu/Diss/Cooper/UNSW.htm

Csikszentmihalyi, M. (1991). *Flow: The psychology of optimal experience.* New York: Harper Perennial.

Deleuze, G., & Guattari, F. (1987). *A thousand plateaus: Capitalism and schizophrenia* (B. Massumi, Trans.). Minneapolis: University of Minnesota Press. (Original work published 1980).

Dennett, D. C. (1971). Intentional systems. *The Journal of Philosophy, 68*(4), 87–106.

Ducheneaut, N., Yee, N., Nickell, E., & Moore, R. J. (2006a). Alone together? Exploring the social dynamics of massively multiplayer games. In *Proceedings of CHI 2006* (pp. 407–416). New York: ACM Press.

———. (2006b). Building an MMO with mass appeal: A look at gameplay in *World of Warcraft. Games and Culture, 1*(4), 281–317.

Edge Staff. (2006). Austin: Secrets of WoW design. *Edge Online,* November 6. http://www.edge-online.com/news/austin-secrets-wow-design

Elitist Jerks. (2011). Rogue section on Elitist Jerks' web forums. http://elitistjerks.com/f78/

ETC Press. (2011). *Well Played* journal [blog post]. http://www.etc.cmu.edu/etcpress/wellplayed

Filiciak, M. (2003). Hyperidentities: Postmodern identity patterns in massively multiplayer online role-playing games. In M.J.P. Wolf & B. Perron (Eds.), *The video game theory reader* (pp. 87–102), New York: Routledge.

Fron, J., Fullerton, T., Morie, J. F., & Pearce, C. (2007). The hegemony of play. *Situated play: Proceedings of the DiGRA 2007 conference* (pp. 309–318). Tokyo, Japan. http://www.digra.org/dl/db/07312.31224.pdf

Galarneau, L. (2005). Spontaneous communities of learning: Learning ecosystems in massively multiplayer online gaming environments. *Proceedings of DiGRA 2005 conference: Changing views – worlds in play.* Vancouver, British Columbia, Canada. http://ir.lib.sfu.ca/handle/1892/1629

Games Learning Society. (2010). Games Learning Society: About us. http://www.gameslearningsociety.org/about-us

Gee, J. P. (2003). *What video games have to teach us about learning and literacy.* New York: Palgrave Macmillan.

Giddings, S. (2007). Playing with nonhumans: Digital games as technocultural form. In S. de Castells & J. Jenson (Eds.), *Worlds in play: International perspectives on digital games research* (pp. 115–128). New York: Peter Lang Publishing.

Goffman, E. (1986). *Frame analysis: An essay on the organization of experience.* Boston: Northeastern University Press.

González, N., Moll, L., & Amanti, C. (2005). *Funds of knowledge: Theorizing practices in households, communities, and classrooms.* Mahwah, NJ: Lawrence Erlbaum Associates.

Goodenough, W. H. (1964). Cultural anthropology. In D. Hymes (Ed.), *Language in culture and society* (pp. 36–39). Bombay, India: Allied Publishers Private.

Goodwin, C. (1994). Professional vision. *American Anthropologist, 96*(3), 606–633.

Gygax, G., & Arneson, D. (1974). *Dungeons & Dragons* [table-top game]. Published under

Tactical Studies Rules, Inc. (TSR).

Hardin, G. (1968). The tragedy of the commons. *Science, 162,* 1243-1248.

Harré, R., Moghaddam, F. M., Pilkerton Cairnie, T., Rothbart, D., & Sabat, S. R. (2009). Recent advances in positioning theory. *Theory & Psychology, 19*(1), 5-31.

Hatano, G., & Inagaki, K. (1986). Two courses of expertise. In H. A. H. Stevenson, H. Azuma, & K. Hakuta (Eds.), *Child development and education in Japan* (pp. 262-272). New York: Freeman.

Hawisher, G. E., & Selfe, C. L. (2007). *Gaming lives in the twenty-first century: Literate connections.* New York: Palgrave Macmillan.

Heath, S. B. (1983). *Ways with words: Language, life and work in communities and classrooms.* Cambridge, UK: Cambridge University Press.

Holland, D., & Leander, K. (2004). Ethnographic studies of positioning and subjectivity: An introduction. *Ethos, 32*(2), 127-139.

Holland, W., Jenkins, H., & Squire, K. (2003). Theory by design. In M. J. P. Wolf & B. Perron (Eds.), *The video game theory reader* (pp. 25-46). New York: Routledge.

Hutchins, E. (1995a). *Cognition in the wild.* Cambridge, MA: MIT Press.

————. (1995b). How a cockpit remembers its speeds. *Cognitive Science, 19,* 265-288.

Iacono, C. S., & Weisband, S. (1997). Developing trust in virtual teams. *Proceedings of the 30th annual Hawaii International Conference on System Sciences (HICSS), 2,* 412-420.

Jakobsson, M., & Taylor, T. L. (2003). The Sopranos meets *EverQuest:* Social networking in massively multiplayer online games. Melbourne DAC, the 5th International Digital Arts and Culture Conference, Melbourne, Australia. http://hypertext.rmit.edu.au/dac/papers/Jakobsson.pdf

Jenkins, H., Purushotma, R., Clinton, K., Weigel, M., & Robison, A. J. (2006). *Confronting the challenges of participatory culture: Media education for the 21st century.* Chicago: MacArthur Foundation.

Juul, J. (2005). *Half-real: Video games between real rules and fictional worlds.* Cambridge, MA: The MIT Press.

Knobel, M. (1999). *Everyday literacies: Students, discourse, and social practice.* New York: Peter Lang.

Kolko, B., & Reid Steere, E. (1998). Dissolution and fragmentation: Problems in online communities. In S. Jones (Ed.), *Cybersociety 2.0* (pp. 212-229). Thousand Oaks, CA: Sage.

Kollock, P., & Smith, M. (1996). Managing the virtual commons: Cooperation and conflict in computer communities. In S. Herring (Ed.), *Computer-mediated communication: Linguistic, social, and cross-cultural perspectives* (pp. 109-128). Amsterdam: John Benjamins.

Koster, R. (2004). *A theory of fun for game design.* Scottsdale, AZ: Paraglyph Press.

Latour, B. (1987). *Science in action: How to follow scientists and engineers through society.* Cambridge, MA: Harvard University Press.

————. (as J. Johnson). (1988). Mixing humans and nonhumans together: The sociology of a door-closer. *Social Problems, 35*(3), 298-310.

————. (2005). *Reassembling the social: An introduction to actor-network theory.* New York: Oxford University Press.

Lave, J. (1988). *Cognition in practice: Mind, mathematics and culture in everyday life.* Cambridge, UK: Cambridge University Press.

Lave, J., & Wenger, E. (1991). *Situated learning: Legitimate peripheral participation.* Cambridge,

UK: Cambridge University Press.

Law, J., & Hassard, J. (Eds.). (1999). *Actor network theory and after*. Oxford: Blackwell and the Sociological Review.

Lee, C. D., Spencer, M. B., & Harpalani, V. (2003). "Every shut eye ain't sleep": Studying how people live culturally. *Educational Researcher, 32*(5), 6-13.

Lemke, J. L. (2000). Across the scales of time: Artifacts, activities, and meanings in ecosocial systems. *Mind, Culture, and Activity, 7*(4), 273-290.

MacCallum-Stewart, E., & Parsler, J. (2008). The difficulties of playing a role in *World of Warcraft*. In H. G. Corneliussen & J. W. Rettberg (Eds.), *Digital culture, play, and identity: A World of Warcraft reader* (pp. 225-246). Cambridge, MA: The MIT Press.

Malaby, T. (2009). *Making virtual worlds: Linden Lab and Second Life*. Ithaca, NY: Cornell University Press.

Malone, K. M. (2009). Dragon kill points: The economics of power gamers. *Games and Culture, 4*(3), 296-316.

Nardi, B. A. (2010). *My life as a night elf priest: An anthropological account of* World of Warcraft. Ann Arbor: University of Michigan Press.

National Research Council. (2010). *Exploring the intersection of science education and 21st century skills: A workshop summary*. M. Hilton, (Rapporteur). Board on Science Education, Center for Education, Division of Behavioral and Social Sciences and Education. Washington, DC: The National Academies Press.

Norman, D. A. (1993). *Things that make us smart: Defending human attributes in the age of the machine*. New York: Basic Books.

Orlikowski, W. J. (2007). Sociomaterial practices: Exploring technology at work. *Organization Studies, 28*(9), 1435-1448.

Oudshoorn, N., & Pinch, T. (Eds.). (2003). *How users matter: The co-construction of users and technology*. Cambridge, MA: The MIT Press.

Paul, C. A. (2011). Optimizing play: How theorycraft changes gameplay and design. *Game Studies: The International Journal of Computer Game Research, 11*(2). http://gamestudies.org/1102/articles/paul

Penny Arcade. (2004). A being of indescribable power. http://www.penny-arcade.com/comic/2004/12/31/

Pickering, A. (1993). The mangle of practice: Agency and emergence in the sociology of science. *American Journal of Sociology, 99*(3), 559-589.

Prensky, M. (2000). *Digital game-based learning*. New York: McGraw-Hill.

Rogoff, B., Topping, K., Baker-Sennett, J., & Lacasa, P. (2002). Mutual contributions of individuals, partners, and institutions: Planning to remember in Girl Scout cookie sales. *Social Development, 11*(1), 266-289.

Salen, K., & Zimmerman, E. (2004). *Rules of play: Game design fundamentals*. Cambridge, MA: The MIT Press.

Silverstein, M. (2005). Axes of evals: Token versus type interdiscursivity. *Journal of Linguistic Anthropology, 15*(1), 6-22.

Sismondo, S. (2004). Actor-network theory. In *An introduction to science and technology studies* (pp. 65-74). Hoboken, NJ: Wiley-Blackwell.

Smith, J. H. (2005). The problem of other players: In-game cooperation as collective action.

Proceedings of DiGRA 2005 conference: Changing views – worlds in play, Vancouver, British Columbia, Canada.

Squire, K. D. (2005). Changing the game: What happens when video games enter the classroom? *Innovate, 1*(6), 25-49.

Steinkuehler, C. A. (2004). A discourse analysis of MMOG talk. In M. Sicart & J. H. Smith (Eds.), *Proceedings from the Other Players conference*, Copenhagen, Denmark.

———— (2006). The mangle of play. *Games and Culture, 1*(3), 199–213.

————. (2007). Massively multiplayer online gaming as a constellation of literacy practices. *E-Learning, 4*(3), 297–318.

Stevens, R. (2000). Divisions of labor in school and in the workplace: Comparing computer and paper-supported activities across settings. *The Journal of the Learning Sciences, 9*(4), 373–401.

Stevens, R., & Hall, R. (1998). Disciplined perception: Learning to see in technoscience. In M. Lampert & M. L. Blunk (Eds.), *Talking mathematics in school: Studies of teaching and learning* (pp. 107–149). Cambridge, UK: Cambridge University Press.

Stevens, R., Satwicz, T., & McCarthy, L. (2008). In-game, in-room, in-world: Reconnecting video game play to the rest of kids' lives. In K. Salen (Ed.), *The ecology of games: Connecting youth, games, and learning* (pp. 41–66). Cambridge, MA: The MIT Press.

Strauss, A. (1985). Work and the division of labor. *The Sociological Quarterly, 26*(1), 1–19.

Street, B. V. (1984). *Literacy in theory and practice.* Cambridge, UK: Cambridge University Press.

Sweller, J. (1988). Cognitive load during problem solving: Effects on learning. *Cognitive Science, 12*(2), 257–285.

Taylor, N. T. (2009). *Power play: Digital gaming goes pro* (Doctoral dissertation, York University, 2009).

Taylor, T. L. (2006a). *Play between worlds: Exploring online game culture.* Cambridge, MA: The MIT Press.

————. (2006b). Does WoW change everything? *Games and Culture, 1*(4), 318–337.

————. (2009). The assemblage of play. *Games and Culture, 4*(4), 331–339.

The Onion. (2000, Nov 29). Report: 98 percent of U.S. commuters favor public transportation for others. Retrieved from http://www.theonion.com/articles/report-98-percent-of-us-commuters-favor-public-tra,1434/

Tolkien, J. R. R. (1954/1955) *The lord of the rings.* New York: Ballantine Books.

Turkle, S. (1995). *Life on the screen.* New York: Simon & Schuster.

Walter, S. E. (2009). *Raiding virtual middle earth: Collaborative practices in a community of gamers* (Doctoral dissertation, Stanford University, 2009).

Walter, S. E., & Chen, M. (2009). A comparison of collaboration across two game contexts: *Lord of the Rings Online* and *World of Warcraft*. Presentation at the 10th Annual Association of Internet Researchers Conference (IR10), Milwaukee, WI.

Wenger, E. (1998). *Communities of practice: Learning, meaning, and identity.* Cambridge, UK: Cambridge University Press.

Wikipedia. (2011a). Loot system. http://en.wikipedia.org/wiki/Loot_System

————. (2011b). Min-maxing. http://en.wikipedia.org/wiki/Min-maxing

Wilson, M. (2002). Six views of embodied cognition. *Psychonomic Bulletin and Review, 9*(4), 625–636.

Wizards of the Coast. (2008). *Dungeons & Dragons, 4th Ed.* [table-top game].

Wolfenstein, M. (2010). *Leadership at play: How leadership in digital games can inform the future of instructional leadership.* (Doctoral dissertation, University of Wisconsin-Madison, 2010)

Woolgar, S. (1991). Configuring the user: The case of usability trials. In J. Law (Ed.), *A sociology of monsters: Essays on power, technology and domination* (pp. 58-99). London: Routledge.

WoWWiki. (2011). Barrens chat. http://www.wowwiki.com/Barrens_Chat

Yee, N. (2006). The labor of fun: How video games blur the boundaries of work and play. *Games and Culture, 1*(1), 68–71.

Zagal, J., Rick, J., & Hsi, I. (2006). Collaborative games: Lessons learned from board games. *Simulation & Gaming, 37*(1), 24–40.

Index

A

access
 based on cultural capital, 12
 based on social capital and sponsorship, 12
actants
 definition of, 93
actor-network theory (ANT), 8, 9, 80, 164, 169
 about tracing relationships, 96
 as alternative social theory, 95
 concept of delegation problematized due to dynamic nature of enrollment, 120
 definition of, 93, 120
 relies only on observable behavior, 95
actors, 10, 165
 definition of, 92
actual player practice, 9
addiction, 116
 personal gaming history, 167
add-ons, 14, 63
 as nonhuman actor, 91
 as part of the actor-network, 92
 common ones for raiding, 46
 function of, 39
 personal usage of, 39
 to manage cognitive load, 39, 63
age and maturity of players a problem, 161
agency
 for players as they imagine a possible future, 5
 in nonhumans through delegation, 94
 in the face of difficult problems, 6

aggro, 61
 definition of, 98
 getting it became okay for routine fights, 67
 real reason rogues were getting aggro during Ragnaros fight, 119
Akrich, M., 96
aliases
 convention for, 20
alignment, 79, 164
 of values within the group, 9
Amanti, C., 134
American Educational Research Association, 5
analysis of chat during a routine fight, 64–66
analysis of MMOG talk, 61–62
Andrew
 We are who we are in the becoming of ourselves, 117
Arneson, D., 11
attack types
 white and yellow, 102
Auction House, 23
Axelrod, R., 57

B

balance
 finding the right balance between spamming and minimizing threat during a fight, 66
 other types of balance in fights, 67

new literacies ¶

AND DIGITAL EPISTEMOLOGIES

Colin Lankshear & Michele Knobel
General Editors

New literacies and new knowledges are being invented "in the streets" as people from all walks of life wrestle with new technologies, shifting values, changing institutions, and new structures of personality and temperament emerging in a global informational age. These new literacies and ways of knowing remain absent from classrooms. Many education administrators, teachers, teacher educators, and academics seem largely unaware of them. Others actively oppose them. Yet, they increasingly shape the engagements and worlds of young people in societies like our own. The *New Literacies and Digital Epistemologies* series will explore this terrain with a view to informing educational theory and practice in constructively critical ways.

For further information about the series and submitting manuscripts, please contact:

Michele Knobel & Colin Lankshear
Montclair State University
Dept. of Education and Human Services
3173 University Hall
Montclair, NJ 07043
michele@coatepec.net

To order other books in this series, please contact our Customer Service Department at:

(800) 770-LANG (within the U.S.)
(212) 647-7706 (outside the U.S.)
(212) 647-7707 FAX

Or browse online by series at:

www.peterlang.com